# A VICTORIAN SALON

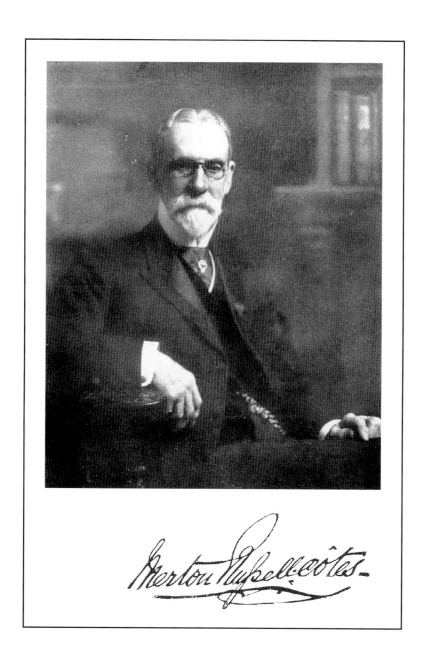

Sir Merton Russell-Cotes

# A VICTORIAN SALON

Paintings from the

Russell-Cotes Art Gallery and Museum

With essays by

SIMON OLDING

GILES WATERFIELD

MARK BILLS

Russell-Cotes Art Gallery and Museum, Bournemouth

in association with

Lund Humphries Publishers, London

# CONTRIBUTORS

SIMON OLDING was Director of the Russell-Cotes Art Gallery and Museum from 1989–98. He is currently Director of Heritage Policy at the Heritage Lottery Fund. His recent publications include studies of the artists Martyn Brewster and Emma Stibbon, with a forthcoming essay on contemporary craft commissioning at Russell-Cotes.

GILES WATERFIELD is an independent curator and art historian and joint Director of the Attingham Summer School and Director of Royal Collection Studies. He was Director of the Dulwich Picture Gallery, London, from 1979–96. He has a particular interest in the history of museums and galleries and was joint curator of the 1998 Royal Academy exhibition *Art Treasures of England.*

MARK BILLS is Visual Arts Officer at the Russell-Cotes Art Gallery and Museum. He has a particular interest in late nineteenth- and early twentieth-century British art and has published various articles, catalogues and books on this area. His most recent publications include the first substantial monograph on the Victorian artist, Edwin Long RA.

# ACKNOWLEDGMENTS

The exhibition has only been made possible through the work of the Dahesh Museum, New York and the Frick Art and Historical Center, Pittsburgh in conjunction with the Russell-Cotes Art Gallery and Museum, Bournemouth.

The coordinators for the Dahesh Museum presentation are J. David Farmer, Director, and Tara Davey, Deputy Director, with Stephen Edidin, Curator, and Jane Becker, Assistant Curator, assisted by Erica Blumenfeld, Registrar, Richard Feaster, Technician, and Maria Celi, Administrator. At the Frick Art and Historical Society, Decourcy E. McIntosh, Executive Director, and Sheena V. Wagstaff, Director of Exhibitions, Collections and Education, coordinated the exhibition with the assistance of staff members Nadine Grabania, Sarah Hall and Michelle Griffin. At the Russell-Cotes Art Gallery and Museum, Simon Olding, Director (1989–98), Cathie Collcutt, Keeper of Museums, Mark Bills, Visual Arts Officer and Diane Edge, Secretary.

In the preparation of the catalogue the advice of Christopher Gridley, Althea H. Huber, Terry Parker and Giles Waterfield was extremely helpful. Invaluable information has been provided for individual catalogue entries by: Lesley Botten, Museums Curator, Annandale and Eskdale, for the entry on W. E. Lockhart; Richard Green, Curator, York City Art Gallery, for the entries on William Etty; Andrew Greg, Curator, Laing Art Gallery, Newcastle, for the entry on Carmichael; Alison Inglis, University of Melbourne, for the entry on E. J. Poynter; Christopher Lloyd, Surveyor of the Queen's Pictures, for the entry on W. E. Lockhart; Jan Marsh, Art Historian, for the entry on Anna Alma Tadema; Stephen Wildman, Curator, Ruskin Library, for the entry on Severn and Ruth Wood, Art Historian, for the entry on B. W. Leader.

# CONTENTS

# FOREWORD

I am delighted that the comprehensive refurbishment programme underway at the Russell-Cotes Art Gallery and Museum has provided the opportunity for an important group of paintings from the core of its collection to be seen by a new audience. The life of an art gallery stems from access to its collection. At a time such as this when the art gallery is closed to visitors the opportunity to reach out in a way that this exhibition allows is immensely welcome. I am indebted to the Dahesh Museum, the Frick Art and Historical Center and the Helsinki City Art Museum for providing this exciting opportunity.

The collections of the Russell-Cotes are no strangers to art galleries in the United States. In earlier decades Albert Moore's *Midsummer* visited America and Canada. The same painting travelled to Washington only recently to be shown in their exhibition *The Victorians*.

But this tour is a major project. Taking so many paintings from a single collection is unusual. The preparation of the paintings has involved paper, painting and frame conservators working together against tight deadlines. The result is the stunningly fresh representative exhibition that you see today. On their return to Bournemouth the paintings will be re-displayed in one of Britain's most important surviving domestic buildings, newly restored and triumphantly repaired for its second century.

Councillor Jean Moore
Chair of the Arts and Museums Sub-Committee,
Bournemouth Borough Council

# A VICTORIAN SALON:
## AN INTRODUCTION

SIMON OLDING

Mr Russell-Cotes has ... devoted considerable time to the bringing together of probably the most notable collection of modern works of Art in the extreme south of England.

*Art Journal* (1895)[1]

Merton Russell-Cotes's 'notable collection of modern works of Art' was presented along with East Cliff Hall, the family home, to the Borough of Bournemouth by way of a lease and deed of gift in 1908. East Cliff Hall is the extravagant and eccentric heart of today's Russell-Cotes Art Gallery and Museum, Bournemouth. The Russell-Cotes's founding collection graced, embellished and filled to overflowing East Cliff Hall, constructed from 1898 onwards. Merton's particular interest in fine art was matched by his wife, Annie's, interests in ethnography and natural history, bringing together a rich and diverse collection presented with unashaming bravura in the elaborate and colourful setting of their home. East Cliff Hall was conceived as a home, lived in as a 'house/museum', and finally presented to the Borough of Bournemouth for use as an Art Gallery and Museum to educate and entertain the citizens of the town, and of course to act as a glittering symbol of the patronage and good taste of the founders.

The Russell-Cotes today is a thriving and highly regarded Art Museum, noted for the splendour of its Victorian inheritance, but also for the strength, for example, of its education and exhibition programme, often featuring the work of contemporary artists and craftspeople. The addition of formal art galleries to East Cliff Hall built between 1916 and 1926 extended the scope and size of the museum enabling the proper display of many of the larger works of the founding fine-art collections. A new extension added to the western elevation of East Cliff Hall in 1990 has given the museum the opportunity within a contemporary building to interpret founding and later collections and to add significantly to an art and craft commissioning programme.

East Cliff Hall however is the lodestone, the source of inspiration and, so to speak, the spiritual heart of the Russell-Cotes Art Gallery and Museum. The building offered Merton and Annie Russell-Cotes the opportunity to act as patrons and curators alongside their chosen architect, the Bournemouth-based John Frederick Fogerty. Fogerty was given a wonderful site on which to work. East Cliff Hall, situated beside the Royal Bath Hotel which the Russell-Coteses themselves had managed since 1876, occupies a very prominent location on the cliffside overlooking Bournemouth Bay. The Russell-Coteses' instructions to their architect must have emphasised the requirement for visual drama. The house, at once an Italian villa and French château with its series of conical roofs and striped copper balconies, presented a bold face to the bay. And if there was nothing abashed about this architecture from the outside, the interiors of East Cliff Hall led the Russell-Coteses' many visitors into a riot of colour and textured surface. Here they found the perfect setting for the crowded display of the changing collections. Recent and detailed scholarly research has proved that East Cliff Hall was embellished at the direction of the owners, who selected fittings and wallpapers from catalogues, as well as instructing the 'house painters', to produce an elaborate series of interior decorative schemes. Annie Russell-Cotes's own personal fortune enabled the couple to indulge in extravagant and colourful purchases for the interior decoration of the house. The overall design and theme however is one of chosen contrast between dark and light, masculine and feminine interiors. The male preserves of the house such as the library, study

Fig. 1.

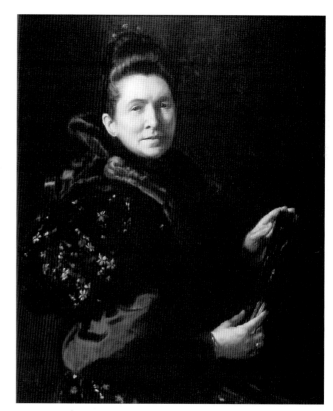

Fig. 2.

and dining-room are finished in deep maroon and reds whereas the female domain, Annie's boudoir and the drawing-room for example, have a lighter and more graceful palette.

One of the most important features of the art works throughout East Cliff Hall is in stencilling. Fine rooms and public spaces, as well as some hidden areas, contain a variety of stencil patterns. Certain areas, for example the grand hall, were specifically intended for the display of the Russell-Coteses' painting collection and in these instances the stencil patterns simply form a decorative frame to the wall. In other domestic areas of the house such as the bedrooms, more elaborate stencilling takes place. Other decorative features throughout the house include fine stained glass and extensive tiling. The most individual expression of fine-art taste is indicated by the decorative art work painted directly onto plastered ceilings and coves throughout East Cliff Hall. Merton had previously employed two artists, John Thomas and his son Oliver, to decorate many rooms in the Royal Bath Hotel and they in turn were engaged to decorate ceilings throughout East Cliff Hall. Whilst the quality of their work varies, the frieze of peacocks in the dining-room of East Cliff Hall is a fine and important survival.

The use of Japanese motifs in the Thomases' work is one of the few points where a fashion for Japanese devices in the Aesthetic era of the 1880s meets with and matches a particular collecting interest of the Russell-Coteses, though it is noticeable that by the time they had chosen this scheme the fashion was already out of date. Indeed, East Cliff Hall itself was outdated even as it was being constructed. The Japanese collections which Merton and Annie built up on a number of trips to the Far East are of fundamental importance in their foundation collection. Originally presented in the Japanese drawing room in the Royal Bath Hotel, the collection was exhibited in a dedicated and appropriately decorated gallery room in East Cliff Hall. John Thomas, the resident artist at the Royal Bath Hotel, supervised the decoration of the Japanese drawing-room while the collections were 'arranged by Japanese artists in the native fashion'.[2] The printed invitations drawing attention to the room stated that 'the furnishings of the room have been specially manufactured from Japanese Native Designs, by Messrs. Kendal, Milne

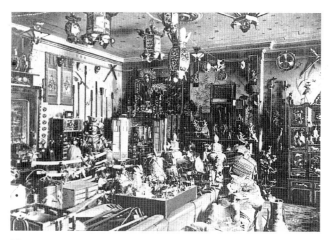

Fig. 3.

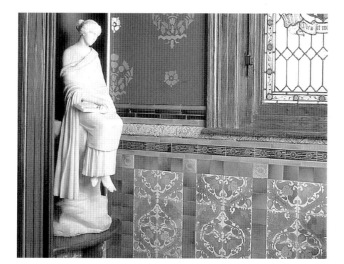

Fig. 5.

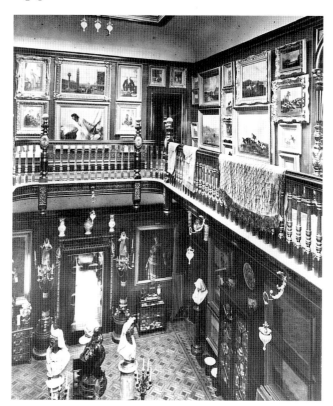

Fig. 6.

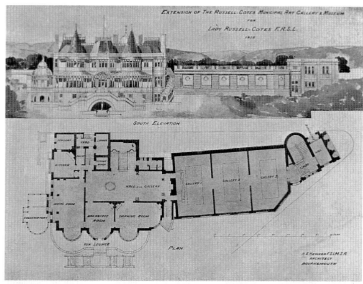

East Cliff Hall, " Russell-Cotes Art Gallery and Museum," showing the New Gallery, opened by H.R.H. Princess Beatrice, 1st February, 1919, the anniversary of our wedding day.

Fig. 4.

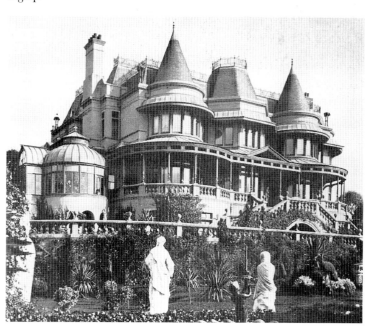

Fig. 7.

Fig. 1.  John Henry Lorimer RSA (1856–1936)
*Sir Merton Russell-Cotes, JP, FRGS, MJS (Mayor of Bournemouth, 1895)*
Oil on canvas
36 x 28 in
Photograph: James Howe

Fig. 2.  John Henry Lorimer RSA (1856–1936)
*Lady Annie Russell-Cotes, FRGS, MJS*
Oil on canvas
36 x 28 in
Photograph: James Howe

Fig. 3.  The Japanese Drawing Room, Royal Bath Hotel

Fig. 4.  H. E. Hawker's proposed plans for the gallery extension to East Cliff Hall

Fig. 5.  Entrance Hall with sculpture titled, *Hope*
Photograph: George Wright

Fig. 6.  The Main Hall, East Cliff Hall, *c.*1907

Fig. 7.  East Cliff Hall from the Grotto Pond, *c.*1907

and Co., under the personal supervision of Mr Thomas of London, by whom the *Decorations and the whole of the Hand Painting* has been executed'.

East Cliff Hall was the greatest piece of domestic architecture undertaken by the architect Fogerty. In working very closely with his client he must have spoken to, or been instructed by Merton to introduce the feeling and character of an artist's studio into the creation of East Cliff Hall. Merton is known to have visited a number of artists' studio houses in London including those of Edwin Long, Albert Moore and possibly Leighton House, the home of Lord Leighton and now the Leighton House Museum in Kensington, London. This specific interest in artists' studio houses must have influenced the planning of his own grand home. The mosaic hall and a Moorish alcove in East Cliff Hall are more directly influenced by the great Arab hall in Leighton's studio house, but the ambience and the sumptuous surroundings gracing the works of fine art and sculpture in East Cliff Hall are a direct evocation of Merton's intention to present himself, if not as an artist, then certainly as a friend and champion of distinguished British artists. There is one other probable connection. In the Art Gallery extension to East Cliff Hall built between 1916 and 1926 Merton provided a series of, it has to be said rather prosaic, texts in elaborate gilt Gothic lettering above the entrances to each gallery.

Both Merton (1835–1922) and Annie (1835–1921) Russell-Cotes spent considerable time and effort in pursuing their civic careers, often promoting good causes and becoming noted philanthropists within the town. There were occasions when these civic works caused more disquiet than praise within the community, and on these occasions Annie and Merton often retreated to take solace in extensive collecting trips abroad. However, their good works and civic endeavours were given the town's most prestigious accolade in 1894 when Merton was elected Mayor of Bournemouth. He had a particularly busy mayoral year opening the town's first libraries, and in being closely involved in the opening of the Meyrick Park development site, presenting the town, on that occasion, with a solid silver golf challenge cup. Merton's promotion of his fine-art, sculpture and decorative art collection also began to attract attention at this time. Merton relished his role as a gentleman, scholar and collector, and his knighthood, conferred in 1897, was the ultimate accolade of his civic and public career.

Merton had a lively fine-art career as a collector. The *Art Journal* reported exhaustively on his fine-art collection in 1895 describing it from its location then in the Royal Bath Hotel. One of the best-known visitors to the hotel, Oscar Wilde, is quoted as saying: 'You have built and fitted up with the greatest beauty and elegance, a palace, and fitted it with gems of art, for the use and benefit of the public at hotel prices.'[3] It is likely that Merton and Annie Russell-Cotes had always seriously considered the gifting of their collections and East Cliff Hall to the people of Bournemouth. They made this gift to the town in 1908. The first indenture of 1 February 1908 between Merton and Annie Russell-Cotes, the Mayor and Aldermen and Burgesses of Bournemouth describes the gift of property and collections in detail. The Russell-Coteses themselves were permitted 'to live peaceably and quietly and to use the premises as a residence' until their deaths.

The indenture describes in detail the foundation collection gifted to the Borough, as a 'collection of paintings, prints, ornaments, bric-a-brac, and other objects of Art and Vertu … for the use, benefit and enjoyment of the inhabitants and visitors to Bournemouth'. The schedule of works is headed, appropriately, by a series of marble busts of the Russell-Coteses which were displayed proudly throughout East Cliff Hall. Ceramic collections and historic furniture decorated the interiors with hundreds of items crammed into the main hall. The collections originally displayed within the hall give a clear indication of the eclecticism of the Russell-Coteses' taste. The Hall displayed everything from marble sculpture through to Maori axes, natural history items, 'framed and glazed, illuminated votes of thanks, from Oldham, Bath, Sheffield, Burnley, Liverpool, Glasgow, Leeds and Manchester' mixed in with highly important Maori cloaks and armour and miscellaneous items such as 'an old English weighing machine and an old English flail', the whole mix surrounded and dominated by Victorian paintings.

Merton Russell-Cotes's founding fine-art collection concentrated on his love

of British Victorian paintings. The original collection was purchased for public and semi-public display within the Royal Bath Hotel as well as for the Russell-Coteses' own private rooms there. In such a setting, where the owners of the hotel would want to emphasise both their good taste and respectability, no paintings in the original hotel collection were selected to offend taste or propriety. One might even feel that the works were selected as a very superior form of wall covering with works intended to be read as a grand and comprehensive sequence of images rather than as individual and excellent works of art. The *Black and White* magazine described the lengthy corridors of the hotel 'hung with specimens of the choicest works of art of such artists as Turner … Corot, Tadema, Sidney Cooper, Edwin Long, Jon. Linnell, Landseer, David Murray, W. L. Wyllie, Herkomer, Fildes, Etty, Webster, Dendy Sadler, Waterlow and a host of others'.[4] The display of this collection was intended by Merton to demonstrate his artistic leanings, his liberal patronage of artists, although the selection of works demonstrates that his taste was essentially conservative and even predictable. However, substantial work by artists such as Edwin Long, Albert Moore, Landseer, Etty and W. P. Frith were also at the heart of his collection. Merton undoubtedly purchased works because of the high artistic and social standing of the artist, and in particular the works attributed then to Albert Moore and a large number of nude studies by William Etty. The very substantial collection of paintings by Edwin Long is one of the most outstanding features of the Russell-Cotes founding fine-art collection. Merton was very careful in the manner in which he bought paintings by these artists: he, typically, bought works from auction or through dealers when the artists' reputations were on the wane. In particular he bought works by Etty and Long when they were unfashionable enabling him to buy work cheaply. He was often helped in these acquisitions by Thomas H. Woods, a senior partner in Christie, Manson and Woods at the end of the nineteenth century on his retirement to Bournemouth. The noted dealer W. W. Sampson of Air Street, London was also a valued colleague. He selected work either through establishing personal contact with artists such as Edwin Long, by buying directly through Christie's sales or purchasing at Agnew's in London.

Merton was a very regular viewer at the commercial galleries on Bond Street in London. He was also a fickle collector, buying and selling work with considerable regularity as taste and whim dictated. His personal acquaintances with artists obviously pleased him, though Russell-Cotes was prone to overstate his friendships. He was certainly not above some gentle bullying of his artist companions. He unashamedly says in *Home and Abroad* that on the purchase of a painting by Solomon J. Solomon he felt that its appearance did not quite come up to scratch:

> … this picture I purchased some years ago. There were a few little things that I considered might be improved. I, therefore, wrote to Mr Solomon, and he replied that if I would send it to him, he would be delighted to look at it and go over it if necessary. I sent the picture, therefore, to him, and he kept it for a long time. He eventually sent an apologetic letter to the effect that he had been exceedingly busy, but that he had done what he considered was necessary for the improvement of the picture, as I had suggested, and that he would at once return it. On its arrival, I was delighted with the improvement which had been made; in fact, so much so that I scarcely knew it again. … I, of course, wrote, tendering him my heartiest thanks for the splendid results which he had obtained, and if he would kindly let me know the amount I was indebted to him, I would send him a cheque.[5]

This episode draws attention to some of Merton's less endearing characteristics: a sense of his own esteem, and a rather mercenary attitude. Merton was forever trumpeting his friendships with artists, members of the minor aristocracy and occasionally cultural figures such as Oscar Wilde and Henry Irving. These seem to have been acquaintances by letter rather than acquaintances of deep personal friendship. Merton was an inveterate name-dropper, and a sterling seeker after the public photograph. His tireless searching for the companionship and acquaintance of the rich and famous seems naive and sometimes charmless today. But Merton was a skilful self-publicist, he had a hotel to run and keep occupied,

and the detailed promotional stories of his friendships and civic improvement schemes led naturally to the dramatisation in the local and regional press of his extraordinary philanthropy and gift of collections to the Borough of Bournemouth.

*A Victorian Salon* has at its heart works brought together for the foundation collection given to the Russell-Cotes Art Gallery and Museum by Merton and Annie Russell-Cotes. These collections were intended for display within East Cliff Hall and then in the purpose-built art galleries. Merton had advanced and innovative ideas concerning the touring of his works. He brought together an extraordinary collection of paintings intended for tour to nationally important municipal museums, mainly in the north of England, and tirelessly promoted these shows at the end of the nineteenth century. The prime source for the purchase of these works for the touring collections was the annual exhibition at the Walker Art Gallery in Liverpool, though Merton also indicates that he especially enjoyed buying works that had been in that year's Royal Academy Exhibition. In *Home and Abroad* he says that his loan collection included 'all admirable works by famous British artists'[6]. Merton's intention here was to 'confer a benefit upon the public and educate them in the art of their own country'. The effort to sustain the Russell-Cotes touring exhibitions after two decades must have become tiresome, for the collection was eventually dispersed, with particularly significant paintings remaining in the founding gift. This model of touring was highly attractive to Russell-Cotes, enabling him to act as a philanthropist, art connoisseur and man of good taste. The tours would have created a very high profile for the Russell-Cotes name and laid a foundation for the national reputation when it opened of the Russell-Cotes itself. Merton undoubtedly sold the collection not only because of the laborious arrangements that it entailed but also because he would have had little space in the hotel or at East Cliff Hall to display the works from this large collection. He retained one third of the touring work for his personal pleasure with the rest of the loan paintings being sold at Christie's on 11 March 1895. Merton describes this with a typical self-importance as 'the most complete representative collection of British Art that they had had through their hands'.[7] The portion which remained in his private collection was subsequently included in the gift of works along with the gift of East Cliff Hall, together with other fine-art, ethnographic and natural history collections.

The fine-art collection was intended to be seen within a very specific context – the sumptuous interior of East Cliff Hall and the grand *beaux-arts* setting of the art gallery extension. Merton was inspired to buy work through a lifelong interest in the fine arts. Driven by his evident enjoyment and affection for the artists themselves and for the chance that the purchase of works gave him to add to his status as a senior citizen of the town of Bournemouth, Merton stuck very carefully to the purchase of modern British and European works and there are indeed important paintings within the collection. Landseer's *Highland Flood*; the oil painting then assumed to be by, and now only attributed to, Turner of *St Michael's Mount*; the full-length portrait *Edward VII* by Tennyson Cole; James Archer's *Henry Irving as Charles I*; and Frederick Goodall's *Subsiding of the Nile*, are among the most impressive works in the collection. The gift of East Cliff Hall and its contents to the Borough of Bournemouth in 1908 saw the ideological transfer from domestic house to public art gallery take place. Although Annie and Merton lived in the house from 1908 until their deaths in 1921 and 1922, public attendance at the house/museum 'in this period was permissible', quaintly on Wednesday afternoons on the purchase of a ticket from the Town Clerk of Bournemouth. One can imagine Merton being a very strong presence at these public viewings taking every opportunity to invite civic and other dignitaries to see his fine-art collection and acting as a personable and authoritative guide to members of the public visiting the museum in its first guise.

Merton and Annie gifted East Cliff Hall and their remarkable collections to Bournemouth with good heart and in good condition. However, between the official opening to the public of the Russell-Cotes Art Gallery and Museum in March 1922 and 1989 significant and deleterious changes to the interior of East Cliff Hall in particular had taken place. Bad municipal redecoration and a lack

of attention to repair and renewal to the fabric of the property had led to very serious disrepair. A major refurbishment and upgrading of the Russell-Cotes Art Gallery and Museum, bringing together in a financial partnership Bournemouth Borough Council and the Heritage Lottery Fund, has led to a complete upgrading and refurbishment scheme currently underway. This project will secure the fabric of the building and return and restore original decorative features throughout East Cliff Hall. The project, when it is completed at the end of 1999, will ensure that the Russell-Cotes Art Gallery and Museum is handed over to future generations in a highly authentic and historically accurate form. Merton and Annie Russell-Cotes themselves would have acknowledged the accuracy and spectacle of this work. The project will enable the Russell-Cotes Art Gallery and Museum to lay claim to a position as one of the most unique and important art museums in the country, a worthy and glamorous home for the remarkable collection of Victorian paintings which is at its heart.

## NOTES

1. 'The collection of Merton Russell-Cotes, Esq., JP', *Art Journal* 1895, p.83
2. *Decorative Arts Journal 1889*
3. Merton Russell-Cotes, *Home and Abroad*, 1st ed., Bournemouth: privately published 1921, p.36
4. *Black and White*, October 1891
5. *Home and Abroad*, p.721
6. *Ibid*, p.686
7. *Ibid*, p.688

# 'A HOME OF LUXURY
# AND A TEMPLE OF ART'

## GILES WATERFIELD

Almost all the municipal art museums of Britain were founded between the late 1860s and the outbreak of the First World War. In 1865 almost no city-run art museums (or 'art galleries' as they are generally known in Britain) existed, even though legislation allowing cities to provide funds for their foundation had been introduced a decade earlier. The principal public provision outside London in mid-century was made for scientific, natural history or archaeological museums: pictures came later. In the last third of the century the transformation of attitudes towards the visual arts, increasing confidence in modern British art and the enormous prices that it commanded, as well as the belief that art could affect the lives of the poor in great cities, ensured that by 1914 almost every town of any size possessed a public art gallery. Often the works of art gallery and the scientific or historical specimens were housed in one building, although as the century advanced the art gallery was sometimes given a more or less ambitious home of its own. By the end of the century a city was considered incomplete without a public gallery.

It is to this history that the Russell-Cotes Art Gallery and Museum belongs. Founded in 1908 and only opened on a daily basis in March 1922 on the founder's death, it is a relatively late but well-preserved example of the type. But although in many ways Sir Merton and Lady Russell-Cotes belonged in the mainstream of late Victorian museum founders, their approach to the possibilities of establishing a gallery was highly individual.

Victorian art galleries and museums relied on both public enterprise and private philanthropy. Some were set up by municipal bodies, with funds for the new (or adapted) building and collection coming from the city itself. Since (then as now, in Britain) cities were reluctant to spend tax-payers' money on providing for the arts, they frequently (as at Glasgow and York) used such devices as the organisation of a major exhibition on the lines of the *Great Exhibition* of 1851. These events were expected to make a profit and provided, in the vacated exhibition buildings, a suitable setting for the new museum. More often, the new galleries and museums resulted from the generosity of private individuals. Sometimes, as in the case of Alderman Walker of Liverpool, such people only provided funds for a new building, and gave no collection. In other instances, such as the Mappin Art Gallery at Sheffield, the founder donated his works of art as well as funds for the provision of a new building. Alternatively, as with the Wrigley collection in Bury near Manchester,[1] the objects for display would be given with the expectation that a building would be provided by the city. In almost every case, the collection was removed from the house which had originally accommodated it, on becoming public property.

What makes the Russell-Cotes Art Gallery and Museum exceptional is that Sir Merton bestowed on his adopted town the house which he had built for his own use as an integral part of the gift. It was a house intended not only for domestic comfort but for the display of works of art, inspired by the splendid artists' houses which he had admired in London. It was designed in a relatively idiosyncratic manner, which combined 'the Renaissance with Italian and old Scottish Baronial styles'.[2] In spite of various unfortunate sales in the early part of the century and the dilution of the Victorian effect in the middle years of this century, the recent restoration of the house and a number of judicious purchases have brought back most of its original atmosphere. Its magnificent position on the East Cliff, overlooking the centre of the town's resort area, not only allows remarkable views for those inside, but makes it a landmark from the sea-front. Few museums or galleries in British towns of the nineteenth century enjoy sites of such prominence or charm.

In the United States the survival of the intact collectors' house-museum is more common than it is in Britain. The Frick Collection in New York, the Frick Art and Historical Center in Pittsburgh, the Huntington Museum and Library in Los Angeles and Hearst 'Castle' in San Simeon, California remain as outstanding examples. The situation in England is different. A number of turn-of-the-century collections, kept in private houses and transformed into semi-public museums, do survive, such as the Powell-Cotton Museum at Quex Park at Birchington, but these do not contain art collections. In the fine-art field, Sir John Soane's Museum in London, from the early nineteenth century, and Leighton House and the Wallace Collection, also in London, can be compared with the Russell-Cotes Art Gallery as residences that have become art museums. But these examples do not altogether fit into the same category as the Russell-Cotes. Other than the Wallace Collection, the buildings belonged to men actively engaged in the fine arts, and were intended as shrines to the artist, similar to late nineteenth-century French examples such as the Musée Gustave Moreau in Paris. Leighton House was not intended by its original owner as a museum, and its domestic character has been re-created in relatively recent years; while the will bequeathing the Wallace Collection to the nation stipulated that a new building should be erected for the works of art. Apart from Sudley Art Gallery in Liverpool, formerly the residence of a leading ship-owning family,[3] the Russell-Cotes is almost unique in Britain as the surviving residence of a Victorian private collector, planned and perpetuated as a permanent art museum.

It was of course not only European paintings that the Russell-Coteses acquired. The extensive Japanese collections, the other exotic objects brought back from their travels and the birds and butterflies which were a special interest of Lady Russell-Cotes, gave the house a miscellaneous feeling which is reminiscent of many Victorian municipal galleries and museums. But it also had a domestic quality. In the collection were assorted examples of the decorative arts, including furniture, Wedgwood ceramics and doors taken from a Florentine *palazzo* which were installed in the drawing-room. A distinguished provenance was particularly important for Merton, as for many collectors: thus he bought a wine-cooler and a table which had been made by George Bullock for Napoleon's exile in St Helena. Theatrical memorabilia, particularly a whole room devoted to Henry Irving, also occupied an important space. The analogy with municipal galleries is one that Merton would probably not have relished. More to his taste (and very likely an indication of his ambitions) would have been the comparison made by his acquaintance Lord Ribblesdale, 'a charming man, a splendid representative of the English nobility and a sportsman'.[4] Ribblesdale was quoted in 1914 as calling the Museum 'a miniature "Wallace" Collection, and much more varied in its exhibits …'.[5] The Wallace Collection, opened to the public in 1900, contained the princely collection of the Marquesses of Hertford and of Sir Richard and Lady Wallace, including paintings, French decorative art, and arms and armour. The effect of a sumptuous aristocratic residence may well have been in the minds of Sir Merton and Lady Russell-Cotes.

In his choice of business Russell-Cotes was also unusual among artistic patrons. His wealth derived from his wife, who was a member of the King Clark family of wealthy Scottish cotton manufacturers, and was invested in the hotel business. Little of this background emerges from the two volumes of his extended memoir, *Home and Abroad*, published privately in 1921. Although his Bournemouth hotel features largely in the volumes, it is presented primarily as a setting for gracious entertainment for members of the Royal Family (many of whose utterances are reverently recorded) or people of culture and wealth. There is no discussion of the hotel trade or of Merton's work in setting up and organising the business. One is given to assume that he delegated everything except important hospitality and the creation of an artistic setting. Sir Merton, if not quite a gentleman, certainly aspired to that status, as the reminiscences of his association with the landed gentry in his natal village of Tettenhall in Staffordshire, in the Midlands, make clear. The hotel provided a commercially viable but also elegant setting for the display of works of art: as Oscar Wilde put it in a mildly ambiguous comment in the visitors' book, 'You have built and fitted up with the greatest beauty and

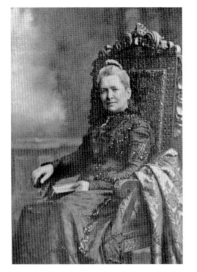

Fig. 8a.

Fig. 8b.

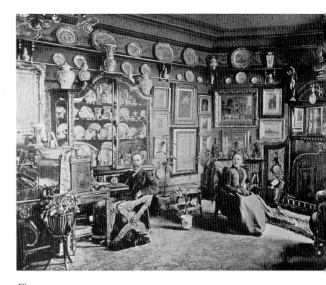

Fig. 9.

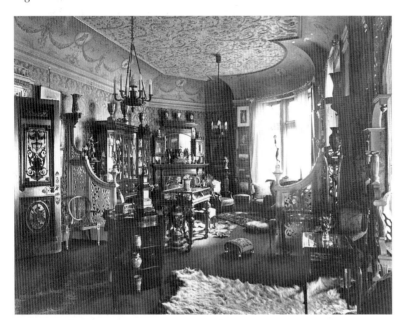

Fig. 12.

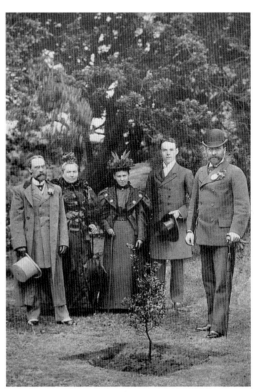

Fig. 10.

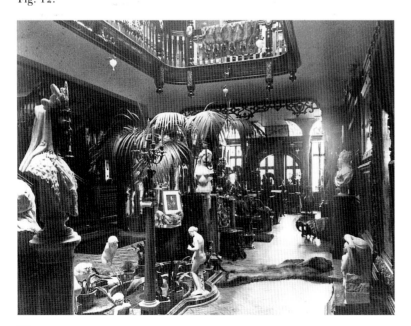

Fig. 13.

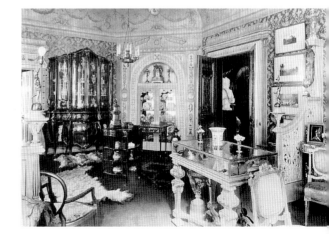

Fig. 11.

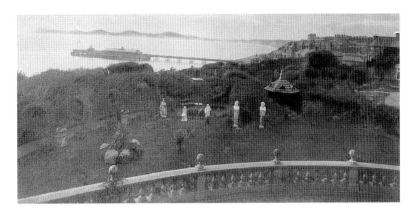

Fig. 14.

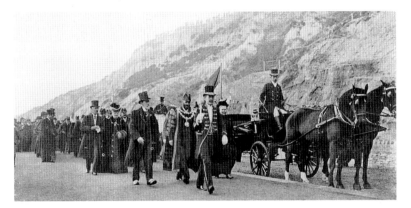

Fig. 15.

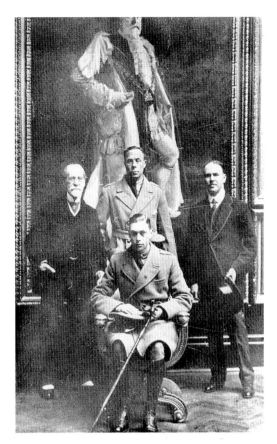

Fig. 18.

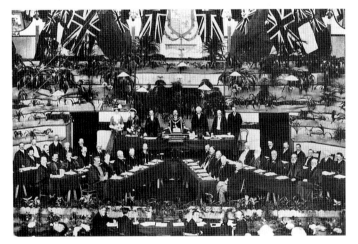

Fig. 16.

Fig. 17.

Fig. 8. Sir Merton and Annie Russell-Cotes in 1909

Fig. 9. 'One of our Sitting Rooms'. Merton and Annie Russell-Cotes at the Royal Bath Hotel

Fig 10. 'Tree planted by Prince Henry of Battenberg in the grounds of the Royal Bath Hotel on the occasion of his visit. The group consists of His Royal Highness, my wife, my daughter, Mrs Stebbing, my son Bert and myself.'

Fig. 11. The Drawing Room, East Cliff Hall, *c.*1907

Fig. 12. The Drawing Room, East Cliff Hall, *c.*1907

Fig. 13. The Main Hall, East Cliff Hall, *c.*1907

Fig. 14. East Cliff Hall's garden, *c.*1907

Fig. 15. The opening of the Undercliffe Drive, Bournemouth, 6 November 1907

Fig. 16. Presentation of the Freedom of the Borough to Merton and Annie Russell-Cotes, Winter Gardens, Bournemouth, 1908

Fig. 17. Gallery I, 1919

Fig 18. 'Portrait Group taken in the Russell-Cotes Art Gallery, HRH Prince Albert (now Duke of York), Wing Commander Louis Greig, HRH's comptroller, my son Bert and myself.' Portrait group in Gallery I, standing in front of Tennyson-Cole's portrait of King Edward VII

elegance, a palace, and filled it with gems of art, for the use and benefit of the public at hotel prices'.[6] The fact that when the Russell-Coteses moved into East Cliff Hall, immediately next to the hotel, they used the hotel staff for their own domestic purposes suggests that the management of a hotel offered them in combination the advantages of an imposing domestic setting and a decent income. As Merton grandiloquently if ungrammatically explained in his memoir, pecuniary considerations were scarcely involved in his acquisition of the hotel: 'One of the most important inducements that seemed to present itself to me was that by purchasing the Royal Bath Hotel Estate [note the word 'Estate'] I should be enabled to gratify my special genius for the love of art and my weakness for building and developing property, and also offered me the opportunity to form an art gallery eventually for the art treasures, of which I had a large collection ...'[7] There was no mention of the fact that he had some difficulty in raising the necessary capital for the purchase.

A hotel filled with works of art was a rare enterprise. Although some Victorian and Edwardian hotels (such as the Hotel Cecil in London, which was flourishing from the 1890s) contained paintings and sculpture, these tended to have the character of superior furnishings. The use of his hotel at Scarborough by Tom Laughton in the 1920s to show his collection of modern British painting, which was later given to Scarborough Art Gallery, is the only other instance of a close relationship between a hotel and a municipal gallery that comes to mind for Britain. The impact made by the Royal Bath Hotel, with its corridors and public rooms and bedrooms filled with pictures, was strong. When a visitor to the hotel, the editor of *Queen Magazine*, expressed her astonishment at seeing such a 'home of luxury and a temple of art', with the 'valuable and beautiful pictures which crowned all its walls, and the exquisite specimens of China and Japanese art', Merton explained his thinking: 'No ordinary home could be found with space enough to contain half the pictures I desire to buy, and I know that such possessions if wisely purchased are a good investment for my money, so whilst I am pleasing myself, and enjoying my life amongst my treasures, I am also advantaging others, and attracting those of similar tastes to the hotel ...'[8]

The Bath Hotel, founded in 1838, was considerably extended by Merton, who added wings and imposing reception rooms to the building. He added the 'Royal' prefix following a visit by a member of the Royal Family.[9] In this building he wanted to do more than provide house-space for the works of art: rather, he intended the building to be a work of art in itself. Additional allure was given by the introduction of elaborate decorative schemes by the well-known London artist John Thomas and his son, who had worked extensively for Queen Victoria and Prince Albert (a connection which may have appealed to this patron). Their work included highly-coloured murals, of which some examples survive. So decorated, the hotel had the character almost of a private residence of the most distinguished sort, where guests could be trusted to behave appropriately in the company of valuable works of art and where the taste and character of the owner could be proclaimed.

In his profession Merton was, again, unusual among patrons of the arts. Of the leading philanthropists who created art collections or art museums in late nineteenth-century Britain, the majority came from commercial backgrounds rather than from the landed classes, the professions or the arts. Very few were members of the traditional aristocracy, which showed little interest in providing works of art for the urban masses. In the case of the two most striking examples of aristocratic gallery founders, John and Josephine Bowes of the Bowes Museum and Sir Richard and Lady Wallace of the Wallace Collection, the husbands were both illegitimate descendants of noble families, for whom the foundation of an art museum offered an alternative form of ennoblement. Much more common was a background in brewing (as with Alexander Laing, of the Laing Art Gallery in Newcastle), which created many late nineteenth-century fortunes but had doubtful connotations in the great age of the temperance movement. The textile industry of Yorkshire and Lancashire also funded a number of new museums. In some cases these newly rich men (and occasionally women) wanted to establish themselves as leading members of the urban élite, and found the creation of an

art museum one of the most effective ways of achieving this objective (and indeed of repaying the debt that they owed to the community from which they had made their fortunes). As a hotel-owner and host to the nobility, Russell-Cotes pursued a similar objective but on the basis of a more refined fortune. His refinement was rendered even more impressive by his assiduously-recorded hob-nobbing with the titled and with artists and actors of whom Henry Irving was the most famous.

Among museum founders, Russell-Cotes was also relatively unusual in being established in the south of England.[10] The majority of new museums and galleries set up in late Victorian England were created in the north or the Midlands. Such old-established industrial or maritime centres in the south and west of England as Bristol and Southampton were remarkably slow to create institutions of this sort, partly because they apparently lacked potential patrons. Even in the numerous resorts of southern England, only Brighton, which enjoyed the active involvement of Henry Willett, had acquired a municipal art gallery of any standing by the end of the century. Perhaps the closest comparison may be made with the Baron de Ferrières, a Belgian nobleman who established himself in Cheltenham (like Bournemouth, a town of genteel character) in the later nineteenth century, involved himself busily in the affairs of the town, of which he became Mayor, and gave his art collection (though not his house) as the basis for a municipal gallery.

Many of the seaside towns of England were developed in the late eighteenth or early nineteenth centuries, the best-known of them being Brighton, a curious blend of royal patronage, comfortable senescence and theatrical raffishness. By the 1840s most of these towns had already achieved their crescent and square and had built an esplanade along the sea-front. Bournemouth, less easily accessible from London in its early days than many of the others, remained little built up at that time, although the potential appeal of its sheltered climate and miles of pine trees was already apparent. In 1841 Dr Granville in *The Spas of England* remarked that it had the capability of 'being made the very first invalid sea-watering place in England' and of 'providing a winter residence for the most delicate constitutions requiring a warm and sheltered locality at this season of the year'.[11] Although the town was just beginning to expand, with the establishment of the Bath Hotel and the developments planned by the fashionable architect Decimus Burton, progress was slow. While residential development and the erection of churches continued in the second half of the century, so that Thomas Hardy in *Tess of the d'Urbervilles* could describe (in the guise of his fictitious Sandborne) 'a city of mansions, a Mediterranean lounging place on the English Channel',[12] Bournemouth remained by comparison with other seaside towns extremely cautious. Many of its citizens were anxious not to provide attractive public amenities or to create a drive along the sea-front which might draw in visitors from outside. No doubt Brighton, already filled with visitors from the poorer parts of London, warned Bournemouthians against the perils of making their town too appealing or accessible. As a result, visitors continuously complained of its dullness. Its Edwardian character was evoked by Rupert Brooke who, forced to convalesce there in 1906, wrote of 'This strange place which is full of moaning pines, and impressionist but quite ungentlemanly sunsets. With other decrepit and grey-haired invalids, I drift wanly along the Cliffs.'[13]

As Simon Olding has shown, Merton Russell-Cotes played a leading part in the transformation of Bournemouth. Much of the character of the modern town is due to this determined and financially pragmatic innovator, described by a local paper in later life as 'that old warrior in the van of progress'.[14] Due in large part to his efforts, a 'sanitary hospital' (a euphemism for a fever hospital) was founded in the 1880s. The Undercliff Drive scheme which created a public road and promenade along the sea-front was introduced, and the provision of railway access to the town from London greatly improved. Almost all these innovations were controversial. Over the hospital idea, which alarmed local residents with the fear of unhealthy people being introduced into their neighbourhood, Merton incurred particular dislike, and his effigy was burnt in the street. Although Russell-Cotes was alarmed and depressed by such opposition, he always defied it,

with ultimate success. By the end of the century, his efforts were rewarded: the town was granted municipal status in 1890, and its population almost doubled in the last decade of the century.

As in a number of towns around the country (inspired by the example of the Crystal Palace both in Kensington and in its later life at Sydenham) the encouragement of the fine arts in Bournemouth was closely associated with other artistic endeavours. Public libraries were established in 1893, with Merton presiding over the opening ceremonies. Especially important was the foundation in 1893 of a municipal orchestra, based in the Winter Gardens, with the support of Russell-Cotes. This was the first body of its sort in the country, and still flourishes as the Bournemouth Symphony Orchestra. The most significant element of this history is that Merton was involved in every aspect of these improvements. Like many founders of art museums in the late nineteenth century he saw the provision of art for all members of the community as an essential element in the creation of a civilised, prosperous and socially cohesive town.

Like many of his contemporaries, Russell-Cotes regarded the encouragement of art by a broad public as part of a more general charitable endeavour. Art was not merely a diversion: it was, as John Ruskin had preached, one of the most essential elements in the nation's life. It provided a means of remedying the ugly and materialistic monotony of an industrial society by offering an experience of beauty which would otherwise be inaccessible to most people. Ruskin's ideas about the creation of educational galleries which would train people in how to use their visual sense, and which were realised in his own museums near Sheffield, were to influence many of the leading benefactors of galleries in Victorian Britain, such as Henry Willett at Brighton and Thomas Dixon at Sutherland. Although Merton did not engage in an extended correspondence with the great man, the tone of the discourse around the establishment of the Russell-Cotes Art Gallery suggests Ruskinian influence, if in rather pallid form. ' "They wished their fellows to share their pleasure"',[15] it was said of the founders, and on the walls of the galleries were inscribed various improving slogans composed by Merton. Most significant, perhaps, was the fact that the creation of the Russell-Cotes Art Gallery formed only one element in a large programme of philanthropy, by which in their latter years this couple graced their adopted town.

The most striking example in late Victorian Britain of the association between support for art galleries or museums and other charitable activities was found in the exhibitions and galleries organised by a group of radical social reformers, all strongly influenced by Ruskin.[16] Among the leaders in this field were Samuel and Henrietta Barnett, who promoted the Whitechapel art exhibitions as part of their campaign to improve conditions in the deprived East End of London; and the artists who supported the South London Art Gallery in Camberwell. In Manchester, T. C. Horsfall set up a museum at Ancoats, another slum area. This offered a range of improving activities, including art displays, concerts and a room for children (anticipating the later development of museum education) as part of a much broader campaign of social betterment. Bournemouth could scarcely be less similar to Ancoats or Whitechapel, and the scope for improving the lot and indeed the morals of the people of Bournemouth through the Russell-Cotes Art Gallery was strictly limited. Indeed, during the lifetime of the founders the Gallery was only open for two hours on the first Wednesday of each month, on the purchase of a ticket in advance, an old-established technique for excluding the socially undesirable. Nonetheless, the Russell-Coteses intended that their gallery should ultimately be available to the whole population, and that it should have a morally improving character. Although this intention is never clearly spelt out in Merton's account of the gallery, his attitudes are conveyed by his comments on the opening of the Bournemouth Public Library, when he suggested to future readers that they should 'avoid as poison the ephemeral and impure literature which at present was emanating from the Press'.[17]

Like the Barnetts, the Russell-Coteses set their patronage of the arts within a broader programme of philanthropy. Early in his career, Merton instituted a touring exhibition of paintings for galleries all over the country, many of which

had been set up before they possessed permanent collections of any substance. This idea, perhaps inspired by the highly developed loan scheme (largely of reproductions of works of art) introduced by the South Kensington Museum in the 1860s, was not a unique venture: a very similar type of touring loan collection had been introduced by William Harvey of Barnsley, in South Yorkshire, who in mid-century assembled for the National Loan Collection Trust a group of seventeenth-century Dutch and Flemish paintings which were sent on loan to galleries all over the country.[18] The idea demonstrated Russell-Cotes's belief that it was the duty of collectors to share their possessions generously in the interests of public enlightenment. But the Russell-Coteses were also active in other areas. Thus, in 1919 the amiable couple together set up the Russell-Cotes Nautical School, intended to equip boys in the care of Dr Barnardo's Homes for the merchant navy. This project allowed a grand foundation stone-laying by Prince Albert (as the future George VI was then known), and gained the benefactors the much-appreciated soubriquet (from the Bournemouth Visitors' Directory) of 'the Good Fairies'. It was followed by a further benefaction, the Russell-Cotes Home for Children, also founded in 1919 and opened by Princess Marie Louise. This was intended as a place where 'anaemic boys and girls of London are to be transformed into sound, wholesome young people'.[19] Its aspirations were close to those of the organisers of the Whitechapel Art Gallery and the South London Art Gallery, one of whose prime aims was to give city people the opportunity to experience the purifying effect of the countryside which otherwise they would never glimpse.

In his taste, Merton Russell-Cotes was typical of the regional collectors of late nineteenth-century England in his enthusiasm for British painting above all else.[20] Whereas British art had attracted relatively few buyers in the eighteenth century in favour of foreign and especially Italian works of art, the situation had become very different at the end of the nineteenth century. The newly rich industrialists and merchants of London and the great regional cities preferred, from the mid-nineteenth century, to buy easily comprehensible works of the native school, an enthusiasm which gathered increasingly strong nationalistic connotations as the century advanced. Merton also bought sculpture and works on paper (especially watercolours, regarded as the quintessential British artistic medium), but paintings predominated. Like many other less sophisticated buyers of the time, he felt that British art, particularly as sanctioned by the Royal Academy and other prestigious events such as the Autumn Exhibition at the Walker Art Gallery in Liverpool, was as good as anything produced by foreigners, and deserved the support of British collectors on patriotic and moral grounds. British art was, after all, healthier than foreign art. When he did buy work by foreigners, he tended to concentrate on the French, who, partly as the result of the promotion provided by Ernest Gambart at his French Gallery in London, were generally regarded as of almost equal merit to the native school, as long as they were safely academic.

Many collectors, such as the pill-manufacturer Thomas Holloway, who assembled the collection at Royal Holloway College between 1881 and 1883, bought works by the artists regarded as the founders of the British school, notably Richard Wilson and Gainsborough, and the later generation of Turner and Constable. Although Merton expressed his admiration for some of these painters, he did not generally acquire their works for the gallery. The only exception was Turner: he bought a large painting of St Michael's Mount attributed (wrongly) to the artist, and a doubtful watercolour. The earliest artists of the native school whom Merton chose to show were William Etty, born in 1787, Sir Francis Grant and Sir Edwin Landseer, born respectively in 1803 and 1804, while Frederick Goodall (born in 1822) belonged to a somewhat later generation. These men were all prominent in the established artistic circles of their day, Grant as President of the Royal Academy, and it was no doubt partly this success that appealed to Merton. As a result, his collection lacked the educational character of a historical representation of the British school.

For Russell-Cotes, as for many contemporary collectors, the main thrust of his activity was directed towards academic and figurative artists. Such figures as Sir

Lawrence Alma Tadema or Benjamin Williams Leader were widely admired for their fine execution of detail and (in the case of the former) for the politely-contained erotic quality of their subject-matter. Merton showed very little interest in the Pre-Raphaelite Brotherhood, regarded by more conservative collectors as excessively daring and indeed immoral. The Olympian School, dominated by Lord Leighton and Albert Moore, did intrigue him, and he wrote with something close to passion about the work of Moore. He also flirted, generally through the medium of the Grosvenor Gallery, with such Symbolist painters as Evelyn De Morgan. The widely popular social-realist school, concentrating on the sufferings of working people, appears not to have attracted him, perhaps because the paintings of Luke Fildes and Frank Holl were extremely expensive, but he did buy such modest works as Radford's *Weary*. The influence of Ruskin and his circle is also apparent in Merton's selection of work by such painters as John Brett and T. M. Rooke, both of whom were close to the sage. In terms of subject-matter, Merton showed a fondness for landscapes, small genre scenes and animal subjects of a type which appealed to many of his fellows. The choice of large historical works which attracted many of his contemporaries was concentrated on the production of Edwin Long, though a pseudo-historical quality was introduced by the purchase of paintings with a theatrical element. Perhaps the most individual feature of Merton's collecting was his penchant for depictions of women, whether portraits of attractive girls or the nudes which, as he zestfully recorded, sometimes aroused scandalised comment when placed on exhibition.

A notable feature of the collection was Merton's conservatism at a time of rapidly changing taste, especially after the First World War. Like many of his contemporaries, he was strongly hostile to Impressionism, Futurism and Post-Impressionism. In the early pages of *Home and Abroad* he somewhat confusingly associated Post-Impressionism with Prussian militarism and the 'scientific craze' which 'will bring down everything that is good'. His views, scarcely refined, are conveyed by remarks of this sort: 'Art has degenerated into what is called "post-impressionism", dabbing little blobs of the blazing colours of the spectrum contiguously all over the canvas, and the artist (save the name) asks us to endorse his method as the last word in knowledge and truth, and to discard the masterly technique of Turner, Leader, Constable, and other great English artists.'[21] Not surprisingly, in later life the mildly innovative Camden Town School held no attractions for him.

The degeneration of art was seen by Russell-Cotes as part of the general decadence of society. Such decadence was manifested both in changing social conditions, which encouraged people to seek higher wages and shorter working hours (which they had attained, without becoming any happier), and in the subversion of traditional British values. The country, he thundered, could not go forward with clean hands 'when England has produced such men as Darwin, Huxley and Bradlaugh, Keir Hardie and many others, who seem to come into the world to undo all the happy, restful and contented faith of the Christian era'.[22] It was to him incredible that some of these men were buried in Westminster Abbey.

Sir Merton Russell-Cotes was always representative of traditional standards, especially in artistic matters. As styles of painting dramatically changed in the twentieth century, he became an example of the artistic insularity of late Victorian and Edwardian England, clinging to his belief in Victorian subject painting when its value in critical esteem and indeed in the sale room had collapsed. The society that he represented and the works of art that he accumulated had by the time of his death become something of a joke, and it is not surprising, given that context, that later curators of the Russell-Cotes Art Gallery tried to undo what they found there. Today, the qualities of the collection and the rare unity of house, garden and collections can be more dispassionately appreciated as a remarkable and evocative survival of a late Victorian temple of art.

1 The Wrigley collection was given in 1897, one of a number of major donations celebrating Queen Victoria's Diamond Jubilee

2 Merton Russell-Cotes, *Home and Abroad*, 1st ed., Bournemouth: privately published 1921, p.217

3 Again, Sudley was not intended to become the home of a museum by its donor

4 *Home and Abroad*, p.315

5 *Ibid*, p.316

6 Quoted in Peter Pugh, *The Royal Bath Hotel*, Cambridge Business Publishing, 1988, p.21

7 *Ibid*, p.33

8 *Home and Abroad*, pp.35–6

9 See Pugh 1988 at note 6

10 Alfred de Pass, who gave drawings to Truro in Cornwall and Plymouth in Devon for the enjoyment of the people, is another example of a patron active in the south of the country

11 Quoted in David Young, *The Story of Bournemouth*, London: Robert Hale, 1957, p.53

12 Thomas Hardy, *Tess of the d'Urbervilles*, London, 1892 ed., p.490

13 Rupert Brooke, *The Letters of Rupert Brooke* (ed. Geoffrey Keynes), London 1968, p.62

14 *Bournemouth Guardian*, 1911

15 *Home and Abroad*, p.280

16 For a summary of this history, see Giles Waterfield, *Art for the People*, London: Dulwich Picture Gallery, 1994

17 *Home and Abroad*, p.105

18 The paintings are now held at Cannon Hall Museum, Barnsley

19 In the words of the Shaftesbury Society's handbook, quoted in *Home and Abroad*, p.373

20 See Dianne Sachko Macleod, *Art and the Victorian Middle Class*, Cambridge 1996, for the most recent and penetrating discussion of this phenomenon

21 *Home and Abroad*, p.6

22 *Ibid*, p.7

# MERTON RUSSELL-COTES,
# ART AND EDWIN LONG

## MARK BILLS

*When a boy, although the trend of my mind developed a love of music, geography, botany and a study of scientific objects, yet Art predominated, and took first place. This passion (if I may call it such), became more intense as I grew older.*

Sir Merton Russell-Cotes[1]

Sir Merton Russell-Cotes (1835–1922) saw himself primarily as a connoisseur and collector of art and art objects. The vast collections of the Russell-Cotes Art Gallery and Museum, Bournemouth, are consistent, only in this sense, that they reflect the tastes and whims of their collector. The important Japanese collection and the objects from their extensive travels around the world are not discerning collections that reflect an understanding of the culture from which they were bought. They are *objets d'art*, mementos of journeys to furnish their home and supply their museum, to send out a message to their visitors that these were items discerningly collected by a widely-travelled connoisseur. For at the very heart of all his collecting was a very particular notion of art. The collection is undoubtedley eclectic, yet led by an idea of connoisseurship which meant that at its centre is that which Merton believed to be the highest forms of art: paintings, drawings and sculpture. In particular he admired work by the leading academic painters of the day and valued his accumulation of paintings above all his other collections. By 1884 he had collected upwards of two hundred paintings, 'all admirable works', he wrote, 'by famous British artists (I was always in favour of the modern British School of Art, and never appreciated the work of the Old Masters).'[2] Merton's preference for the works of the modern British School is reflected in the painting collection that can be found in the museum today. Like many of his Victorian contemporaries who had new-found wealth, his partiality was to a new British art that displayed confidence, status, visual and moral conservatism and came out of an artistic world that had a discernible hierarchy. The most favoured element of his picture collection are works by famous Victorian artists, mainly Royal Academicians whose position at the centre of the Victorian art world he thoroughly approved of. Many other works surround this core, which were purchased mainly through the Bond Street galleries and auction houses as well as the Royal Academy Summer Exhibitions. He wrote, 'I invariably visited the Walker Art Gallery there, [Liverpool] and made purchases of one, two, three or even more pictures at the Autumn Exhibition, chiefly works that had been in that year's Royal Academy.'[3] The Royal Academy meant a great deal to Merton as a collector and in his eyes it acted as a guarantee of quality. It is interesting to note that his admiration of Albert Moore, expressed in several pages of *Home and Abroad*, often focuses on the artist's exclusion from the Royal Academy's select ranks. 'The reason why Albert Moore has never succeeded in entering Burlington House', he explains, 'was purely personal and not at all dependent on anything inherent in his work.'[4]

## ARTISTIC OPINIONS

Merton's opinions on art and life are well recorded in his autobiography, *Home and Abroad*. In the foreword he notes that 'Egotism and egoism may appear to predominate at times', a point that the reader is unlikely to challenge, for there is little doubt that he had a very high regard for his own opinions, particularly

those on art. Indeed, quotations from this two-volume tome were chosen by him and emblazoned in gold above the arches of his art galleries at Bournemouth, a gesture indicative of his own confidence in the role of patron and connoisseur.[5] As confident as he was in his own opinions, however, Merton still sought sanction from those whom he admired. In matters of art this was, above all others, John Ruskin. 'Of all the great Englishmen I have met', he wrote, 'John Ruskin as a man of letters and connoisseur of art stands alone.'[6] In *Home and Abroad*, Ruskin receives a much lengthier exposition, over ten pages and several illustrations, than any of the long catalogue of admired artists that he chooses to mention. He claims to have met Ruskin, but it is likely that it was only briefly for there are no accompanying anecdotes in a largely anecdotal book. Although Merton and Annie Russell-Cotes made the pilgrimage to Ruskin's Lakeland home at Brantwood, Coniston (see Cat.43), it was probably after his death when the house had become a shrine to the great man. The length that he devotes to Ruskin in his autobiography is more a reflection of the important influence that Ruskin exerted over Merton as Ruskin did over many artists and collectors in the late nineteenth century. As a person who desired respectability and status in all areas of life, Merton looked towards Ruskin as the highest authority in matters of taste. By the end of the nineteenth century, John Ruskin had become a living national monument. Pictures of the long white-bearded figure at his retreat at Brantwood in Coniston were pictures of the man perceived to be the very soul of British art. The importance of Ruskin's opinion was seen to be paramount. New collectors and industrialists sought Ruskin's sanction for a new building or painting for their picture collection.[7] Merton was certainly keen in seeking Ruskin's approval for the pictures that he most admired and it is a measure of his confidence in his own taste that he sent a second rate work to Ruskin for approval. Furthermore it reveals his own blinkered viewpoint that he valued so greatly the diminutive response that he received. In 1884 Merton sent a painting of fruit by the artist George Walter Harris (1835–1912) to John Ruskin. As an admirer of Harris, Merton wrote that he had collected over fifty paintings by him, giving many away for presents:

> I sent one of Harris's small fruit pictures to Ruskin and begged his acceptance of it and also asked if he would give me his opinion of his merits. He wrote me an autograph letter as follows:-

> *Herne Hill*
> *S.E.*
> *With Mr. Ruskin's compliments and best wishes. He is very much pleased with Mr. Harris's work, but is curiously hurt by the too prominent signature, and having no introductory light in the margin.*

> *Herne Hill 27th April, 1884.*[8]

Merton was so delighted at receiving a response that a photograph of the letter appears in *Home and Abroad* despite appearing to have been written by his secretary: 'I have several elegant sketches by Ruskin, but only one letter from him in which he eulogises Harris' admirable water-colour drawings, and oils, of fruit, flowers, etc.'[9] A very lacking eulogy we might think, but the fact that it had come from Ruskin meant that its importance in Merton's eyes was assured.

If in matters of taste, Ruskin's words were supreme to Merton, artists' opinions were also important, particularly when he was trying to establish the authorship of a painting. Verification and provenance are two very important things to collectors and Merton often went to great lengths to establish these. In the case of Thomas Sidney Cooper he was disgruntled at having to part with a fee for the service (see Cat.9). In Edwin Long's case he actually took a painting to him for verification.

> It was agreed, therefore, that before I purchased it, it should be submitted to Mr. Long. The picture was placed on the top of a 'growler' and I drove to the artist's beautiful mansion in St. John's Wood. On arriving there, we found ourselves to be

in rather a dilemma as to how to remove the picture to the house, there being no one to do so except the cabman, but upon explaining the object of my visit to Mr. Long, he smilingly offered his services, and the three of us carried the large picture into his house. After examining it, he declared that it was a work painted by himself, and quite genuine.[10]

Whilst Merton sought the opinion of artists it was often tinged with an interfering arrogance which reflected his own good opinion of himself. He sought guidance, but perhaps more importantly ratification of his own opinion and what he wanted from Ruskin was sanction, not advice. Similarly with artists whose work he bought, he sought their authority and sometimes even requested changes, for although he was buying their work, he wished them to accommodate his opinions. With Solomon J. Solomon's work 'There were a few little things that I considered might be improved'.[11] In a portrait by Philip Tennyson-Cole of Edward VII, he reputedly had the king's hat painted out, leaving the arm in a rather uncomfortable position.[12]

## FAVOURITES AND EDWIN LONG

To Merton collecting was not simply about buying works of art. He also wished to become part of an artistic community, to mix with artists and connoisseurs. Even when it came to the business of selling work: 'My relations with Christie's were more of a friendly nature than of a business character; moreover, it was a rendezvous where one could meet and be met by lovers of art.'[13] Indeed, Merton was a regular visitor to Old and New Bond Street where he visited amongst others Agnew's, Dowdeswell and Dowdeswells, the Doré Galleries and the short-lived Edwin Long Gallery. He bought and sold work regularly and kept himself well informed of the fluctuations in the art world. He built a long and friendly relationship with Mr Woods of Christie, Manson and Woods, who moved to Bournemouth and who was a 'frequent guest with us as East Cliff Hall, and never seemed to tire of looking through our collection. Many of the art treasures, by the way, were purchased under his hammer.'[14]

Socialising in the art world was not limited to his fellow connoisseurs that were drawn to the commercial galleries of London and like many other collectors he visited the studios of those artists he admired in order to meet the artists and on occasion to buy works directly from them. The whole design conception of the Russell-Cotes Art Gallery and Museum owes a great deal to the artists and their grand ostentatious homes, which Merton so admired and sought to emulate. Of course Merton's studio visits were by no means exceptional and were common practice amongst collectors. The creation of grand studios was in part developed from artists' need to provide a showroom for potential clients. Merton clearly wished to be seen as exceptional, however, and when he writes that, 'Among all my artistic friends I esteem none more than my dear old friend, Louis B. Hurt ...',[15] we wonder to what extent the relationship between them actually was, for just a few pages later he writes, 'Amongst all our artistic friends, there is none for whom we had a sincere regard than Mr. Fred Goodall RA ...'[16] The illustrations and examples that Merton gives from his collection are blessed with a similar set phrase, 'considered one of his finest examples'. His own desire to mix with the art world did mean a lot of studio visits to 'the palatial residences erected by Leighton, Alma Tadema, Edwin Long and other leading artists'.[17] The visits he made, however, seem to be typical of an artist-client relationship rather than the deeper one which Merton suggests.

There is no doubt that Merton had his favourites and he writes several pages in *Home and Abroad* on each of these artists alongside a resumé of their careers. A particular favourite of Merton's who has come to epitomise the Russell-Cotes fine-art collection is Edwin Longsden Long RA. Merton had the highest admiration for him. 'I am very proud', he wrote, 'that I have secured five of his greatest works.'[18] The enormous works that Merton bought included *Anno Domini*, which in canvas size alone covers 128 square feet. They were hung permanently in the

Russell-Cotes Art Gallery after it was opened in 1916 by Princess Beatrice who, according to Merton, 'expressed unfeigned admiration for Edwin Long's wonderful works, more especially "The Chosen Five".'[19]

Edwin Long suffered greatly from the vicissitudes in taste and works by him that had once set auction house records sold for a fraction of their original value in the first half of the twentieth century.[20] This is when Merton bought many of Long's most important, large-scale works, for although the market place afforded them a meagre value, Merton remembered Long in his heyday when he was at the height of his reputation. Merton visited Long and he recalls in some detail his visit to the artist's grand studio home at Netherhall Gardens, which was an august reflection of his achievements as an artist. There he would have passed through the monumental doors, designed by Long himself, and travelled through the prolonged gallery, up the majestic staircase to Long's studio where he saw the artist's last important work in progress, *The Parable of the Sower* (1891, 101 x 203 in).

> He afterwards invited me to go up with him into his studio, which was reached by a wide corridor running the whole length of one side of the house, and a grand staircase at the other end. It was one of the finest studios that I have ever entered, both for size and light. He explained to me that it extended over the whole of the house. He was at work at that time on a huge canvas depicting our Saviour preaching from a boat on the Sea of Galilee. He also had in hand at the time several other fine works. I expressed my great admiration for his works, which seemed to please him very much.
>
> Mr. Long was, I may add, one of the most courteous and genial men among the Royal Academicians that I have known.[21]

## EDWIN LONG RA

Edwin Longsden Long (1829–91), portraitist, Spanish genre, Biblical and history painter, was born at Bath on 16 July 1829, the son of Mr James Long, gentleman, of a family resident in Kelston in Somerset. Little is known of his parents. He was educated at Dr Viner's Academy, Bath and moved to London in 1846 to pursue a career as a painter and enrolled as a student at James Matthew Leigh's School of Art. He studied at the school with many artists who were later to become part of the St John's Wood Clique, a group of artists living near to each other in St John's Wood who met every week at their studios to paint and criticise each others work. This coterie included G. D. Leslie, P. H. Calderon and J. B. Burgess, a follower of John Phillip, whom he later travelled to Spain with. He attempted to join the Royal Academy Schools on two occasions and although he was admitted as a 'probationer' he failed to become a student there. The reason that the Royal Academy gave for his refusal was that his drawing was weak. This must have been a great blow to Long who was forced into portraiture rather than pursuing more ambitious subjects that he would have been able to explore as a student at the Royal Academy. He moved back to his home town of Bath and began painting portraits and carrying out some copy work, often for military sitters. This was considered by Long to be at the bottom of the artistic ladder and ill befitting his own talents and ambitions.

A visit to Italy, following a minor success with his portrait of Sir Hugh Gough,[22] broadened his artistic horizons. Whilst there he met his future wife, Margaret Jemima Aiton, whom he married in March 1853 at the British Consulate in Rome. After returning from his visit he moved to new premises in Bath with renewed ambitions. Three of his portraits from 1855 were accepted at the Royal Academy exhibition to modest critical acclaim. His portrait painting from this period was somewhat unfashionable in terms of style yet highly accomplished in technique. The Royal Academy was an important showcase for potential clients and in 1856 he was commissioned to paint several prestigious portraits including Lord Ellesmere (now in the National Portrait Gallery, London) and Lord Robert Grosvenor. From 1855 he was a regular exhibitor at the Royal Academy Summer

Exhibitions until his death in 1891. He may have failed to achieve his ambition of training at the Royal Academy Schools but he still sought acclaim and recognition from the leading artistic institution through exhibition and ultimately membership.

1857 was an important year for Long who moved back to London, the hub of the Victorian art world. There he re-established old artistic acquaintances and developed new ones. He attended the classes of the Scottish artist, John 'Spanish' Phillip, so named because of the predominantly Spanish subjects of his paintings. On his advice, Long turned to Spain for a new subject for his work. He travelled there with Phillip who introduced Long to Spanish life as well as to their master painters, notably Velasquez and Murillo. Long was much taken by the country which became the main subject for his own work for the next seventeen years. Spanish genre painting was extremely popular in this period and Long visited Spain on several occasions. He even joined shepherds in Andalucia and lived 'with them for a month or more upon the mountains far away in the heart of the country, and this in spite of the warnings with which he was hotly plied by the English consul'.[23]

Long saw several successes for his Spanish paintings, commercially and critically. As a subject it was limiting however, and Long was unable to explore his wider ambitions. It also meant that he remained within the shadow of Phillip. Even in 1875, the real turning-point in Long's career, he was still described by the *Art Journal* as 'a disciple of John "Spanish" Phillip'.[24] The change in his reputation was dramatic and came with the *Babylonian Marriage Market* that was exhibited at the Royal Academy of 1875. Long had made an extensive visit to Egypt and Syria, the year before, and the work had been some time in conception. The enthusiastic critical reception was unprecedented for Long and the work ensured his Associateship to the Royal Academy in January 1876. Praise from the major art journals and from the pen of John Ruskin ensured that the importance of the work was recognised.

Although the *Babylonian Marriage Market* was a breakthrough for Long, there had been many signs within his paintings that his work was moving towards such a remarkable achievement even if the treatment and choice of subject are a little difficult for a modern audience. Spanish history had increasingly come to interest him and he had carried out quite detailed research to produce these paintings. He consulted contemporary texts and studied portraits in galleries to emulate the likenesses of historical figures. It was in the 1870s that his work first began to take on a wholly more serious character. The critics acclaimed *A Question of Propriety* (1870) for its painting. It depicts a scene of a young dancer before the Inquisition accused of corrupting public morality. It was more ambitious as a painting but contained a lightness and humour in dealing with its subject and did not entirely escape from the genre tradition from which it ultimately arose. *The Suppliants: Expulsion of the Gypsies from Spain* (1872) of two years later was of an altogether different order and the *Art Journal* saw Long as 'on the road to high achievement'.[25]

In 1873 Long began a transitory work, *A Dorcas Meeting in the 6th Century* (1873–7) which marked his first real exploration of the ancient world which was to dominate his paintings from 1875. 'It was my very first attempt at anything like a

Fig. 24.

---

Fig. 19. Photograph of Edwin Long
*Art Journal*, 1891

Fig. 20. Edwin Long
*Anno Domini or the Flight into Egypt*, 1883
Oil on canvas, 96 x 192 in

Fig. 21. Edwin Long's home and studio at Fitzjohn's Avenue
*Art Journal*, 1881

Fig. 22. Paul Renouard
Edwin Long working on his *Crown of Justification* at his Netherhall Gardens studio
*The Graphic*, 9 June 1888

Fig. 23. Edwin Long
*Dialogus Diversus*
Oil on canvas, 51 x 40 in

Fig. 24.
Edwin Long Gallery catalogue, 1894

Fig. 25. Engraving after Edwin Long's portrait of Henry Irving as Hamlet, inscribed to Merton Russell-Cotes from Irving

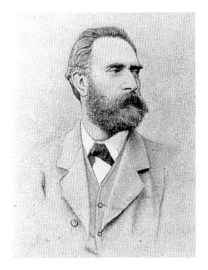

Fig. 19.

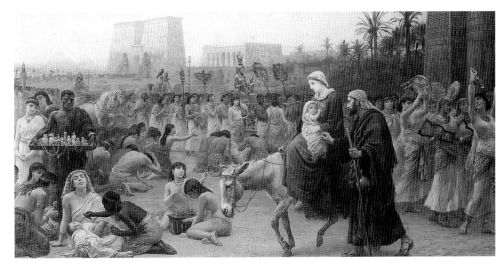

Fig. 20.

Fig. 22.

Fig. 21.

Fig. 23.

Fig. 25.

classic subject', Long wrote, 'a sort of transition picture between modern Spanish and the Antique ...'[26] If it was not altogether a success it showed brilliance in places and was an interesting precursor to his later works.

In 1874 Long visited the Middle East, a decision that was to be as axiomatic as his first visit to Spain in 1857. This time it was not through the eyes of John Phillip, and Long visited Egypt and Syria with the eyes of a mature painter in search of an individual voice. Certainly he must have been influenced by the great interest at the time in ancient Egypt as much as he was aware of the paintings of Sir E. J. Poynter and Alma Tadema, but the influence was not so direct or limiting as it had been with Phillip. Before his travels of 1874 he had already developed an interest in the Middle East and ancient history. According to Spielmann he had already decided on a subject from Herodotus for his next major painting. Sketches on his travels tied with bookish research and visits to the British Museum enabled him to paint this scene which had 'Fired his imagination', and became *The Babylonian Marriage Market*.[27]

The recognition that Long received for the painting was almost immediately reflected in his own personal circumstances and he moved in 1875 to 19 Marlborough Hill at the heart of the artists' colony at St John's Wood. There he had a garden studio built which he named *Long's Den* after his own middle name. He had moved up in the world and it was not long before he was commissioning Shaw to design a studio house for him in Hampstead. With growing success and a larger home the circle of his friends and patrons grew.

In 1879 the Long family joined the Baroness Burdett-Coutts, an important wealthy philanthropist and patron of the arts, on a Mediterranean cruise aboard her yacht *The Walrus*. Other guests included the actor, Henry Irving, the greatest tragic actor of his day. There followed a spate of commissions from the Baroness which included three important portraits of Irving in costume. Clearly Long was establishing himself within a new circle of friends and patrons. His upward mobility was further reflected in March 1880 when he moved into his new home at Fitzjohn's Avenue designed by the fashionable architect Norman Shaw. He named the house 'Kelston' after his family home near Bath. A year later on 13 July 1881 he was elected a full member of the Royal Academy, three days before his fifty-second birthday. He had found himself at the heart of the establishment that he had striven to join for so many years. It was over thirty years since he had failed to become a student at the Royal Academy Schools. Long entertained potential clients lavishly in his studio home and surrounded himself with the props and images of his art. His studio, with its large inglenook fireplace and church organ, had very definite religious overtones that reflected the sentiment of many of his works from this period. In this studio he painted some major works including: *Then to her Listening Ear ...* (1881), *Anno Domini* (1883), *Love's Labour Lost* (1885) and *The Chosen Five* (1885).

It was also within this period that Long was commissioned by the fine-art dealers and publishers, Fairless and Beeforth, to produce works exclusively for exhibition at their Bond Street Galleries. In 1886 he was commissioned by Thomas Agnew and Sons (an important art dealership that had already commissioned many works from him), to produce a series of paintings to commemorate the Queen's Golden Jubilee of 1887. Long produced twenty works which were exhibited under the title of *Daughters of Our Empire*. They depicted three-quarter length portraits of young women from countries within the British Empire in national dress set within a landscape that typified their origin. This patriotic, very narrow and Eurocentric depiction of paintings appealed to an eager public. In retrospect they appear to epitomise so much that was typical and constrictive about Victorian art. Commentators at the time however saw them as artistically flawed and on the whole they were ignored by critics.

In 1888 Long moved into a new home also named 'Kelston' and also designed by Shaw at Netherhall Gardens, next door to his first 'Kelston'. This time, the house was even grander and quite the 'palatial' residence that Merton describes. The scale of the building was an even greater reflection of the commercial and critical success that he achieved in his own lifetime. Unfortunately for Long his residence at this grand address was short-lived, since he died prematurely from

pneumonia brought on by influenza in May 1891. His total estate on his death was close to £120,000, a testament to that success. His final works included *Alethe* (1888), *The Crown of Justification* (1888) and *The Parable of the Sower* (1891) and it is perhaps an indication of his financial independence that his works were painted on an ambitious scale with an increasingly religious content. He even refused 5,000 guineas for his last important work, *The Parable of the Sower*.[28] After his death his reputation fell quite quickly despite attempts by his wife to revive interest by setting up the Edwin Long Gallery in 1893 at 25 Old Bond Street, a venture which did not last beyond two years. Tastes were changing and Long was no longer in fashion. When Long's widow Margaret Jemima died, her collection of her husband's works were sold at Christie's on 1 February 1908, including *The Parable of the Sower* which sold for £131 and 5 shillings. It is only in recent years that the work of this notable Victorian artist is being seriously reconsidered.

## THE RUSSELL-COTES LONG COLLECTION

Merton knew very well of Long's success as an artist, seeing Long's work in his studio, at the Royal Academy and on the walls of Bond Street including the Edwin Long Gallery set up after the artist's death in 1893.[29] He also visited the galleries owned by Fairless and Beeforth who exhibited Long from 1884 to 1897. 'Mr. Beeforth, whom I knew intimately', Merton wrote, 'was a very wealthy art collector and connoisseur.'[30]

Many works by Long passed through Merton's hands and the collection houses sixteen oil paintings as well as a large collection of prints after his work. It is an important collection because it is the largest single collection of his works and because it shows the breadth of his career including Spanish genre, portraiture, Spanish history, Egyptian, classical and Biblical painting. It also includes some of his most important work, most notably, *Anno Domini*, *The Chosen Five* and *Alethe* as well as some of his finest painting such as *Then to her Listening Ear*.

The history of these works has always held a fascination to those who have visited the Russell-Cotes Art Gallery and Museum. This was also true of those who visited in Merton's lifetime: 'Many of those that visit the Gallery', he wrote 'may feel curious to learn how these grand works came into existence.'[31] *Anno Domini* in particular, whose enormous size almost completely covers the north wall of Gallery 1 (now the Long Gallery), begs the question of a patron and how it came into Merton's hands. There is no domesticity in its scale and it was clearly painted for a gallery rather than a home and was the pride of Merton's very public collection. It was commissioned for the walls of a commercial gallery and remained on display on Bond Street for about fifteen years under its original title and later as *The Unknown God*.[32] The work was of great public interest and visitors paid their shilling to see the work. Works displayed in this way were lucrative for the owner of the painting and its copyright and Fairless and Beeforth's gallery was set up to give visitors a chance to experience the work at first hand and then to buy prints of the image. Prints were extremely popular and as Merton pointed out 'the engraved reproductions of these works ... became a gold mine'.[33] The engraved images, before photography had advanced sufficiently to provide clear and concise prints, were eagerly sought and Merton himself collected many engravings after the work of Long, in particular, an engraving of Long's painting of Irving as *Hamlet*,[34] admired by Merton and inscribed to him in 1899 by the actor knight himself. When exactly Long purchased *Anno Domini* is unclear but it was purchased after 1910 when Long's reputation had sufficiently diminished to ensure a very modest cost. The sale of Long's widow in 1908, just seventeen years after her husband's death, revealed how much the value had fallen: from thousands of guineas to between £100 and £150 for major works. What Merton paid we can only speculate; certainly the figure of £50,000 recorded in his autobiography which was originally paid to Long for five major works was likely to have dropped to the region of under £1,000 when Merton bought them. Such major works were of great importance to Merton who could afford to fill his gallery with important large-scale paintings, however unfashionable they might be at that time.

In many ways Merton was similar to Long. They both came from similar backgrounds and sought recognition of an established hierarchy in which they believed in unflinchingly. In religion, morality and art they stood in similar positions and wished to uphold the same religious values and artistic élite. They both wished to move upwards in society and used art as a means to achieve this. They were quintessentially of their own time.

It is in the Russell-Cotes collection and in particular the Long collection that a distinct picture emerges of a patron that was in many ways typical yet unique. Merton left an important collection of Victorian art that has survived the vicissitudes of fashion and has remained a fascinating glimpse of a certain time, of a period's aspirations and values and a wonderful experience for visitors who get a chance to see the paintings.

## NOTES

1. Merton Russell-Cotes, *Home and Abroad*, 1st ed., Bournemouth: privately published 1921, p.683
2. *Ibid*, pp.686–7
3. *Ibid*, p.686
4. *Ibid*, p.713
5. These include: 'Art Is Promoted by a Cultivated Mind' and 'Art is the most Immediate Form of Knowledge'. William Gaunt in his article, 'An Edwardian Bequest', *Architectural Review*, no.119 (March 1956), suggests that the inspiration for these came from Lawrence Alma Tadema's studio
6. *Home and Abroad*, p.745
7. In a characteristic response to the councillors of Bradford who requested his opinion on their newly proposed wool exchange, Ruskin began: 'You send for me, that I may tell you the leading fashion' and continued by refusing to do so through pointing out his belief in a moral theory of art. 'I want you to think a little of the deep significance of this word "taste"; for no statement of mine has been more earnestly or oftener controverted than that good taste is essentially a moral quality.' From one of Ruskin's popular lectures. This was delivered at Bradford Town Hall and titled *The Crown of Wild Olive*, 1866, repr., London: George Allen 1908, pp.730–4
8. *Home and Abroad*, pp.725–6
9. *Ibid*, p.753
10. *Ibid*, pp.708–9. The picture is *Dialogus Diversus* (oil on canvas, 51 x 40 in), bought by Merton *c*.1860s. See Bills, pp.69–70, p.71 (ill.)
11. *Ibid*, p.721. See Simon Olding's Introduction
12. Philip Tennyson Cole, *King Edward VII* (oil on canvas, 103 x 63 in). Although there is no evidence other than verbal for this story, the painting displays clear pentiment as to where the hat was.
13. *Home and Abroad*, p.690
14. *Ibid*, p.693. See Appendix 1 no.13
15. *Ibid*, p.707
16. *Ibid*, p.722
17. *Ibid*, p.722
18. *Ibid*, p.709
19. *Ibid*, p.711
20. Long's *Babylonian Marriage Market* (1875) sold at Christie's on 13 May 1882 for £6,615 (including copyright) setting a record for the highest auction price paid for the work of a living artist
21. *Home and Abroad*, p.709
22. *Sir Hugh Gough*, *c*.1850. Lithographed by J. H. Lynch in 1850. See Bills, pp.56–7
23. M. H. Spielmann, 'Painters in Their Studios - II - Mr. Edwin Long', *The Graphic*, 9 June 1888, p.612.
24. *Art Journal*, 1875, p.250
25. *Art Journal*, 1872, p.149
26. Edwin Long, in a letter dated 11 July 1889, in the Art Gallery of New South Wales, Sydney, Australia
27. M. H. Spielmann, 'Painters in Their Studios - II - Mr. Edwin Long', *The Graphic*, 9 June 1888, p.612
28. *Daily Telegraph*, 1908, undated review in Bath Reference Library
29. A catalogue is still in the collection. See Appendix 1, no.6
30. *Home and Abroad*, p.709
31. *Ibid*, p.709
32. See Bills, pp.139–42
33. *Home and Abroad*, p.710
34. From E. Long's *Henry Irving as Hamlet* 1880. Long painted several portraits of Irving in roles including Richard III and Vanderdecken

# CATALOGUE

## Mark Bills

### INTRODUCTION

The catalogue lists forty-seven works that were initially selected for the exhibition *A Victorian Salon*. They are a representative core of the Russell-Cotes Art Gallery and Museum painting collection and were, on the whole, collected by Sir Merton Russell-Cotes. The works are ordered alphabetically by artist surname. The main entry gives the basic details of the artist alongside any pertinent information, preceded by a chronological provenance, exhibition history and references that specifically relate to the work. The exhibition focuses upon Merton as a collector and therefore when his views on a particular artist or painting are known, they are noted.

### ABBREVIATIONS

After artists' names

| | |
|---|---|
| ARA | Associate of the Royal Academy of Arts |
| ARWS | Associate of the Royal Watercolour Society |
| HRCA | Honorary Member of the Royal Cambrian Academy, Manchester |
| HRSW | Honorary Member of the Royal Scottish Watercolour Society |
| PRA | President of the Royal Academy of Arts |
| RA | Member of the Royal Academy of Arts |
| RBA | Member of the Royal Society of British Artists, Suffolk Street |
| RCA | Member of the Royal Cambrian Academy, Manchester |
| RE | Member of the Royal Society of Painters and Etchers |
| RI | Member of the Royal Institute of Painters in Watercolours |
| ROI | Member of the Royal Institute of Painters in Oil-Colours |
| RSA | Member of the Royal Scottish Academy |
| RSW | Member of the Royal Scottish Watercolour Society |
| RWS | Member of the Royal Watercolour Society |

Exhibitions

| | |
|---|---|
| BI | British Institution |
| RA | Royal Academy of Arts |

### LITERATURE

*Academy Notes* – *Academy Notes with Illustrations of the Principal Pictures of Burlington House*, edited by Henry Blackburn

*AJ* – *Art Journal*

Bills – Mark Bills, *Edwin Longsden Long RA*, London: Cygnus Arts 1998

*Bulletin* – *Bulletin of the Russell-Cotes Art Gallery and Museum*

Gaunt – William Gaunt, 'An Edwardian Bequest', *Architectural Review*, no.119 (March 1956), pp.170–4

*Home and Abroad* – Merton Russell-Cotes, *Home and Abroad* [2 volume autobiography], 1st ed., Bournemouth: privately published 1921

Quick – *Catalogue of the Pictures and Sculpture in the Russell-Cotes Art Gallery and Museum*, compiled by Richard Quick, 1923

Quick, *Illustrated Souvenir* – *The Russell-Cotes Art Gallery and Museum, Bournemouth, Illustrated Souvenir*, compiled by Richard Quick, 1924

Quick, *Long* – *The Life and Works of Edwin Long R.A.*, Bournemouth: The Russell-Cotes Art Gallery and Museum, by Richard Quick, 1931

*So Fair a House* – Simon Olding and Shaun Garner, *So Fair a House, the story of the Russell-Cotes Art Gallery and Museum, Bournemouth*, Bournemouth: Russell-Cotes Art Gallery and Museum 1997

and his second wife, Laura, producing classical genre scenes, interiors and still-lifes, often on a miniature scale. She exhibited at the Royal Academy, Grosvenor Gallery, Fine Art Society and Walker Art Gallery, Liverpool, and despite achieving some success in the early years of her career she died in relative obscurity and poverty. She painted several finely detailed watercolour interiors, two of which were exhibited at the Royal Academy, in 1885 and 1887, the second of which the *Art Journal* called 'a wonderful bit of painting'.[1] The subject of this work, 1a Holland Park, was owned by the Coronio family in 1887.[2] On the left-hand side of the watercolour is a painting by D. G. Rossetti, the red and black chalk study for *Mariana*,[3] once owned by Aglaia Coronio and now in the possession of the Metropolitan Museum, New York. *Drawing Room, 1a Holland Park* was painted in April 1887 and exhibited at the Grosvenor Gallery exhibition of the same year.[4]

Merton Russell-Cotes had a great admiration of Sir Lawrence Alma Tadema and was influenced by his studio house as well as admiring his works. He owned several works by the artist although all of these have been subsequently sold.[5] The only Alma Tadema remaining from his collection is by Laura (see Cat.2); the Anna Alma was acquired by the museum in 1995.

1. *AJ* 1887, p.280 about *The Garden Studio* by Anna Alma Tadema exhibited at the 1887 RA exhibition (1180) in the watercolour room
2. The building was subsequently destroyed in the war. A new building was constructed in the 1940s which houses the Greek Embassy today
3. Listed in Virginia Surtees, *The paintings and drawings of Dante Gabriel Rossetti (1828–1882): a catalogue raisonné*, Oxford: Clarendon Press 1971 (213A)
4. It is interesting to note that both Alma Tadema paintings in this exhibition were exhibited at the 1887 Grosvenor Gallery exhibition although only one was purchased by Merton
5. See Appendix IV of 1905 Christie's sale lot nos 134–5

## 1: Anna Alma Tadema

(1865–1943)
*Drawing Room, 1a Holland Park*, 1887

Watercolour and bodycolour on paper on board
Image size: 27 x 17.9cm, 10¾ x 7 in.
Frame size: 50.2 x 41.1cm, 19¾ x 16¼ in.
Signed: l.l. 'ANNA ALMA TADEMA 28/4/87'
Inscription (on back): written in ink on printed label '*IV The Drawing Room 1a Holland Park an Interior*'. Artist: *Anna Alma Tadema*. Name and Address: *17 Grove End Road* NW

PROV: Gift of Doris Heading to the Russell-Cotes Art Gallery and Museum in 1995
EXH: Grosvenor Gallery 1887 (60)
LIT: Grosvenor Gallery Catalogue 1887, p.16
COLL.NO: BORGM: 1995.65

Anna Alma Tadema was the daughter of the artist Sir Lawrence Alma Tadema and his first wife, Marie Pauline (née Cressin). She came under the influence of her father

## 2: Laura Alma Tadema

(1852–1909)
*Always Welcome*, 1887

Oil on canvas
Image size: 37 x 54.6cm, 14½ x 21½ in.
Frame size: 61.6 x 76.2cm, 24¼ x 30 in.
Signed: l.l. '*Laura T.A.T. Op.LXVI*'[1]

PROV: Russell-Cotes in 1893; Russell-Cotes Christie's Sale 11 March 1905 (lot 136) sold to W. W. Sampsons for £63; Russell-Cotes in 1910
EXH: Grosvenor Gallery 1887 (136); *Columbian Exhibition*, The Art Institute of Chicago 1893 (62) *[loaned by Sir Merton Russell-Cotes]*; *Lady Alma Tadema Memorial Exhibition*, Fine Art Society 1910 (11) *[loaned by Sir Merton Russell-Cotes]*; *Out of the Drawing Room: Nineteenth Century Women Artists in Britain*, Russell-Cotes 1992 (unnumbered)
LIT: Grosvenor Gallery Catalogue 1887, p.28; *AJ* 1895, p.372, facing p.372 (ill.); Fine Art Society Catalogue 1910 (ill.); *Home and Abroad*, facing p.722 (ill.); Quick, p.45 (no.188); Quick, *Illustrated Souvenir*, p.61 (ill.) (no.188); Patricia De Montfort, in *Dictionary of Women Artists* (ed. Delia Gaze), London and Chicago: Fitzroy Dearborn, 1997, vol.1, p.180; *So Fair A House*, p.42 (ill.)
COLL.NO: BORGM RCO0112

Laura Epps was born in 1852 the daughter of Dr George Napoleon Epps. Often overshadowed by the work of her husband Sir Lawrence Alma Tadema,[2] Laura produced paintings independent of his influence. She is best known for historical genre paintings of seventeenth-century Dutch settings. Her own studio was filled with Delft-tiled walls as well as objects and costumes of the period that she used as models for her paintings. She revelled 'in the details of domestic life, Dutch habits, Dutch dress of the gentler and more courtly sort in the seventeenth century'.[3] Her paintings tend to focus primarily on children and often include the figure of the mother. They are idealised and gentle pictures on a domestic scale that consider the role of women and reflect her love of children. *Always Welcome* is a charming evocation of this period. It focuses on the relationship between mother and daughter in the rich setting of a seventeenth-century Dutch panelled bedroom.

The picture strongly reflects the role of women in late Victorian Britain, as Patricia De Monfort suggests: 'Works such as … *Always Welcome* (1887; Russell-Cotes Art Gallery, Bournemouth) portray children faced with the realities and social conventions of adulthood. In *Always Welcome* a young girl attends her bedridden mother and learns moral lessons of humility and compassion. The painting also offered didactic value to young women, according to Victorian ideals of nurturing, submissive femininity. Furthermore, in an era of high infant and maternal mortality, sickness was a well-established symbol of Christian fortitude and acceptance, and a recurrent theme in art. In *Always Welcome*, the message is doubly potent – the mother, upholder of the spiritual fabric of society, rests, watched over by the female child, symbol of – moral purity.'[4]

Merton admired this painting and knew the value of it within her body of work and was happy to loan it to her memorial exhibition in 1910. According to him the work was selected by Leighton 'during his office as Commissioner for the British Art section in the Chicago International Exhibition'[5] for display in that important exhibition. The work was selected for comment and illustration in the 1895 *Art Journal* which featured Merton's collection. It praised the sentiment and realism of the work which undoubtedly attracted Merton to the painting alongside the values that it portrayed 'a vein of true pathos underlies all the cunningly arranged accessories … The child is a real child, and the way her little hand holds that of the invalid is a charming touch in the picture.'[6]

1. Like her husband, Laura assigned opus numbers to works that she considered her most important
2. She was Sir Lawrence Alma Tadema's second wife
3. Alice Meynell, 'Laura Alma Tadema', *AJ* 1883, p.345
4. Patricia De Montfort, in *Dictionary of Women Artists* (ed. Delia Gaze), London and Chicago: Fitzroy Dearborn, 1997, vol.1, p.180
5. *Home and Abroad*, p.726
6. *AJ* 1895, p.372

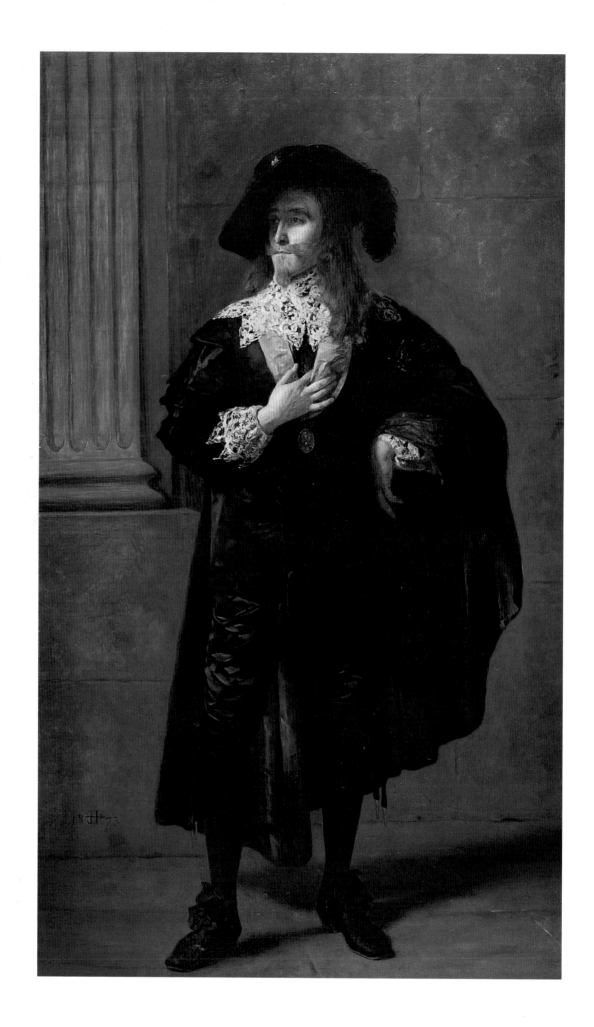

## 3: James Archer RSA
### (1823–1904)
### *Henry Irving as Charles I*, 1873

Oil on canvas
Image size: 22.3 x 131cm, 87½ x 51½ in.
Frame size: 263 x 170.2cm, 103½ x 67 in.
Signed: l.l. Monogram and dated '*18 JA 73*'
Inscriptions (on back): Printed invite: '*Mr. Henry Irving
presents his compliments Mr. J. L. Toole (in ink) and requests
the pleasure of his company … Supper in the Beef Steak Room
of the Theatre Saturday Evening, July the First, 1882 at Half
past Eleven o' Clock to commemorate the C…. Hundredth
representation of "ROMEO AND JULIET" LYCEUM
THEATRE, June 1882, PLEASE ANSWER*'
Typed letter (torn): '*Dear Mr. Russ … In answer to yours of
February 7th, regarding the "Irving" portrait – James Archer
R.S.A.*, the artist, left Edinburgh in 1862, and since then his
London career is not much known by the remaining artists of his
time in Edinburgh. My impression … I … portrait … used to
hang … memory … at 80 he … some clue … an Yours very
truly …*'
Handwritten letter (torn): '*Sir … are the only facts I can get …
club known all-there is … and one … .., London*'
Printed label: *Frost and Reed, Bristol 1924–4 Dec, Dec 8, 1924*
In chalk: '*428*'

PROV: Presentation portrait for Sir Henry Irving; Bought
by Sir Merton Russell-Cotes from the Christie's sale, *The
Collection of Ancient and Modern Pictures, Watercolours and
Drawings and Theatrical Portraits, the Property of Sir Henry
Irving*, on 16 December 1905 (lot 110) for £110 23s 2d
EXH: RA 1873 (236)
LIT: *The Sphere*, 23 December 1905, p.243 (ill.); *Home and
Abroad*, p.802 (ill.), pp.803–4, p.810, p.909; Quick, p.9
(no.9); Quick, *Illustrated Souvenir*, p.13 (ill.) (no.9);
*Bulletin*, September 1929, vol.VI no.3, p.35 (ill.)
COLL.NO: BORGM RC00160

James Archer was a Scottish painter of portraits, landscapes,
genre and historical scenes. He was born in Edinburgh in
1823 and studied art in the city at the Trustees Academy
under Sir William Allan. His historical scenes are for the
most part medieval, beginning a series of works based on
Arthurian legends in 1859. He moved from Edinburgh in
1862 to settle in London where he produced many fashion-
able portraits.

   *Henry Irving as Charles I* was painted for Irving in 1873.
It is a large flamboyant full-length figure painting of the
stylish actor in the costume of Charles I, a role he made
famous. Archer had already painted Irving a year earlier
in *Henry Irving in 'The Bells'* (RA 1872) as well as historical
paintings set in the English Civil War period including *In
the Time of Charles I: Family Portraits* (RA 1867) and *Against
Cromwell: A Royalist Family Playing at Soldiers* (RA 1869).
This painterly portrait relishes the theatricality of Irving
and the lavish costume he is wearing.[1] The work was owned
by Irving and hung in the Beef Steak Room of the Lyceum
Theatre: '*The picture was presented to Sir Henry by the artist,
Archer RSA, and hung for many years in the 'Beefsteak Room'
at the Lyceum Theatre, and it was in this room Sir Henry almost
nightly entertained his many distinguished friends, by whom it was
considered a special privilege and unique.*'[2]

   Merton Russell-Cotes was a great admirer of the cele-
brated actor Sir Henry Irving. This is strongly reflected in
the art collection which houses many portraits of him. He
bought this portrait at the sale of Irving's substantial pic-
ture collection at Christie's on the actor-knight's death in

1905. An illustration of the auction was made by Sidney
Paget and shows Archer's portrait clearly in the back-
ground.[3] (see above)

1. Edwin Long RA painted a copy of Vandyke's portrait of Charles I
   for Irving's dressing room to allow him to more easily move into
   the character. See Bills
2. *Home and Abroad*, p.810. An invite to one of these occasions is
   glued to the back of the painting
3. See watercolour by Sidney Paget ill. in *The Sphere*, 23 December
   1905, p.243, 'THE DISPERSAL OF SIR HENRY IRVINGS
   TREASURES, lot 175 – A Scene at Christies.' The suit of armour
   shown being sold, Irving's costume for Charles I was also pur-
   chased by Merton Russell-Cotes

## 4: William Baptiste Baird

(b.1847, fl.1872–99)
*Landscape with Poultry*

Oil on canvas on board
Image size: 32.3 x 23.6cm, 12¾ x 9¼ in.
Frame size: 57.5 x 45.6cm, 22¾ x 18 in.
Signed: l.r. '*BAIRD*'
Inscriptions (on back): Printed label: '*Dowdeswell &
   Dowdeswells, Publishers Valuers and Dealers in Works of Fine
   Art, 36 Chancery Lane and 102 New Bond Street, Gallery at
   133 New Bond Street*'
Printed label (torn): '*Picture and Mirror Frames Pier and
   Console ... 103 St Vincent Street, Glasgow*'

PROV: Merton Russell-Cotes original collection
LIT: Quick, p.42 (no.161)
COLL.NO: BORGM RC00188

William Baptiste Baird was born in Chicago in 1847.
Little is known of the artist who appears to have studied
in France and for the most part painted domestic genre
scenes. He was certainly resident in London in the mid-
1870s to the early 1880s where he lived in the areas of the
major artistic communities. From there he moved to Paris
in the early 1880s where his studio address until 1899 was
3 Rue d'Odessa. He exhibited a number of works at the
Royal Academy up until 1899, all of which appear to be
genre scenes. *Landscape with Poultry* is a charming example
of his work which indicates his main subject area and his
French training.

   Presumably the work was purchased by Merton through
Dowdeswell & Dowdeswells, on New Bond Street where he
purchased several works including Edward Radford's *Weary*
(see Cat.38).

## 5: John Brett ARA

(1831–1902)
*Land's End, Cornwall*, 1880

Oil on canvas,
Image size: 17.5 x 35.6cm, 6¾ x 14 in.
Frame size: 35.6 x 54cm, 14 x 21½ in.
Inscription on painting: t.l. (inscribed into paint) '*The black
   east wind. Oct 16.80*'
Inscription on back of canvas: (in pencil) '*The h... rock The
   black east wind*'

PROV: Bequeathed to the Russell-Cotes Art Gallery and
   Museum by W. Child Clark, Esq. in 1929
COLL.NO: BORGM RC00356

John Brett was born near Reigate on 8 December 1831.
His artistic studies began with lessons from the landscape
painter James Duffield Harding (1797–1863) in 1851. This
was to be particularly influential for Brett who was not only
taught by a landscape artist, but more significantly, one who
had taught John Ruskin. He became an ardent supporter
of Ruskin and followed closely his advice given in *Modern
Painters*. 'By the time he had finished reading the first
volume of *Modern Painters* he had decided that Ruskin was
"one of the great lights of the age" (Brett diary, July 1852).
*Modern Painters*, vol.4, was published on 14 April 1856 and
Brett's diary indicates that two months later he had left his
lodgings in Albert Street near Regent's Park and 'rushed
off to Switzerland in obedience to a passion that possessed
me and wd listen to no hindering remonstrance' (*ibid*,
9 December 1856). There can be no doubt that this pas-
sion was inspired by Ruskin's words.'[1] Brett had already
come under the influence of the Pre-Raphaelites meeting
Holman Hunt in 1853. Works such as *The Glacier of
Rosenlaui* and *The Stonebreaker* exhibited at the RA of 1857
and 1858 respectively are important Pre-Raphaelite works
and elicited much praise from Ruskin.

   His career as a painter did not continue entirely in the
Pre-Raphaelite vein and he moved towards painting highly
detailed coastal scenes and seascapes primarily for their
geological and botanical interest increasingly using a set
formula. Devon, Cornwall and Pembrokeshire were con-
stant subjects of his paintings and he produced many simi-
lar paintings in subject and size. Ruskin influenced his work
which remained true to nature in their observation and
detail. He hired yachts to travel the coastline until he
bought the schooner, *Viking*, in 1883. This Cornish work
was painted by Brett on 16 October 1880, and subtitled
'*The black east wind*'.

   Although the two works by Brett in this exhibition are
not part of the original Russell-Cotes collection, Merton
owned at one point at least two works by him.[2]

1. David Cordingly, in *The Pre-Raphaelites*, London: Tate
   Gallery/Penguin Books 1984 (intro. by Alan Bowness)
2. Merton bought *Penally* by Brett for £36 12s at Agnew's on
   19 February 1887 and sold *Ebb Tide*, 1881 (7 x 14 in.) at his
   Christie's sale of 1905 (lot 27), see Appendices II and IV

## 6: John Brett ARA

(1831–1902)

*On the Cornish Coast*, 1880

Oil on canvas
Image size: 17.5 x 35.6cm, 6¾ x 14 in.
Frame size: 35.6 x 54cm, 14 x 21½ in.
Inscription on painting: t.l. (inscribed into paint)
   *'Porthcurnow. Sep 13.80'*

PROV: Bequeathed to the Russell-Cotes Art Gallery and
   Museum by W. Child Clark, Esq. in 1929
COLL.NO: BORGM RC00357

This painting by Brett of Porthcurnow painted on 13

September 1880 is identical in size to the other landscape
by him in this exhibition (Cat.5) and indicates a clear
format to which he worked on his coastal visits. Cornwall
attracted Brett because of its dramatic rock formations and
sea views. Indeed, it was popular with many artists. The
*Magazine of Art* ran a series titled 'Artists' Haunts' in 1878
which features two long articles on Cornish cliffs. It wrote
of this scene: 'Then comes Porthcurnow, with its magnifi-
cent rocks and fine view of the famous Logan Rock …
Here the unusually bright colour of the rhomboidal blocks
of granite which build up the headland … covered in part
with byssos, afford fine studies.'[1]

1. Walter H. Tregellas, 'Artists' Haunts I – Cornwall: The Cliffs;
   The Land's End', *Magazine of Art* 1878, p.11

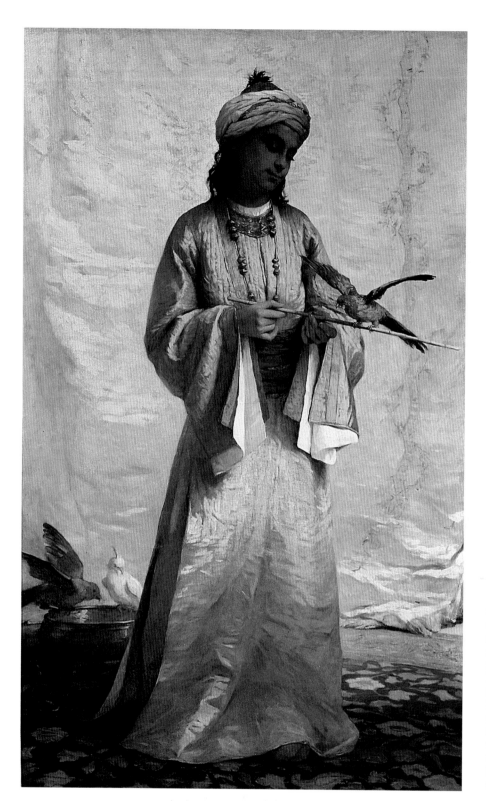

## 7: Henriette Browne
(1829–1901)
### *A Moorish Girl with Parakeet*, 1875

Oil on canvas
Image size: 147 x 90.7cm, 57¾ x 35¾ in.
Frame size: 189.7 x 133.4cm, 74¾ x 52½ in.
Signed: l.l. *'Htte Browne 1875'*
Label on back: *'Thomas McLean, Printseller and Publisher, Dealer in Works of Art, 7 Haymarket, London, Next door to Haymarket Theatre'*

PROV: Merton Russell-Cotes original collection
EXH: Russell-Cotes Art Gallery 1992, *Out of the Drawing Room: Women Artists in 19th Century Britain*, Bournemouth (unnumbered)
LIT: Quick, p.9 (no.4); Quick, *Illustrated Souvenir*, p.9 (ill.) (no.4); Julia King, in *Dictionary of Women Artists* (ed. Delia Gaze), London and Chicago: Fitzroy Dearborn, vol.1, p.327
COLL.NO: BORGM RC00374

Henrietta Browne was a pseudonym adopted by Sophie Boutellier in 1853. She was born on 16 June in Paris in 1829 and later received drawing lessons from Emile Perrin and studied at the female classes of Charles Chaplin (1825–91) from 1851. She achieved an artistic reputation in both England and France and exhibited regularly at the Paris Salon and the Royal Academy. She received the patronage of Emperor Napoleon III and Empress Eugénie, a reflection of her fashionable status. In the 1860s she had become known for her orientalist paintings which were inspired by her travels in the East. *A Moorish Girl with Parakeet* is typical of her orientalism. The skilled technique that she used to produce such luminous colour and texture is also clearly apparent in this work. It is interesting to note, however, that the tonal qualities of the face are unconvincing. It appears that it has been darkened after it was painted from the model, for it is not in shadow and should have highlights as the hands do. This seems to suggest that the model was not Moorish and the artist attempted to darken the skin after painting it from a white model. The work was painted in 1875 the year she exhibited a similar subject, *The Pet Goldfinch*, at the RA (239).

## 8: John Wilson Carmichael
(1800–68)
*Bournemouth from the Sea*, 1861

Oil on panel
Image size: 24.1 x 47cm, 9½ x 23¾ in.
Frame size: 37 x 60cm, 14½ x 23¾ in.
Signed: l.r. *'J.W. CARMICHAEL 1861'*
Inscription on back: (in ink on panel) *'Bournemouth J.W. Carmichael 1861'*

PROV: Purchased in 1922 from J. W. Day for 22 guineas
EXH: Bournemouth Literature and Art Association, Bournemouth College 1922 (unnumbered)
LIT: Quick, p.62 (no.342); Quick, *Illustrated Souvenir*, p.65 (ill.) (no.218); *Bulletin*, September 1923, vol.II, no.3, p.28, p.29 (ill.), p.30
COLL.NO: BORGM RC00434

John Wilson Carmichael, a maritime painter, was born in Newcastle upon Tyne in 1800. He went to sea at an early age and became apprenticed to a shipbuilder who employed him in drawing and designing. By 1823 he had become a full-time artist painting in watercolours and in 1825 starting to work in oils. From 1838 he was a regular exhibitor at the Royal Academy and the British Institution. He moved to London in 1845 and to Scarborough in 1862 where he lived for the rest of his life. He was prolific and successful and received many commissions including covering the Crimean War for the *Illustrated London News*.

Carmichael's painting of Bournemouth from the sea depicts the construction of the town's pier. A pier was considered essential to a developing health and leisure resort and building began in July 1859 under Mr Thornaby when the first piles were driven into the sea bed. Carmichael visited Bournemouth in 1859 and painted a large watercolour on 29 September of the pier's construction which shows what a complex task it was.[1] In fact the slow progress meant that it was not until two years later, on 17 September 1861, that the formal opening took place. Carmichael's oil painting of 1861 is more of a panoramic view of Bournemouth and does not focus entirely on the pier, showing the Bath Hotel, later owned by the Russell-Coteses.

1. John Wilson Carmichael, *The Building of Bournemouth Pier*, watercolour and bodycolour, 1859, 10 x 28 in., Russell-Cotes Art Gallery and Museum original collection (see above)

## 9: Thomas Sidney Cooper RA
(1803–1902)
*Cows*, 1881

Oil on canvas
Image size: 49.3 x 74.8cm, 19¾ x 29½ in.
Frame size: 80 x 105.5cm, 31½ x 41½ in.
Signed: *'Sidney Cooper RA 1881'*
Incised initials *'TSC'* on stretcher
Label on back (torn): *'...Town, Canterbury'* [remains of the
  artist's address Harbledown, Canterbury]

PROV: Merton Russell-Cotes original collection
LIT: Quick, p.13 (no.22); Quick, *Illustrated Souvenir*, p.16
  (ill.) (no.22); *Bulletin*, June 1935, vol.XIV, no.2, p.18,
  p.19 (ill.); S. Sartin, *Thomas Sidney Cooper CVO, RA*, Leigh-
  on-Sea 1976, p.69 (cat. no.254); Kenneth Westwood,
  catalogue raisonné [to be published as cat. no.0.1881.9]
COLL.NO: BORGM RC00542

Thomas Sidney Cooper's life of ninety-nine years was re-
flected in his prolific output of animal paintings. His name
became synonymous with paintings of cows and sheep[1] and
his success within his own lifetime meant that he was often
copied and imitated. At his best he showed a masterly
understanding of the forms of animals painted with rare
detail. At his worst his work was formulaic, particularly in
his later years when he could rely on a tried and tested
formula. He was born in Canterbury in 1803 and moved
to London in 1823 where he entered the Royal Academy
Schools. His talent was recognised early and was encour-
aged by some of the leading painters of the day including
Sir Thomas Lawrence. He spent time in Brussels and
London but orientated to his hometown where he became

known as a constant benefactor, finally dying there in 1902.
His character was notoriously curt although he was known
for his philanthropy within Canterbury.

Merton owned several genuine works by Cooper, two of
which remain in the collection alongside a copy.[2] He was
keen to have his work verified by Cooper, an artist whose
work was so often copied, an experience which led him
to call Cooper 'a covetous elf, and the only artist who so
treated his patrons'.[3] He wrote at length of the experience:
'He [Cooper] even, by his cupidity, made capital on
account of his pictures being copied so much. It has been
said that the originals and copies were so marvellously alike
that he occasionally inadvertently had given guarantees to
these copies! He actually charged a fee of from five to ten
guineas for looking at his own pictures, and giving an ex-
ceedingly meagre pencil sketch of it, which took him a few
minutes to execute ... It was such a miserable production
that I wrote complaining that it was unrecognisable as a
copy of the original. He wrote back saying that he ought to
have charged me ten instead of five guineas! By adopting
this money grubbing habit he encouraged copyists, because
dealers and others declined to pay his blackmail for verify-
ing his own pictures, and this very grasping action on
Cooper's part has reduced the value of his works, simply
because it is absolutely impossible, in many cases, to really
detect the difference between the copy and the original.'[4]

1. He became nicknamed 'Cow Cooper', to distinguish him from
   Abraham Cooper RA (1787–1868) who was nicknamed 'Horse
   Cooper'. See George Dunlop Leslie RA, *The Inner Life of the Royal
   Academy*, London: John Murray 1914, p.28
2. See Appendix IV (nos 36–9) and *AJ* 1895, p.217 for reference
   to these works
3. *Home and Abroad*, under an illustration of Cooper's letter to
   Merton, opp. p.698
4. *Ibid*, pp.228–9

## 10: Henry William Banks Davis RA
(1833–1914)
*Approaching Thunderstorm, Flocks Driven Home,*
*Picardy, c.*1869

Oil on canvas
Image size: 113 x 241.3cm, 44½ x 95 in.
Frame size: 156.5 x 287cm, 61¾ x 113 in.
Signed: l.r. '*H.W.B. Davis*'
Inscription on back: (on a white label in ink) '"*Approaching*
 *Thunderstorm Flocks Driven Home – Picardy*" H W B Davis,
 *10A Cunningham Place, St John's Wood*'

PROV: Sir Merton Russell-Cotes
LIT: Quick, p.18 (no.49); Quick, *Illustrated Souvenir*, p.31
 (ill.) (no.49); *Bulletin*, September 1923, vol.II, no.3, p.30,
 p.31 (ill.)
COLL.NO: BORGM RC00647

Henry William Banks Davis was born in August 1833. He
entered the Royal Academy Schools in 1852 as a sculptor
where he won medals for modelling from life and perspec-
tive. Sculpture did not remain his primary medium, how-
ever, and he has subsequently become known for his
landscapes and animal paintings of Wales, Scotland and
Northern France. His first significant paintings (two land-
scapes) were exhibited at the Royal Academy in 1855.
Shortly afterwards he took a home a few miles from
Boulogne and produced many scenes of this area of
France. M. P. Jackson in the *Magazine of Art* noted that one
work produced at this time was influential in encouraging
his interest in animal painting. In '1860 he exhibited at
the Portland Gallery a landscape picture of a scene near

Boulogne, a number of sheep introduced into which
elicited such marked expressions of public approval as is
a measure to have originated the artist's best habit of
painting animals'.[1]

 *Approaching Thunderstorm, Flocks Driven Home, Picardy* was
painted by Davis whilst resident in his studio at 10a Cun-
ningham Place, sometime between 1867 and 1872. He had
already painted views of Picardy and *Picardy Sheep*, a later
work, was exhibited at the 1879 Royal Academy exhibition.
One of his most important works, *Returning to the Fold* (RA
1880; Tate Gallery, London), shows a later working of a
similar subject. In the 1850s and 1860s, Davis came under
the influence of the Pre-Raphaelites, and in particular their
approach to the landscape. Similarly he combined intense
observation with a highly detailed technique. The scrupu-
lous detail and vivid colours allied with the lighting effects
in this painting give a strong sense of drama to the work.

1. M. P. Jackson, 'Our Living Artists, Henry William Banks Davis',
 *Magazine of Art* 1881 (pp.125–8), pp.126–7

## 11: Evelyn De Morgan (née Pickering)
(1855–1919)
*Aurora Triumphans*, 1886

Oil on canvas heightened with gold
Image size: 117 x 172.5cm, 48 x 68 in.
Frame size: approximately 178 x 121cm, 72 x 90 in.
Signed (false signature): l.l. *'EBJ 1876'*

PROV: Herbert Russell-Cotes [son of Merton and Annie];
given by him in 1928 to Russell-Cotes Art Gallery and
Museum, Bournemouth
EXH: Grosvenor Gallery 1886 (184); Walker Art Gallery;
21st Liverpool Autumn Exhibition, 1891 (887), for sale
£350; Festival of Britain 1951, lent to Old Battersea
House; British Council (travelling Japan), *Burne-Jones and
his Followers*, 1987 (49); Russell-Cotes Art Gallery; 1992,
*Out of the Drawing Room: Women Artists in 19th Century
Britain*, Bournemouth (unnumbered); *Evelyn De Morgan*
(retrospective), Russell-Cotes Art Gallery 1996–7 (9);
*Pre-Raphaelite Women Artists*, Manchester, Birmingham
and Southampton, 1997–8 (61)
LIT: *Bulletin*, September 1822 vol.I, no.3, pp.26–8, p.28
(ill.); Quick, pp.31–2 (no.104); A. M. W. Stirling, *William
De Morgan and his Wife*, London: Thornton and Butter-
worth 1922, p.192, facing p.192 (ill.); Catherine Gordon
(ed.), *Evelyn De Morgan, oil paintings*, London: De Morgan
Foundation 1996, p.18 (cat. no.27); Mark Bills, *Drawings
and Paintings of Evelyn de Morgan* [exh. cat.], Bournemouth
1996, p.6, p.16 (ill.); Mark Bills, 'The Drawings of Evelyn
De Morgan', *Antique Collecting*, March 1997, p.23 (ill.),
p.25; Jane Sellars, in *Dictionary of Women Artists* (ed. Delia
Gaze), London and Chicago: Fitzroy Dearborn, 1997,
vol.I, p.450; Jan Marsh and Pamela Gerrish Nunn, *Pre-
Raphaelite Women Artists* [exh. cat.], Manchester 1997, p.87
(ill.), pp.140–1, p.141 (ill.)
COLL.NO: BORGM RC00665

Evelyn De Morgan's *Aurora Triumphans* is a key work within
her artistic career. Exhibited at the Grosvenor Gallery in
1886, it represents the goddess of dawn overcoming the
bonds of night. The symbolism reflects De Morgan's own
spiritual beliefs in the triumph of light over dark, a sym-
bolic dichotomy explored in many of her works. Several
studies for the work exist in the collection of the De
Morgan Foundation. These reveal both an overall sym-
metrical construction for the original compositional idea
and several detailed studies more characteristic of her pre-
liminary work and reflective of her time at the Slade under
Poynter.[1] The model for Aurora is Jane Hales.

The work was originally for sale at the Liverpool Autumn
Exhibition in 1891. When Herbert Russell-Cotes purchased
the work is uncertain although it was in his possession by
1922. It looks as though the work's purchase was something
of a misunderstanding and the work was passed off as an
Edward Burne-Jones. The false signature *'EBJ 1876'* is in-
correct in both date and attribution. This is not to suggest
that the Russell-Cotes would have not bought the work had
they known its true authorship. Merton owned Evelyn De
Morgan's *Phospherus and Hesperus* although it is no longer
in the collection.[2] Mrs Stirling, Evelyn De Morgan's sister,
who knew the work well wrote to the gallery stating that 'I
am in a position to deny most emphatically that Burne
Jones did one single stroke of the picture AURORA TRI-
UMPHANS. Though ten years younger than my sister,
Evelyn de Morgan, I was alive when she painted it, and saw
her painting it. She was then a girl of about 21.'[3] She later
wrote that 'I found one of my brother's school-boy letters
from Eton not long ago in which he says "Evelyn is now
painting three angels blowing tin trumpets in the sky!
WHAT NEXT?"'[4]

1. See Mark Bills, in *Drawings and Paintings of Evelyn de Morgan*
   [exh. cat.], Bournemouth 1996
2. *Phospherus and Hesperus* (1881), oil on canvas, 23¾ x 17¼ in.,
   Grosvenor Gallery 1882 (no.204). Merton sold the painting at
   Christie's on 27 April 1904 to Lister for £73 10s
3. Mrs Stirling letter to Mr Orr Paterson (Curator of the Russell-
   Cotes), *c.*1951, Russell-Cotes archive
4. Mrs Stirling letter to Mr Orr Paterson (Curator of the Russell-
   Cotes), *c.*1951, Russell-Cotes archive

## 12: William Etty RA
(1787–1849)
*The Dawn of Love*, 1828

Oil on canvas on panel
Image size: 49 x 59.7cm, 19¼ x 23½ in.
Frame size: 88.3 x 96cm, 34¾ x 37¾ in.
unsigned

PROV: Joseph Strutt Collection; Sir Merton Russell-Cotes
EXH: BI 1828 (5); Glasgow, The People's Palace 1899 (87);
   Birmingham Society of Arts 1829 (45); *Etty Centenary
   Exhibition*, City of York Art Gallery 1949 (31); Arts
   Council of Great Britain, *William Etty* 1955 (15);
   *The Nude in Victorian Art*, Harrogate Art Gallery 1966
   (unnumbered)
LIT: Joseph Strutt Collection Catalogue 1835, cat. no.595;
   William Gilchrist, *Life of William Etty RA*, London: David
   Boyne, Fleet Street (2 vols) 1855, vol.II, p.336; *Home and
   Abroad*, pp.732–6 (ill.); Quick, p.49 (no.207); Quick,
   *Illustrated Souvenir*, p.62 (ill.) (no.207); *Bulletin*, June
   1935, vol.XIV, no.2, p.18, p.21 (ill.); William Gaunt and
   F. G. Roe, *Etty and the Nude, The Art and Life of William Etty*,
   Leigh-on-Sea: F. Lewis 1943, p.90, pl.46 (ill.); Dennis
   Larry Ashwell Farr, *William Etty*, London: Routledge &

Kegan Paul 1958, p.52, p.56, p.57, p.157 (no.103),
   pl.27b (ill.); *So Fair a House*, p.43 (ill.)
COLL.NO: BORGM RC00768

The painting was originally titled, *Venus now wakes and
wakens love* when it was exhibited at the British Institution
in 1828. The lines are from Milton's *Comus*:

> Night hath better sweets to prove,
> Venus now wakes, and wak'ns Love.
> Come let us our rights begin,
> 'Tis onely day-light that makes Sin
> which these dun shades report.
> Hail goddesse of Nocturnal sport[1]

The sensual subject of this and many other subjects that
Etty painted scandalised many Victorians. He died in 1849,
only twelve years after Victoria's ascension to the throne
and in his neo-classical imagery and frank nudes he be-
longs in many ways to an earlier age. The outrage that this
particular work caused, when it was exhibited in Glasgow in
1899 is gleefully recorded by Merton in his autobiography:
'The above picture, however, created quite a furore when
exhibited in the Glasgow Corporation Gallery … It may
interest some art lovers to glance through the correspon-
dence shewing how divergent criticisms on art may be,
especially when portraying "the Human form Divine".'[2]

William Etty was born in York, in 1787, the son of a baker. Having no artistic connections but wishing to take up art as a career he served as a printer's apprentice from 1798–1805. In January 1807 he entered the Royal Academy Schools, in 1808 studying under Sir Thomas Lawrence. He began exhibiting at the Royal Academy in 1811 and was made an ARA in 1824. 1828, the year of this painting, was an important one for Etty who reached full RA status on 9 February and in May won £100 from the British Institution, where this work was exhibited, in an 'Acknowledgement of his talents, industry and perseverance'.[3] In his work, Etty employs classical and mythological subjects to explore the nude, particularly the female nude. His influence on Victorian art was immense although he emerged from an earlier age. His works by many were deemed unfashionable and his influence was mainly within mid-Victorian art. Pickersgill and Frost in particular followed his example.

*The Dawn of Love* is one of Etty's most important paintings and is typical of his nudes in its sensual and voluptuous representation of classical imagery. A small study of the work which sketches out the composition and positioning of the two figures is in the Victoria and Albert Museum, London.[4]

1. John Milton, *Comus: A Maske presented at Ludlow Castle, 1634 etc.* London: Humphrey Robinson 1637
2. *Home and Abroad*, pp.732–3. The letters that follow regarding the painting are to be found on pp.733–6. Two examples follow: "From the" Glasgow Evening Times," July 4th, 1899:-"Sir,- Replying to 'East Ender' query in your issue of Saturday anent the painting, entitled, The Dawn of Love,' in the People's Palace Gallery, I would say that it has absolutely no moral value, but if it were on exhibition as a prelude to a night's debauchery, I would consider it the best oil painting of its kind I have yet seen exhibited publicly in Glasgow. "I am, etc., "CANDID CRITIC."
   From the "Glasgow Evening Times," July 10th, 1899 "Sir,-I observed in your correspondence column lately letters regarding the above painting, No.87, in the catalogue of the People's Palace collection. I inspected this painting on Saturday, and think its title a misnomer, as in civilised life the dawn of love (real love) is seldom heralded in with clothes off. Many artists indeed have in recent years, succeeded in portraying love on the canvas merely by the expression of the face. Some of these pictures are delightful studies, and I myself have spent hours over them-but the clothes were on. "'THE DAWN OF LOVE.'", p.733
3. William Gilchrist, *Life of William Etty RA*, London: David Boyne, Fleet Street (2 vols) 1855, vol.1, p.250
4. 5 x 7.6cm, pencil on paper, museum no.7650.12

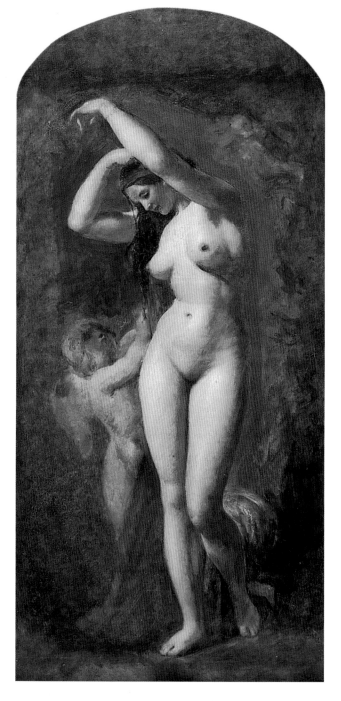

## 13: William Etty RA
(1787–1849)
*Venus and Cupid*

Oil on millboard on panel
Image size (arched): 78 x 37cm, 30¾ x 14¾ in.
Canvas size: 80.8 x 39cm, 31¾ x 15½ in.
Frame size: 107.8 x 66.5cm, 42¼ x 26¼ in.
unsigned

PROV: Merton Russell-Cotes original collection
LIT: Quick, *Illustrated Souvenir*, p.48 (ill.) (no.101);
   *Bulletin*, September 1946, third page [unnumbered]
   (ill.); William Gaunt and F. G. Roe, *Etty and the Nude, The Art and Life of William Etty*, Leigh-on-Sea: F. Lewis 1943, pl.7 (ill.); Dennis Larry Ashwell Farr, *William Etty*, London: Routledge & Kegan Paul 1958, p.155 (no.94)
COLL.NO: BORGM RC00769

Merton called Etty 'one of the most famous English artists of the classical school of painting',[1] and there is little doubt of his admiration of the artist which led him to buy several works. *Venus and Cupid* is a subject that Etty painted on a number of occasions. This version is typical of Etty in the sensuality and voluptuousness that he gives to the subject, a characteristic that Merton particularly delighted in and which is further evident in the nudes of his art collection.

1. *Home and Abroad*, p.732

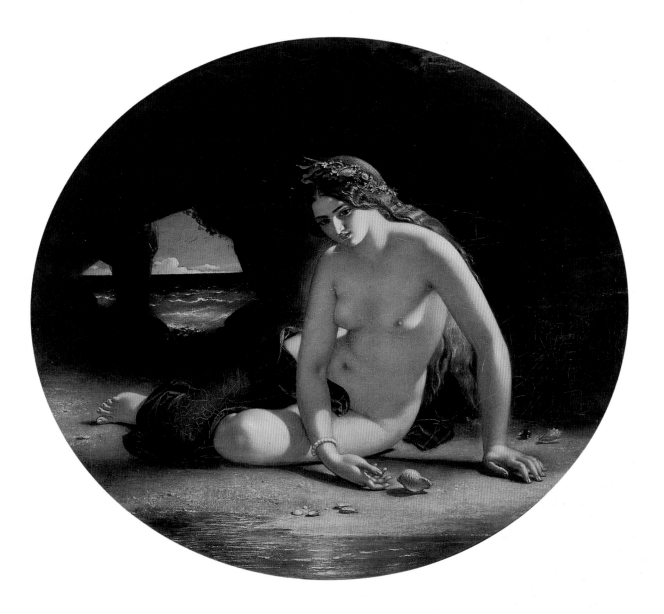

## 14: William Edward Frost RA
(1810–77)
*The Sea Cave, c.1851*

Oil on canvas
Image size (oval): 40.6 x 47cm, 16 x 18½ in.
Canvas size (rectangular): 43.2 x 50.2cm, 17 x 19½ in.
Frame size: 75 x 80cm, 29½ x 31½ in.
unsigned

PROV: Painted for Alderman Spiers, Oxford; Baron Albert
   Grant sale at Christie's on 27–28 April 1877 sold for 220
   guineas; E. G. Potter; Bought by Agnew's 30 July 1880;
   Bought by Merton Russell-Cotes 22 September 1891 for
   £100; Put in a sale at Christie's 4 April 1910 (lot 125)
   remained unsold; Put in a sale at Christie's 27 April 1914
   (lot 160) remained unsold
EXH: BI 1851 (238)
LIT: *AJ* 1851, p.74; *AJ* 1857, p.6, p.7 (ill. with an engraving
   by J. and G. P. Nicholls); *AJ* 1895, p.281 (ill.); W. Roberts
   *Memorials of Christie's A Record of Art Sales from 1766 to
   1896*, London: George Bell & Sons, 1897, vol.1, p.272;
   *Home and Abroad*, facing p.722 (ill.); *Bulletin*, September
   1922, vol.1, no.3, front page (ill.), pp.28–9; Quick, p.27

(no.89); Quick, *Illustrated Souvenir*, p.43 (ill.) (no.89);
   Gaunt, p.172 (ill.), p.172
COLL.NO: BORGM RC00851

'Some sea-born maid, who here, with her green tresses
   disarrayed,
Mid the clear bath unfearing and secure …' Doubleday

The painting was exhibited at the British Institution with
these lines of verse which characterise the painting's idyllic
scene. Many of Frost's classical paintings were based upon
lines from literary texts in particular Milton and Spenser.
In *The Sea Cave*, Frost used lines by Thomas Doubleday
(1790–1870), the poet, dramatist and radical politician.
   William Edward Frost was born in 1810. Around the age
of fifteen he came under the influence of his friend and
mentor William Etty on whose recommendation he entered
the art academy of Henry Sass at Bloomsbury Street. As
a successful student there he made the transition to the
Royal Academy Schools in 1829 where he won several
medals including the gold medal in 1839 for his *Prometheus
bound by Force and Strength*. He became an exhibitor at the
Royal Academy in 1836 where he regularly exhibited for
the rest of his life. He was made an ARA in 1846 and a full
Academician in 1870. In his heyday, Frost was one of the

leading painters of the nude. Like Pickersgill he owed a lot to the influence of Etty although his work is more subdued than Etty and more finely detailed. When *The Sea Cave* was first exhibited at the British Institution of 1851 it received great praise, the *Art Journal* noted: 'A study of a nude figure – a Nereid – presented in a reflected light, touched here and there with a gleam that tells upon the shaded mass with great power. The figure is painted with infinite care.'[1]

It was bought by Merton in 1891 who described it as 'one of his finest and best known works'.[2] By this time the work was generally deemed unfashionable as the *Art Journal* commented in 1895 when it wrote about Merton's collection: 'it is vastly different from what is now held to be

good art'.[3] The figure of £100 was a low price and reflected the change in taste. Merton recognised its value as a fine example of Frost's work and his admiration of Etty must have played a part in his decision to buy the work. Merton tried to sell the work on two later occasions in 1910 and 1914 which seems to indicate that he had tired a little of it. The fact that he included an illustration of the painting in *Home and Abroad*, however, is an indication that he understood its importance within his collection.

1. *AJ* 1851, p.74
2. *Home and Abroad*, facing p.722 under the ill. of the work
3. *AJ* 1895, p.281

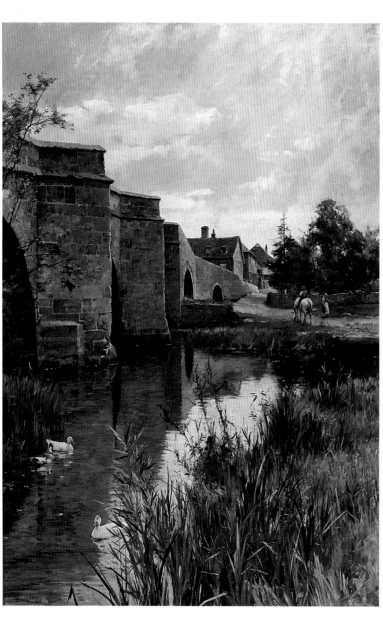

## 15: Alfred Glendening Junr RBA
(1861–1907)
*The Bridge*, 1892

Oil on canvas
Image size: 105.5 x 100cm, 59¼ x 39¼ in.
Frame size: 195 x 142cm, 76¾ x 55¾ in.
Signed: l.l. with monogram and dated '*1892*'
Label on back: '*No 1 The Bridge, Alfred Glendening Jnr, 141 Sumatra Road, W Hampstead*'

PROV: Merton Russell-Cotes original collection
EXH: RA 1892 (975)
LIT: Quick, *Illustrated Souvenir*, p.34 (ill.) (no.57); *Bulletin*, September 1923, vol.II, no.3, p.26, p.27 (ill.)
COLL.NO: BORGM RC00889

Alfred Glendening was born in 1861, the son of the landscape painter Alfred Augustus Glendening. He painted primarily landscapes and saw some success, moving to the fashionable artistic district of Hampstead in 1891, where this work was painted. This is an important painting by Glendening who displays more of an impressionist and *plein air* approach than is usual in his works which have a tendency to move towards a fussier style.[1] The French influence in this work is very clear and in 1892 many works exhibited at the Royal Academy and New Gallery by artists such as H. H. La Thangue, Clausen and Stanhope Forbes reflected this general influence within British landscape. Glendening's success was short-lived however, and he never quite achieved the status of a leading artist turning to painting theatrical sets in his later life.

1. Another important work worth noting is his 1898 painting *Haymaking*, now in the Tate Gallery collection, which shows a debt to Millet in both subject-matter and style

## 16: John William Godward RBA
(1861–1922)
### An Italian Girl's Head, 1902

Oil on canvas
Image size: 49.5 x 43.2cm, 19½ x 17 in.
Frame size: 70.5 x 62cm, 27¾ x 24¼ in.
Signed: t.l. '*J W GODWARD 1902*'

PROV: Merton Russell-Cotes original collection

LIT: Quick, p.26 (no.85); Quick, *Illustrated Souvenir*, p.42 (ill.) (no.85); Vern Grosvenor Swanson, *John William Godward, The Eclipse of Classicism*, Woodbridge: Antique Collectors' Club 1997, p.79, p.160 (pl.136 ill.), p.208, (cat. no.1902.10)

COLL.NO: BORGM RC00895

John William Godward is an artist whose place within British art is at the twilight of classical influence. As a result his reputation has been undervalued and it has taken a recent book by Vern Swanson to re-assess his often-masterly paintings.[1] As Swanson notes, 'Godward, as one of the last practitioners of the classical ideal, represents the summation of this incredibly important paradigm'.[2]

The work was painted whilst he was living at 410 Fulham Road, London, a studio unusual for its privacy, for 'unlike Alma Tadema, who made his home the social centre for the London élite, the retiring Godward veritably hid himself behind the high wall surrounding No.410'.[3] The work is typical of his classical female heads set against a marble backdrop with its skilful rendition of form and texture. The only uncharacteristic feature of the work is the addition of jewellery.

Merton's taste in art veered towards the academic and classical and this is no exception to that preference. Swanson names Merton as 'one of the most important collectors of Godward's work during the 1890s'.[4] Indeed, there is another work by Godward in the collection and in 1905 he sold three works by the artist.[5] Merton does not write about Godward and the fact that he was a retiring artist who did not freely entertain may account for this. The artists that Merton visited opened their studios to a wide circle of patrons, where he was just one of many.

1. Vern Grosvenor Swanson, *John William Godward, The Eclipse of Classicism*, Woodbridge: Antique Collectors' Club 1997
2. *Ibid*, p.13
3. *Ibid*, p.54
4. *Ibid*, p.79
5. See Appendix IV, lots 57–9. *Ethel Warwick* (1898) by Godward remains in the collection

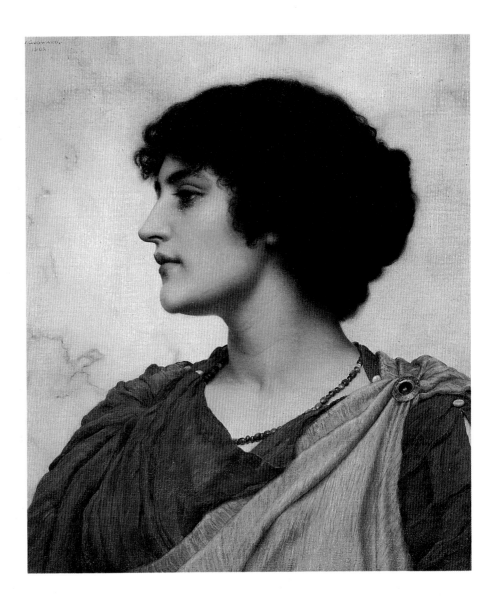

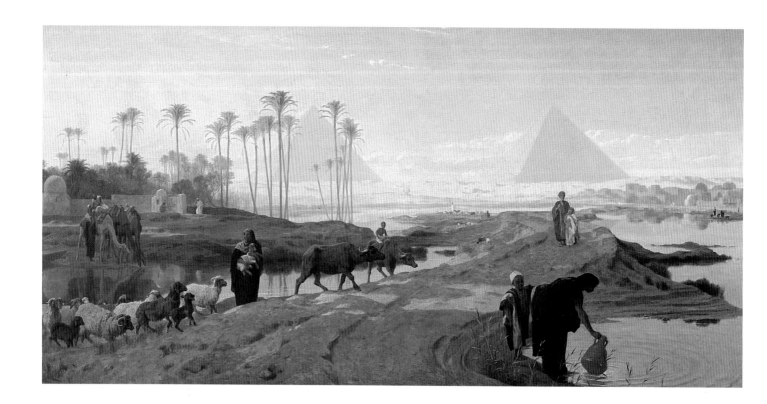

## 17: Frederick Goodall RA
(1822–1904)
*The Subsiding of the Nile*, 1873

Oil on canvas
Image size: 75 x 151.1cm, 29 x 59 in.
Frame size: 111.8 x 188cm, 44 x 74 in.
Signed: l.l. with monogram and dated '*1873*'

PROV: Merton Russell-Cotes original collection
LIT: Quick, p.10 (no.12); Quick, *Illustrated Souvenir*, p.14 (ill.) (no.12)
COLL.NO: BORGM RC00908

Frederick Goodall came from an artistic family. His father, Edward, was an engraver and his brother, Edward Alfred, was a painter and illustrator. His first paintings were rustic genre scenes in the manner of Sir David Wilkie. From 1860, however, his reputation was established with his paintings of Egypt and Biblical genre scenes. Goodall visited Egypt on several occasions and collected around him models for the details of his pictures including date plants, palms and even a small flock of Egyptian sheep which were quite tame and lived in his garden. Merton recalled his studio as 'decorated with all kinds of Eastern trophies, mostly those he collected in Egypt and used by him as models in painting his beautiful Eastern subjects'.[1] *The Subsiding of the Nile* is a copy painted by Goodall of his 1873 Royal Academy picture (292) which sold at Christie's in 1888 for £1,522.[2] He wrote of the original that it was painted in his London studio and was the first picture to use his flock of Egyptian sheep as models.[3] This was combined with 'studies I have made for it in the immediate locality, especially the ancient causeway supposed to have been built for transporting the stones of which the Pyramids are built ... The most beautiful time of the whole year is when the Nile overflows almost to the foot of the Pyramids.

As it subsides, there almost immediately springs up on the higher portions of the land the vegetation which affords without any cultivation an immense quantity of food for the Bedouin flocks.'[4] Goodall painted many very similar scenes of matching proportions including, *The Water of the Nile, The Flooding of the Nile*, and in particular *The Ancient Causeway* (RA 1898) which takes almost the exact viewpoint and includes a flock of sheep being herded on the causeway.

Merton was a great admirer of Goodall, whom he described as his 'old friend'. He owned many works by him, several of which are no longer in the collection such as *The Palm Offering* (RA 1863) and *The Sackiyeh* as well as a palette owned by the artist.[5] He wrote that 'amongst all our artistic friends, there is none for whom we had a more sincere regard than Mr. Frederick Goodall R.A. He ought to have been President of the Royal Academy; a remarkably handsome man and unusually courteous and genial, with a quiet personal dignity of manner. As a kindly host, he was to the manner born, and our visits, no one could have afforded us more cordial hospitality than did he and his wife.'[6]

1. *Home and Abroad*, pp.722–3
2. The original was purchased by Mr Gambart for 1,200 guineas, sold to Sir William Agnew and to Mr Orr of Glasgow in 1902
3. 'Norman Shaw had made me a grand painting-room, where I painted some of my most important pictures ... "Subsiding the Nile", a picture twelve feet long, in which I introduce my Egyptian sheep.' *The Reminiscences of Frederick Goodall R.A.*, London and Newcastle: The Walter Scott Publishing Co. Ltd, 1902, p.283
4. *Ibid*, p.384
5. See *AJ* 1895, pp.216–17, *The Sackiyeh* is illustrated on p.216. *The Palm Offering*, one of Goodall's most important works is illustrated in *Home and Abroad*, facing p.722 which went up for auction in 1905 and was disposed of in 1961. See Appendix IV, lot 60
6. *Home and Abroad*, p.722

## 18: Frederick Goodall RA
(1822–1904)
### *Egyptian Woman and Child*, 1879

Oil on canvas
Image size: 104.2 x 74.9cm, 41 x 29½ in.
Frame size: 139.7 x 109.2cm, 55 x 43 in.
Signed: l.r. with monogram and dated
  *'1879'*
Inscription on back: *'RX, WXYX'* (written
  on a circular label)

PROV: Presented to the museum by C. E.
  Hett in 1955
LIT: Quick, p.60 (no.324) [drawing, p.60,
  no.325]
COLL.NO: BORGM RC00909

The arbitrary title of the work is mislead-
ing and was probably given by an art
dealer or previous owner. The scene is
more typical of Goodall's Biblical genre
scenes and a small oil sketch of the work
seems to testify to its real subject. The
small study is titled, *The Infant Samuel*, and
indicates that the painting depicts Hannah
and her son, Samuel.[1] This would certainly
make more sense, as the figures do not
look Egyptian and that it is more charac-
teristic of Goodall's Old Testament genre
subjects. Furthermore in the same year of
this work, Goodall sent two similar scenes
to the Royal Academy, *Hagar & Ishmael*
and *Sarah and Isaac*. It is very possible that
the work is *Hannah's vow* exhibited at the
Royal Academy in 1880 (339).[2] It is a very
finely and sensitively painted portrait of
a mother and child and has echoes of a
Madonna, despite its subject. The work
was given to the museum in 1955. It could
not be more appropriate as Merton had
purchased a full-sized drawing of the
work.[3]

1. *The Infant Samuel*, oil on panel, 40.5 x 30.5cm
  (16 x 12 in.), sold at Sotheby's, London on
  21 July 1981 (lot 157), illustrated in the cata-
  logue
2. The work was subtitled 'And she brought him
  unto the house of the Lord in Shiloh, and the
  child was young'. RA cat. 1880 (339)
3. *An Egyptian Woman and Child*, black and white
  chalks on paper, 106.8 x 81.2cm (42 x 32
  in.), Merton Russell-Cotes original collection
  (see right)

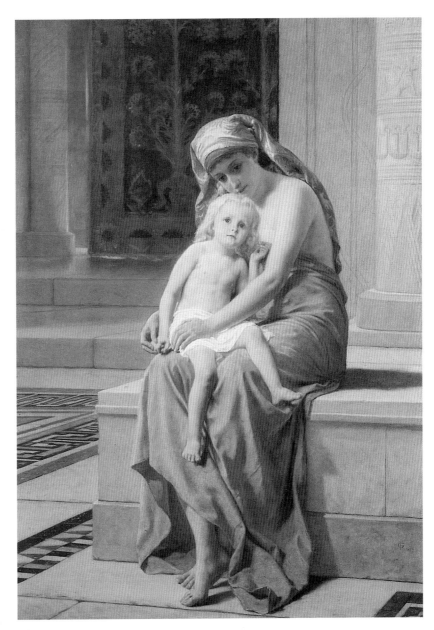

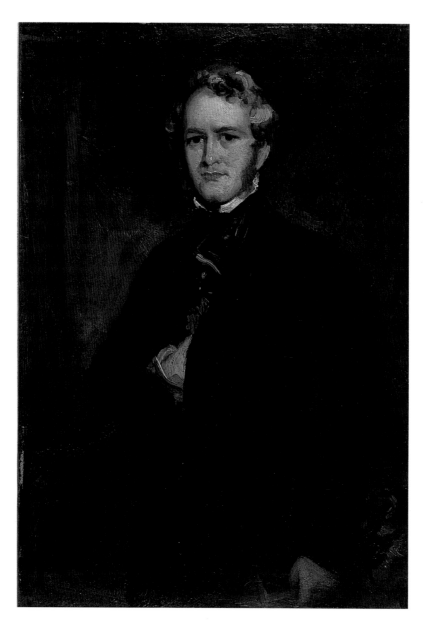

## 19: Sir Francis Grant PRA
(1803–78)
### Portrait of Edwin Landseer, 1852

Oil on millboard
Image size: 31.8 x 22cm, 12½ x 8¾ in.
Frame size: 57 x 46.7cm, 22½ x 18¾ in.
unsigned
Date on frame: '1852'

PROV: Presented to the gallery in 1924
by W. H. Benn Esq.
LIT: *Bulletin*, September 1931, vol.X,
no.3, p.42 (ill.), p.39
COLL.NO: BORGM RC00919

Sir Francis Grant was born the youngest
son of the Laird of Kilgraston, Perthshire.
He began as an amateur artist but
became a professional artist sometime in
the 1830s. His connections in society and
flattering portraiture ensured him suc-
cess. He was chiefly a painter of portraits
and sporting scenes who rose with
unusual swiftness through the artistic
establishment becoming an ARA in 1842,
RA in 1851 and President of the Royal
Academy in 1866. As the leading fashion-
able painter of the day he painted many
important figures including Palmerston,
Macaulay and Richard Redgrave. He
painted and drew several portraits of
Edwin Landseer. Grant had a lot of ad-
miration for Landseer and sought his
advice on matters including the dis-
courses he gave to students at the Royal
Academy, G. D. Leslie recalled: 'I remem-
ber his bringing the manuscript ... to Sir
Edwin Landseer for his advice and criti-
cism; I was in Sir Edwin's studio at the
time, and I remember how nervous Sir
Francis seemed about it as he read it over
to Sir Edwin, who suggested a few slight
alterations.'[1] This painting of Landseer is
a study for a full-sized work, now in the
collection of the National Portrait Gallery,
London.[2] The study was given to the
gallery in 1924 by W. H. Benn, an addi-
tion that is fitting to Merton's original
collection both in its artist and sitter.

1. George Dunlop Leslie RA, *The Inner Life of
the Royal Academy*, London: John Murray
1914, p.94
2. *Portrait of Edwin Landseer*, 1852, oil on can-
vas, 114.3 x 89.2cm (45 x 35⅛ in.) cat.
no.834

## 20: John Atkinson Grimshaw
(1836–93)
### *An Autumn Idyll, 1885*

Oil on canvas
Image size: 75.6 x 62.5cm, 29¾ x 24¾ in.
Frame size: 105.4 x 92cm, 41½ x 36¼ in.
Signed: l.r. *'Atkinson Grimshaw 1885'*

PROV: Merton Russell-Cotes original collection
EXH: *Atkinson Grimshaw 1839–1893*, Scarborough Art Gallery 1993 (47)
LIT: Quick, p.35 (no.114); *Bulletin*, March 1931, vol.x, no.1, front page (ill.), p.2; *Atkinson Grimshaw 1839–1893*, Scarborough Art Gallery [exh. cat.] 1993, p.24
COLL.NO: BORGM RC00933

John Atkinson Grimshaw was born in Leeds in 1836, the son of an ex-policeman. Despite opposition from his parents he became an artist. He was initially very influenced by Pre-Raphaelite landscape painting and developed a style similar to the Leeds artist, John William Inchbold (1830–88). Grimshaw has subsequently become known for his highly characteristic and individual style of landscape painting that often depicts atmospheric scenes in semi-darkness. The subject for his works were mainly focused around his homes and studios at Temple Newsam (outside Leeds), Scarborough and Chelsea. His style of work is formulaic and his interest in photography led him to use the camera obscura in forming the outlines of his scenes. There is a distinct lyrical atmosphere in his paintings which made him extremely popular and well sought after. Grimshaw also painted highly accomplished portraits, fairy paintings, and neo-classical scenes for which he is less well known. This particular picture, purchased by Merton, is typical of Grimshaw's ability to capture the mood of a particular time in autumn. The scene is thought to be Chelsea.[1]

1. *Atkinson Grimshaw 1839–1893*, Scarborough Art Gallery [exh. cat.], 1993, p.24

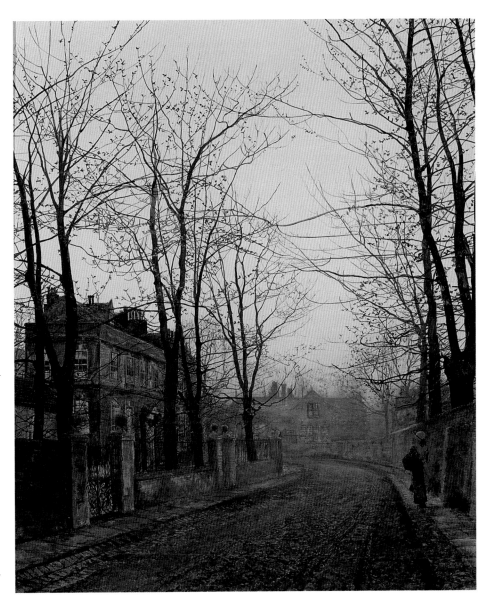

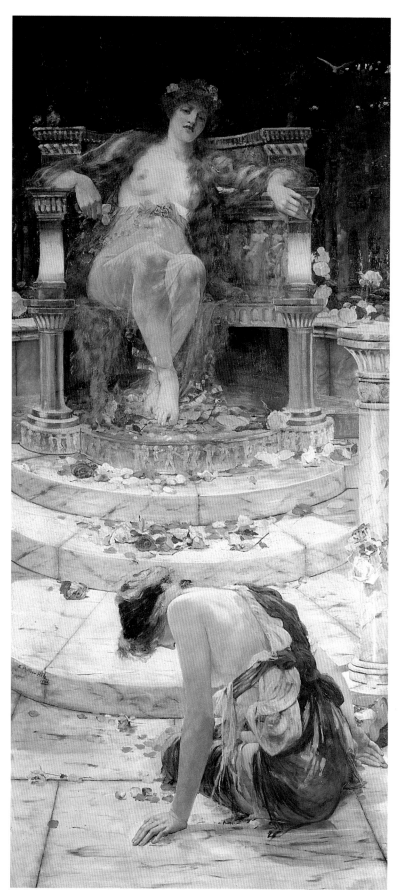

## 21: Edward Matthew Hale ROI
### (1852–1924)
### *Psyche at the Throne of Venus*, 1883

Oil on canvas
Image size: 199 x 88.9cm, 78¼ x 35 in.
Frame size: 236 x 127cm, 92¾ x 50 in.
Signed: l.l. (on marble steps) '*E Matthew Hale 1883*'
Printed label on back: '"*The Victorian Era Exhibition. London 1897." Fine Art Section, Title of Picture: Venus and Psyche No.: 1 Artist: E Matthew Hale Contributors: W. Badger Esq. Address: 192 Broadhurst Gardens, West Hampstead Price if for Sale: £200/–/– Please attach this label to the back of the picture PD and S6*'
Written on stretcher: '*95-19*'

PROV: W. Badger in 1897; Sir Merton Russell-Cotes
EXH: Grosvenor Gallery, Summer Exhibition 1883 (22); *The Victorian Era Exhibition*, Earl's Court, London 1897 (1)
LIT: *AJ* 1883, p.203; Grosvenor Gallery cat., Summer Exhibition 1883, pp.8–9; Quick, p.15 (no.31); Quick, *Illustrated Souvenir*, p.21 (ill.) (no.31); Gaunt, p.171, p.173 (ill.); Christopher Wood, *Olympian Dreamers, Victorian Classical Painters 1860–1914*, London: Constable 1983, p.210 (ill.), p.215; Alison Smith, *The Victorian Nude*, Manchester: Manchester University Press 1996, p.223, p.224 (ill.)
COLL.NO: BORGM RC00967

Edward Matthew Hale was born in Hastings in 1852 the son of Dr Hale. He was educated at Marlborough College. His artistic education took place in Paris between 1873 and 1875 where he trained under Cabanel and Carolus Duran. The subjects of his works can be broadly divided into three categories: classical genre and mythology; Norse and early English history and military scenes.[1] The Russell-Cotes has several examples of his work collected by Merton such as *After the Raid* (1892),[2] which depicts a Viking raid on the British coastline. *Psyche at the Throne of Venus* is the most interesting of the collection which depicts a scene from classical mythology. The Grosvenor Gallery catalogue contained the following descriptions:

> Psyche, a king's daughter, by her exceeding beauty caused the people to forget Venus; therefore the goddess would fain have destroyed her: nevertheless she became the bride of Love, yet in an unhappy moment lost him by her own fault, and wandering through the world she suffered many evils at the hands of Venus, for whom she must accomplish fearful tasks. But the gods and all nature helped her, and in the process of time she was reunited by the Father of gods and man.[3]

Hale had dealt with the same subject at the Grosvenor Gallery four years earlier when he exhibited *Psyche's Toil in Venus' Garden* (no.17). The *Magazine of Art* found her 'a belle of the London streets with canary-coloured hair and blackened eye-lashes'.[4] *Psyche at the Throne of Venus* was more particularly based upon an adaptation of the myth that appeared in Morris's *Earthly Paradise*:

> See now the thrice-tried gold,
> That all men worshipped, that a god would have
> To be his bride! How like a wretched slave
> She cowers down, and lacketh even voice
> To plead her cause. Come, damsels and rejoice
> That now once more the waiting world will move,
> Since she is found, the well-loved soul of love.
> 'The Story of Cupid and Psyche'[5]

It was not well received at its exhibition at the Grosvenor Gallery. The *Art Journal* wrote that 'No.22. E. Matthew Hale, "Psyche before Venus"' is 'a large canvas, chiefly devoted to the display of the nude; attractive in colour, but unnatural in pose and vulgar in sentiment.'[6] This criticism is reflective of the fact that it is uncharacteristically Victorian in its treatment of a classical subject. Christopher Wood, in his survey of Victorian classical painters, *Olympian Dreamers*, notes: 'His [Hale's] *Psyche at the Throne of Venus*, like Solomon's Ajax, brings the flamboyance of the French academic style to the generally more staid atmosphere of Victorian classicism.'[7] Indeed, Hale's French training is evident in the work. Its treatment was clearly considered to overstep the unwritten borders of taste established by the example of artists such as Alma Tadema and Lord Leighton. Alison Smith in her recent work on the Victorian nude suggests this tendency was recognisable in the 1880s which 'saw a discernible shift towards the flamboyance of the French school of nudes'.[8]

1. Hale was special artist for the *Illustrated London News* when he covered the Russo-Turkish War
2. *After the Raid*, 1892, oil on canvas, 12 x 15 in., Merton-Russell-Cotes original collection
3. Grosvenor Gallery cat., Summer Exhibition 1883, p.8
4. *Magazine of Art*, 1879, p.164
5. Grosvenor Gallery cat., Summer Exhibition 1883, pp.8–9
6. *AJ* 1883, p.203
7. Christopher Wood, *Olympian Dreamers, Victorian Classical Painters 1860–1914*, London: Constable 1983, p.215
8. Alison Smith, *The Victorian Nude*, Manchester: Manchester University Press 1996, p.223

## 22: Arthur Hill RBA

(fl. 1858–93)
*Captive Andromeda*, 1876

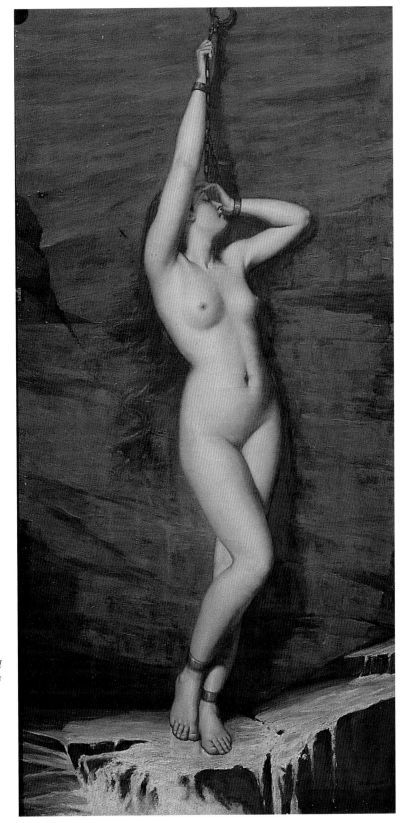

Oil on canvas
Image size: 89 x 43.8cm, 35¼ x 17¼ in.
Frame size: 113 x 72.5cm, 44½ x 28½ in.
Signed: l.r. '*Arthur Hill -/76*'
Label on back: '*W. W. Sampson, The British Galleries, 13 Air Street, Regent Street, London, Wholesale Fine Art Dealer*'

PROV: Merton Russell-Cotes original collection
EXH: RA 1875 (473); *The Nude in Victorian Art*, Harrogate Art Gallery, August 1966
LIT: *AJ* 1875, p.249; Quick, p.48 (no.200); Quick, *Illustrated Souvenir*, p.64 (ill.) (no.200); Joseph A. Kestner, *Mythology and Misogyny, The Social Discourse of Nineteenth-Century Classical-Subject Painting*, The University of Wisconsin Press 1989, p.248, p.269 (ill.)
COLL.NO: BORGM RC01073

Arthur Hill is a painter of whom little is known. His contribution to the Victorian art world was limited and in the words of Joseph Kestner he 'amalgamated Poynter's style to that of Tadema'.[1] He is primarily remembered for his lascivious nudes which have come to exemplify one aspect of the complex debates that surround the representation of the nude female figure in Victorian art. Kestner in his *Mythology and Misogyny* wrote that 'Hill's *Andromeda* (1875) follows the corresponding canvases of Poynter by only a few years and exhibits his careful anatomy. Contorted in agony, the model has one chained hand raised above her head. In the eerie light she is the image of Victorian sadism.'[2]

In 1875, critics saw the work quite differently, even as

morally uplifting: 'In "Andromeda" (473), A. Hill makes by no means an unsuccessful dash at the female nude, and has been able to appropriate it to a picture at once classic in tone and chaste in sentiment. She stands with one arm stretched up to the chain that fastens the other, which, under the circumstances, is a natural pose, at the same time that it is striking. The flesh tints are well preserved, and the modelling of the figure comes out well from the upright rock against which it stands. We are always glad when a painter of moral boldness rises to a level with his artistic power.'[3] The overt sexuality of the work is ignored in this *Art Journal* review which focuses instead on what it saw as 'chaste sentiment'.

Merton collected many nudes, which were considered an important part of any contemporary collection. Indeed, he disregarded their often explicit nature, which was opposed by many at the time, through their legitimacy as 'art'. Another of Hill's work in his collection, *An Egyptian Water-Carrier* (1881), shows a nude figure revealed through a see-through garment.

*Andromeda* was exhibited at the 1875 RA exhibition. The date given by Hill suggests that the work was retouched at a later date.

1. Joseph A. Kestner, *Mythology and Misogyny, The Social Discourse of Nineteenth-Century Classical-Subject Painting*, The University of Wisconsin Press 1989, p.248
2. *Ibid*
3. *AJ* 1875, p.249

## 23: Lucy Elizabeth Kemp-Welch
RI ROI RBA RCA
(1869–1958)
*Gypsy Horse Drovers*, 1894

Oil on canvas
Image size: 120.7 x 242.6cm, 47½ x 95½ in.
Frame size: 162.2 x 285.1cm, 63¾ x 112¼ in.
Signed: l.l. '*L.E. Kemp-Welch 1894*'
Label on back: '*This frame can be repeated at any time by Quoting this number:* (in ink) *27,454 R. Dolman & Son, 9 Compton Street, Soho, London, WC*'

PROV: Sold to Sir Frederick Harris in 1895 [just prior to its RA exhibition] for £60, copyright purchased by the Fine Art Society; Bought by Sir Merton Russell-Cotes at Christie's in 1917 for £220
EXH: RA 1895 (610); *The Equestrian Scene*, Russell-Cotes 1969 (no.5) [the sketch for the work was exhibited as no.75]
LIT: *Bulletin*, March 1922, vol.II no.1, pp.7–8, p.9 (ill.); Quick, p.19 (no.54); Quick, *Illustrated Souvenir*, p.32 (ill.) (no.54); *Home and Abroad*, p.724; David Messum, *The Life and Work of Lucy Kemp-Welch*, Woodbridge: Antique Collectors' Club 1976, p.15 (ill.), p.16, p.17; Laura Wortley, *Lucy Kemp-Welch 1869–1958, The Spirit of the Horse*, Woodbridge: Antique Collectors' Club 1996, pp.36–7, p.39 (ill.)
COLL.NO: BORGM RC01178

Lucy Elizabeth Kemp-Welch was born in Bournemouth in 1869. She studied at the famous Herkomer School of Art at Bushey under its founder, Hubert von Herkomer. Her achievements there were reflected in the fact that she took over the school in 1905. She found success as an animal painter and more specifically in her representation of horses for which she showed particular empathy and understanding. *Gypsy Horse Drovers* was her first work to be exhibited at the Royal Academy, painted whilst still a student at Bushey. She recalled how the subject for the work arose:

On one memorable day ... I saw from our front window a long procession of horses of all sorts and types going up the muddy road, no doubt to Barnet Fair a few miles off. They were shepherded and driven by wild-looking gypsy men on horseback, with frequent rushes to prevent the outliers from getting through the gates or turning up the side lanes. Never was there such an opportunity I rushed from the house, gathering up my palette and a bit of something to paint a sketch on this turned out to be part of the wooden slide out of my paint box – and ran after the procession which had now halted at a bit of green by a public house before going up the long, steep hill. There I made a light-ning sketch of the scene – my long training of quick sketches in the street helping greatly.[1]

The work was envisaged on a large scale and she ordered a canvas some 8 x 4 ft. The artist had caught measles and although she had planned to paint the picture in a large, rented studio, she found herself confined to her modestly-sized lodgings. When she was able to begin work on the canvas it was in the cramped space of her tiny sitting room. It was practice at the art school to attend regular group sessions of criticism led by Herkomer. The next criticism she was able to attend she arrived with the enormous work, as yet incomplete.

'I was, at the time', she wrote, 'one of the younger and newer students at the great Herkomer school. We all used to take any sketches and pictures that we did – outside school hours, to show to our Head Master, Professor Herkomer, and get a great criticism on them (sometimes a nerve-racking business – as he was very severe). One day amongst a crowd of other students – I stood waiting my turn to show my work, at last the moment came and I dragged forward my 8 ft canvas only half complete – with dreadful misgivings. There followed an unforgettable moment – the surprise and delight of the master – the stir and excitement amongst the students, and curiosity to see this work which had moved the great painter – sarcastic and severe as he usually was – out of his calm. From that day he never ceased to be the kindest and sincerest critic and guide, that ever a young painter had. This is roughly the history of the picture "the Gypsy Horse Drovers" please use this little story if you think it of interest, but in this case I should like it printed as I have written it – without alteration or addition.'[2]

Herkomer, when seeing the work completed, suggested that next term she should send it to the Royal Academy. 'I accordingly sent it', she recalled modestly. 'It was well hung, but did not so far as I know attract any particular attention. That was in 1895.'[3]

Merton was a keen admirer of Kemp-Welch, whom he recalled 'sprang up in a phenomenal way a few years ago, making her mark instantly. She is a daughter of a gentle-man I have known for years, who was at one time the prin-cipal proprietor of Schweppes' Mineral Water Co. He was for many years chairman of the bench of magistrates, Christchurch. I have in the Russell-Cotes Art Gallery two of Miss Welch's finest pictures; in fact, the one that created the first recognition of her skill and obtained for her great commendation. The first picture she exhibited in the R.A. was in 1894. Her pictures have been bought both for the Chantrey Bequest and for the National Gallery of Victoria at Melbourne, Australia. She has been called the "English Rosa Bonheur" and she certainly well deserves it, and from

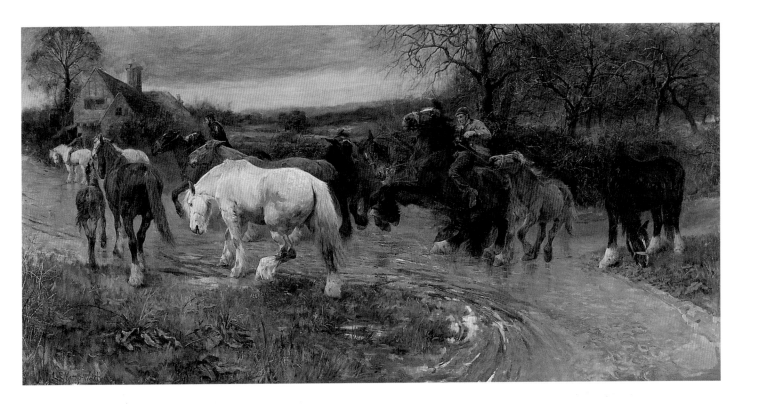

my own standpoint I am of the opinion that she will excel this great French artist if she has not already done so.'[4]

1. Lucy Kemp-Welch, quoted in Laura Wortley, *Lucy Kemp-Welch 1869–1958, The Spirit of the Horse*, Woodbridge: Antique Collectors' Club 1996, p.36. The study, oil on panel 6¼ x 11½ in., was given by the artist to the Russell-Cotes collection in 1956 (see above)

2. Letter from Lucy Kemp-Welch to Richard Quick (first Curator of the Russell-Cotes), *c.*1922 (undated) in the Russell-Cotes collection

3. Quoted in Wortley, op.cit

4. *Home and Abroad*, p.724

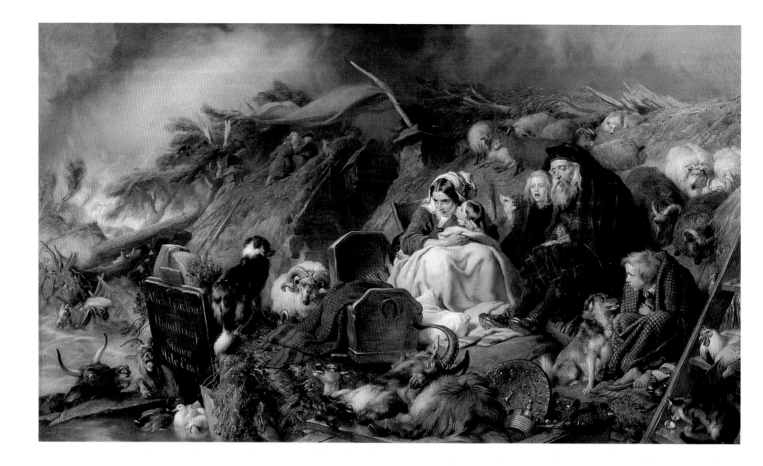

## 24: Sir Edwin Henry Landseer RA
(1802–73)
*Flood in the Highlands*, 1864

Replica painted by Landseer for L. Flatow of the original
    work exhibited at the 1860 RA exhibition (Aberdeen Art
    Gallery)
Oil on canvas
Image size: 69.5 x 121.7cm, 27¼ x 47¾ in.
Frame size: 107.5 x 160cm, 42¼ x 63 in.
unsigned
Inscription on back: (in chalk) '399'

PROV: L. Flatow for 1,500 guineas; Sir Merton Russell-
    Cotes
EXH: Worthing Art Gallery, *Painters of the Victorian Scene*
    1965 (32); *The Four Elements*, Brighton Art Gallery and
    Museum 1986 (unnumbered)
LIT: *AJ* 1895, p.294 (ill.), p.295; Frederick George
    Stephens, *Memoirs of Sir Edwin Landseer*, London 1874,
    pp.1131–4; James Alexander Manson, *Sir Edwin Landseer
    R.A.*, London 1902, (ill. facing p.184); *Home and Abroad*,
    p.711, p.722, p.727; Quick, p.32 (no.108); Quick,
    *Illustrated Souvenir*, p.29 (ill.) (no.45)
COLL.NO: BORGM RC01247

The work of Edwin Landseer is at the very heart of the Vic-
torian art world, Queen Victoria being one of his greatest
admirers. As a sculptor, sporting and portrait painter he
was distinguished. As an animal painter he was without
rival. All other painters of animals in this period such as
Briton Riviere or H. W. B. Davis automatically drew com-
parisons to Landseer. He was born in London, the son of
John Landseer ARA, an eminent engraver. He was pre-
cociously talented and his first exhibition at the Royal
Academy in 1815 was at the age of thirteen. His dedicated
study of animals was quite exceptional. At times he moved
toward the sentimental in depicting animals aping human
emotions, a tendency that was characteristic of Victorian
art. He was elected ARA at the age of twenty-four, RA five
years later in 1831, knighted in 1850 and was elected
President of the Royal Academy in 1866, a position which
he declined to accept.

The painting depicts the 'Muckle Spate' (the Moray
floods of 1829) and is a reduced copy by Landseer of *The
Flood in the Highlands*, painted in 1860, now in Aberdeen
Art Gallery.[1] The floods resulted from the unusually high
rainfall on 3 and 4 August, which had fed the rivers from
the Cairngorms and Mondahliath Hills. The resultant
flooding caused widespread destruction, homelessness and
loss of life. The scene in Landseer's painting represents
Dandaleth, a farm below Craigellachie where the waters
of the Fiddick and Spey combined and swept through the
countryside. The main protagonists of the drama are Alick
Gordon, proprietor of the inn for cattle drovers, his wife
and children who are sheltering on the roof. The painting
also depicts a proliferation of wildlife sheltering alongside
the family and reveal the artist's skill in depicting con-
vincingly the reactions of animals. On its exhibition at the
Royal Academy, the *Art Journal* wrote that 'There is not
a single shade of romance; the narrative is a newspaper
report'. This is a measure of the impact that the picture
exerted on contemporary audiences rather than its realism,
for its composition and rather strange perspective are not
entirely convincing.[2] In the later years of his life Landseer
suffered increasingly from depression and nervous illness
and the pessimism of this scene and of works such as *Man
proposes, God disposes* (1864) is typical of this period.

The replica was bought in 1864 by Monsieur Flatow,[3] an art publisher whom Merton recalled with typical exaggeration as 'a great French dealer … the first man to commission the leading artists to paint pictures for him almost regardless of the cost. With these pictures he toured the country for the purpose of obtaining subscribers' names … [for print sales] and this arrangement he carried on for years and made a huge fortune, eventually building a villa and settling down on the Riviera.'[4] Princess Beatrice, on opening the art galleries of the Russell-Cotes on 1 February 1919, saw *Flood in the Highlands* and told Merton that 'she recognised as having seen it hanging at the villa of M. Flatow on the Riviera'.[5] He was proud of the work in his collection and he wrote that ' "A Highland Flood"… is a most forcible telling picture of what happens occasionally in the Highlands of Scotland, when the water rushes down the mountain sides, carrying everything before it with incredible swiftness. This is admirably portrayed in this fine example of Landseer's work.'[6] Merton claims to have met Landseer on two occasions and the fact that these are not elaborated on in his autobiography indicates that they were probably brief.

The painting is certainly an important part of his collection despite being a replica. The work was after all painted by the hand of Landseer who noted that 'The copy has been very greatly admired'.[7] The status of replicas within Victorian art, although not the same as an original, was high, particularly an important work by Landseer. The *Art Journal* when reviewing Merton's collection in 1895 wrote of the painting: 'his picture is really as fine a work of Art and as desirable as the original painting'.[8]

1. *Flood in the Highlands*, exhibited RA 1869 (106), 177.8 x 312.7cm. Provenance: Lord Cheylesmore; Sold at Agnew's in 1842 for £7,000; Sir James Caird, gift to Aberdeen Art gallery in 1947
2. *AJ* 1860, p.164
3. Six letters regarding the Russell-Cotes' *The Flood in the Highlands*, reveal the commissioning of the work:

A. Landseer to Flatow 8 July 1864
8 July 1864 St John's Wood Road NW (i)
Dear Sir
In reply to your proposal for the two pictures viz., the Flood and the picture exhibiting at the British Institution (ii) I beg to say that I have the pleasure to accept your offer – of Five thousand pounds only for the two subjects [?] including copyright – my friend Mr. Hills kindly undertakes the final arrangement of the transaction
I am Dear Sir
Sincerely yours E Landseer
  i. Landseer's address from 1825 was 1 St John's Wood Road, Lisson Grove, London
  ii. Landseer exhibited only one work at the British Institution in 1864: *Well-bred Sitters, that never say they are "bored"* (68)

B. Landseer to Flatow 13 July 1864
July 13th 1864
Dear Sir
In answer to your kind invitation I beg to say a previous engagement to Melton Mowbray will prevent my taking advantage of it – Mr. Hills tells me you expected to receive the picture of the Flood today. Now I am desirous to put it in to high condition before it goes in to your hands – which will occupy a day or two – on its completion I will communicate with our friend Mr. Hills or can as easily let you know.
Dear Sir Sincerely yours
J E Flatow Esq
E Landseer

C. Landseer to Hills 30 August 1864
August 30th 1864
Dear Hills
I hope to start for the North about the 6 or 7th of September. Pray have the goodness to let Mr. Flatow know that I have worked on the small picture copy of the Flood – Whatever it may suit him to send for the pictures – viz. The original and the copy – he may have them – I should like to be informed as to what is decided on by Mr. Flatow relative to the engravings and publication of the plate.

Ever yours sincerely
E Landseer

D. Hills to Flatow 31 August 1864
London 338 … Street, August 31st 1864
My dear Sir
I beg to acknowledge the receipt of both notes and to apologise for not replying earlier to the first. I have much pleasure in congratulating you on having a most magnificent copy of the Flood which Sir Edwin has been and is working on and which I believe will be finished and ready for you if you send an order for it to No 1 St John's Wood Road on the 4th, 5th or sixth of Septr at the same time must tell you that I am now speaking without Sir Edwin's knowledge or consent and will tell him what I have written and ask him if possible to carry out my suggestions.
I must now hope that the ??? and the ??? have quite set you up for another glorious campaign in 1865 and so like you that I am now about leaving London for Germany myself and perhaps may reach Vienna hoping to get home again about the 1st of October. With best wishes to Mrs. Flatow hoping that you are both well.
Yours very truly T H Hills Excuse haste

E. Landseer to Flatow 5 September 1864
September 5 1864, St John's Wood Road, NW
Dear Sir,
The large – original picture of the Flood with the copy is here awaiting your intentions – The copy has been very greatly admired. On my return in a few weeks I wish to go over it again. I shall be back about the first week in October. If you send the copy w. Mr. Hills – he will on my return – convey it to me Wishing you success in your publication.
I am sincerely yours
E Landseer

F. Landseer to ? 5 September 1864
6 Sept 1864
Dear Sir
I write in gt haste to say the enclosed was written with the expectation of your sending for the pictures – I hope to be back by the 1st week in October and work it for a little more on the copy – Yours sincerely E Landseer

4. *Home and Abroad*, p.722. Louis Victor Flatow was an extraordinary character described by Jeremy Maas as 'coarse, illiterate, without an "h" to his name, appallingly vulgar, an excellent mimic, and an even better ventriloquist. He was withal a much-loved character and his early death was mourned by many artists. He was alleged to have begun his career as a purveyor of fraudulent Old Masters, before setting up as a chiropodist…. Thereafter he became one of the leading dealers in London.' Jeremy Maas, *The Victorian Art World in Photographs*, London: Barrie & Jenkins 1984, p.197
5. *Ibid*, p.711
6. *Ibid*, p.727. Merton refers to the painting's title as *A Highland Flood* which is not strictly accurate
7. Edwin Landseer, letter to Flatow, 5 September 1864, Russell-Cotes archive
8. *AJ* 1895, p.295

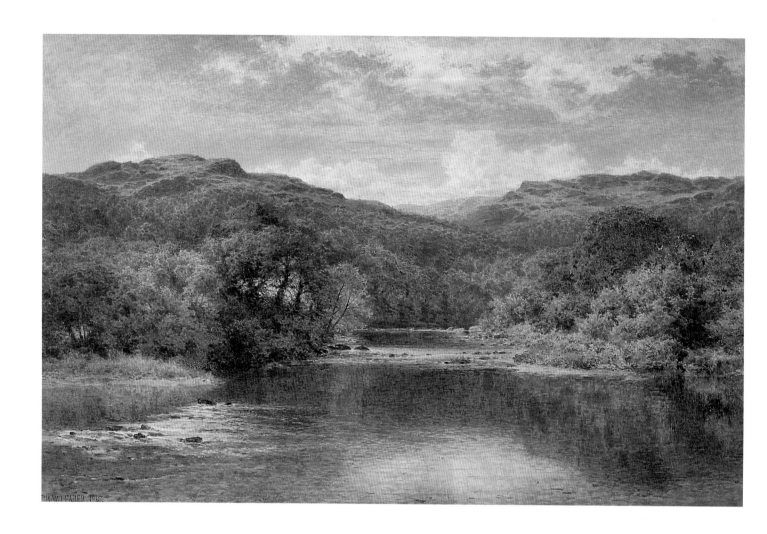

## 25: Benjamin Williams Leader RA
(1831–1923)
*A Welsh River*, 1907[1]

Oil on canvas
Image size: 89.5 x 141cm, 35¼ x 55½ in.
Frame size: 130.5 x 181cm, 51¼ x 71¼ in.
Signed: l.l. 'B.W.LEADER.1907'

PROV: Sold c.August 1907 for 525 guineas; Purchased by
the gallery for 200 guineas from N. Mitchell in 1927
EXH: RA 1907 (157); *Edwardian Reflections*, Cartwright
Hall, Bradford 1975
LIT: *Academy Notes*, 1907, p.14; *Royal Academy Pictures*, 1907,
p.36 (ill.); *The Church Monthly*, October 1920, XXXIII, 10,
p.202 (ill.); *Bulletin*, June 1927, vol.VI, no.2, p.14, p.15
(ill.); Ruth Wood, *Benjamin Williams Leader RA, 1831–
1921 His Life and Paintings*, Woodbridge: Antique
Collectors' Club 1998, p.130
COLL.NO: BORGM RC01286

Benjamin Williams Leader was an artist whose work defined
and epitomised a distinctive Victorian approach to land-
scape painting. His faithfulness to his subject is apparent
in his paintings which shun symbolic imagery in favour of
a naturalism espoused by many British artists. He trained

as an engineer before joining the Royal Academy Schools
where he changed his name from Benjamin Leader
Williams to Benjamin Williams Leader. He became an ARA
in 1883 and a full RA in 1893 as well as amassing numerous
honours including a medal at the Chicago's World's Fair in
1893.

The setting of the work is the River Llugwy between the
villages of Betws-y-coed and Capel Curig in North Wales.
This area was a popular haunt for Leader and his contem-
porary landscape painters. North Wales in particular was a
favourite subject for Leader who visited every summer from
the late 1850s until 1889.

Merton collected several paintings by Leader, including
one which was recently discovered not to be by him.[2] *A
Welsh River* was sold to the Russell-Cotes in 1927 on the
advice of George Knight who wrote to Quick saying that it
'was considered the best picture of the year' at the 1907 RA
exhibition.[3]

1. An oil sketch of the same scene is in the collection of the
   Geelong Art Gallery, Victoria, Australia. Leader also painted
   a smaller version of *A Welsh River* titled *On the Llugwy* in 1907
   (16 x 24 in.)
2. *One more day drops into the shadowy gulf of bygone things* (oil on
   canvas, 24 x 36 in.). Merton did own other Leaders including
   a view of Derwentwater now in the collection (oil on canvas,
   27 x 46 in.). See also Appendix IV, lots 82–3
3. Letter from George Knight to Richard Quick, 28 March 1927,
   Russell-Cotes archive

## 26: Frederic, Lord Leighton
### PRA RWS HRCA HRSW
(1830–96)
### *Perseus and Andromeda (study), c.1891*

Oil on canvas
Image size: 28.7 x 16cm, 11¾ x 6½ in.
Frame size: 52 x 39.6cm, 20½ x 15¾ in.
Signed: l.l. 'F.L.'
Label on back: Exhibition label with '*513*' printed on it

PROV: Purchased from the artist's studio by Merton
Russell-Cotes *c.*1892
EXH: *International Exhibition*, Glasgow, 1901 (335);
Leighton House, an exhibition of the works of the late
owner, 1901 (unnumbered)
LIT: Official Catalogue of the Fine Art Section, *Inter-
national Exhibition*, Glasgow: Chas P. Watson 1901, p.24;
*Bournemouth Observer*, 19 December 1903; *Home and
Abroad*, pp.729–30, p.738; Quick, pp.43–4 (no.170);
Leonée and Richard Ormond, *Lord Leighton*, London
and Newhaven: Yale University Press 1975, p.120, p.127,
p.170–1
COLL.NO: BORGM RCO1295

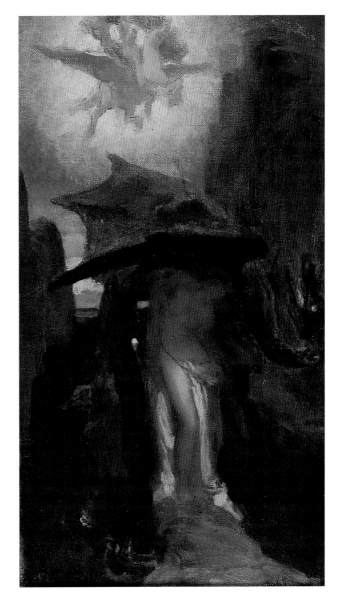

Lord Leighton was at the very heart of the Victorian art
world. More cosmopolitan than some of his contem-
poraries, Leighton raised the standard of painting in
Britain. He studied art in Paris, London, Rome, Dresden,
Berlin, Frankfurt and Florence. In 1855 he exhibited his
first painting at the Royal Academy, *Cimabue's Celebrated
Madonna*, to great success and attracted the attention of
Queen Victoria who bought the work. He was made an
ARA in 1864, a full RA in 1868 and became President of
the RA from 1878 until his death in 1896.

This painting is a study for his finished work, *Perseus and
Andromeda* which was exhibited at Burlington House in
1891.[1] Andromeda was the daughter of Cephus, King of
Aethiopia, and his wife Cassiope. When she had boasted
that she was fairer than the Nereids, Poseidon, who had
married a Nereid, sent a sea monster to ravage the country.
Andromeda was ordered by the oracle to be tied naked to
a rock as a sacrifice to abate their misfortune. Perseus, the
slayer of Medusa, came to Andromeda's rescue. The source
for the legend is in Ovid's *Metamorphoses* and Ariosto's
*Orlondo Furioso*. The legend is also reborn in the Christian
story of St George. In the painting, Perseus can be seen
riding Pegasus the winged horse firing arrows at the
monster that shrouds Andromeda.

Leighton made many studies for the work in paint as well
as plaster models of the main figures.[2] The study is compo-
sitional and reflects some of the nightmarish quality of the
finished work. It was bought by Merton directly from the
artist: 'Lord Leighton's original study of "Perseus and
Andromeda" I purchased from him, although he was reluc-
tant to part with it, assuring me he had always made a firm
resolution never to part with his original pictures. In my
case, however, he made an exception.'[3] Merton had a tend-
ency for exaggeration as this passage illustrates. Further-
more he notes that Leighton selected this particular study
to travel to the *Columbian Exhibition* at the Art Institute of
Chicago in 1893. He clearly confuses this with a work by
Edward Blair Leighton which he loaned alongside works
by Laura Alma Tadema, Goodall and Rooke.

There is no doubting Merton's admiration for Leighton,
however. He wrote: 'Leighton, who was a veritable
"Admirable Crichton", made an ideal President of the R.A.,

a tall, fine figure, an intelligent handsome face, a profusion
of dark brown curly hair, quick penetrating eyes, urbane,
and with that old world courtesy that is now so rare. He
looked every inch the noble and courtly President he was;
a gentleman in every sense of the word, everything about
him contributed to his exceptional figure as President of
the Royal Academy. He maintained an extremely dignified
deportment, so that in the midst of a crowd of his guests he
was always recognisable, but as a host in his own house he
was most genial, and threw off all reserve. His chairmanship
at the banquet and his oratory were a revelation. He was
incomparably the noblest and most gracious host the R.A.
ever had.'[4]

1. *Perseus and Andromeda*, oil on canvas 235 x 129.5cm, Walker Art
Gallery, Liverpool
2. See *Frederic, Lord Leighton*, RA exh. cat., New York and London:
Harry N. Abrams 1996, pp.218–20
3. *Home and Abroad*, p.729
4. *Ibid*, p.730. Merton's admiration for Lord Leighton is further
reflected in the artist's palette purchased by Merton at Christie's
(see Appendix 1). He also bought *The Temple of Philæ: looking up
the hill*, 6¾ x 11 in., at the artist's studio sale which he sold at
Christie's on 27 April 1914 (lot 168) to Sampson for 5 guineas

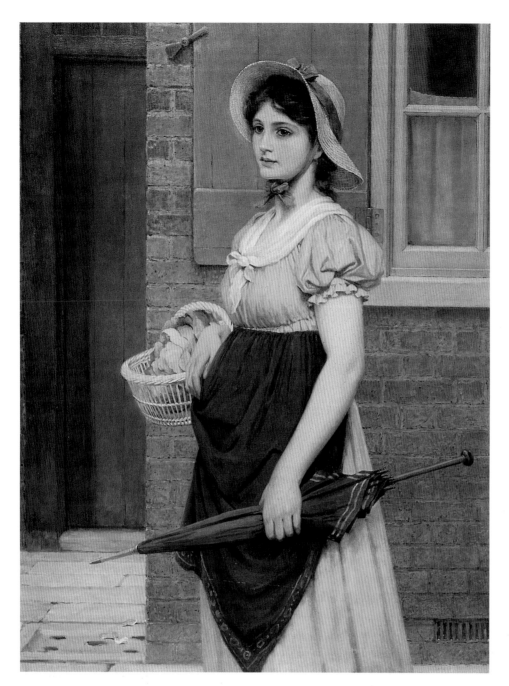

## 27: George Dunlop Leslie RA
### (1835–1921)
### *Portrait of a Girl*

Oil on panel
Image size: 98.9 x 72.9cm, 38¾ x 28¾ in.
Frame size: 116.8 x 90.9cm, 46 x 35¾ in.
unsigned
Inscription (on back): *'G.D. Leslie RA, 8 Grove End Road'*

PROV: Given by Mrs Doughty Browne to the Russell-Cotes Art Gallery and Museum in 1946 [unframed]
COLL.NO: BORGM RCO1305

George Dunlop Leslie was the son of the successful painter, Charles Robert Leslie RA (1794–1859). He studied at Cary's School of Art, making the successful transition to the Royal Academy Schools in 1854 when he enrolled as a student there. He became a member of the St John's Wood Clique, moving to 8 Grove End Road, St John's Wood, in 1870, where he remained until 1883. The group which included P. H. Calderon, W. F. Yeames and G. C. Schwabe met every Saturday at different members' studios to draw a different subject. The Clique's badge of a grid-iron referred to the ruthless grilling that they gave one another in critical sessions. Leslie mainly painted figures of women and children in costumes from around 1800, but also painted landscapes and some historical scenes under the influence of the St John's Wood Clique.

This is a characteristic work by Leslie and is notable for its fine paintwork. 'My aim in art', Leslie wrote, 'has always been to paint pictures from the sunny side of English domestic life, and as much as possible to render them cheerful companions to their possessors. The times are so imbued with turmoil and misery, hard work and utilitarianism, that innocence, joy and beauty seem to be the most fitting subjects to render such powers as I possess useful to my fellow creatures.'[1]

Although the work was given to the museum in 1946 it is very reflective of the taste of Merton.

1. George Dunlop Leslie, quoted in Wilfrid Meynell, 'Our Living Artists, George Dunlop Leslie, R.A.' *Magazine of Art*, 1880 [pp.232–6], p.232

## 28: William Ewart Lockhart

RSA ARWS RSW

(1846–1900)

*Sir Henry Irving, study for his Jubilee Picture, 1887*[1]

Oil on canvas glued to board
Image size: 34 x 24.1cm, 13½ x 9½ in.
Frame size: 53.3 x 43.4cm, 21 x 17¼ in.
unsigned
Inscription (on back): Printed key of the photogravure of
   Lockhart's painting of the Jubilee 1887, No.221 Henry
   Irving and No.222 Ellen Terry are marked [Russell-Cotes
   collection]
Printed label: *'Frederick Pollard'*
Handwritten label: *'Sir Henry Irving'*

PROV: W. E. Lockhart; Sold at the Christie's sale of the late
   W. E. Lockhart, 7 April 1900 (lot 150) to Frederick
   Pollard for £2 15s; Merton Russell-Cotes
LIT: Sir Oliver Millar, *The Victorian Pictures in the Collection of
   Her Majesty the Queen*, Cambridge University Press 1982,
   p.176
COLL.NO: BORGM RCO1330

William Ewart Lockhart was born in Dumfriesshire, the
son of a small farmer. He studied in Edinburgh and came
under the influence of John Phillip who led him, as he had
Edwin Long, to Spain and Spanish subjects. In the later
years of his career he established himself in London as a
leading portrait painter. He exhibited at the Royal Scottish
Academy from 1861 and the Royal Academy from 1873.
In 1887 he was commissioned by Queen Victoria to paint a
large and important painting of her Golden Jubilee Service
at Westminster Abbey which took place there on 21 June
1887. This portrait of Sir Henry Irving is a study for that
work, now in the Royal Collection. Lockhart's painting
depicts the moment when the Archbishop of Canterbury
reads the prayers and pronounces benediction. He was

219. Augustus Hare.
220. Robert Browning.
221. Henry Irving.
222. Miss Ellen Terry
223. Madame Albani.

paid £1,300 for the work which took him three years to complete. The studies for the heads were, in some cases, painted from life, as in this case, others from photographs. Several of the studies, including this one, were sold at Christie's on Lockhart's death in 1900.[2] 'A Key to the work was produced by W. Doig who exhibited it in his Galleries in Pall Mall in July 1890.'[3] Merton cherished his friendship with Irving and the collection contains two head studies for Lockhart's painting: this study and one of Miss Ellen Terry. It is likely that the work was purchased by Merton from the

dealer Frederick Pollard who bought the work in 1900 and whose label is on the back of the painting.

1. *Queen Victoria's Golden Jubilee Service, Westminster Abbey, 21 June 1887*, oil on canvas, 233.4 x 304.8cm, signed and dated: '*W E Lockhart RSA/ 1887–1890*', Royal Collection
2. *Sale of the late W. E. Lockhart*, Christie's, 7 April 1900, lots 132–52 were studies for the Jubilee picture. Lot 150 was Sir Henry Irving and lot 152 was '*Miss Ellen Terry*', Russell-Cotes collection (sold to Pollard for 3 guineas)
3. Sir Oliver Millar, *The Victorian Pictures in the Collection of Her Majesty the Queen*, Cambridge University Press 1982, p.172

## 29: Edwin Long RA
### (1829–91)
### *The Suppliants*, 1864

Oil on canvas
Image size: 111.8 x 86.4cm, 44 x 34 in.
Frame size: 144.7 x 114.3cm, 57 x 45 in.
Signed: l.l. with monogram and dated '*1864*'

PROV: Purchased by the Russell-Cotes Art Gallery and Museum from Messrs Frost and Reed, February 1929
LIT: *Bulletin*, vol.III, no.2, June 1929, p.18, p.20 (ill.); Quick, *Long*, p.44; Jeannie Chapel, *Victorian Taste*, London: Royal Holloway College, 1982, p.107; Bills (cat. no.58), p.75 (ill.), p.76
COLL.NO: BORGM RCO1336

This work by Long is typical of many of his Spanish genre paintings in subject, treatment and scale. Long was very much aware of the market for his works and the domestic-scaled, colourful scene is reflective of this. Its bright colours and heightened contrast of light are reminiscent of John Phillip, Long's early mentor who had led him to Spanish subjects. The painting's title, *The Suppliants*, refers to the Spanish gypsies in the painting. The title was also used for a much more ambitious historical painting of 1872 (Royal Holloway Picture Collection) which represents the gypsies petitioning for their right to remain in Spain. This is more typical of Long's genre painting however.

Merton owned several Spanish genre scenes by Long although he came to know the artist's work through his later paintings of the ancient world. Indeed when he purchased Long's Spanish scene titled *Dialogus Diversus* he thought that the work was by John Phillip: 'It is a very beautiful picture, but, as I had said, I felt certain knowing his work so well, that it had been painted by my old friend John Phillip, R.A.'[1]

1. *Home and Abroad*, p.708

## 30: Edwin Long RA
(1829–91)
*Then to her Listening Ear…*, 1881

Oil on canvas
Image size: 87.7 x 104.2cm, 34½ x 41 in.
Frame size: 122.8 x 141cm, 48½ x 55 in.
Signed: l.r. *'EDWIN LONG 1881'*

PROV: Merton Russell-Cotes original collection
EXH: *Fine Material for a Dream*, Harris Art Gallery, touring
  exhibition 1992 (unnumbered)
LIT: Quick, p.35 (no.111); *Bulletin*, vol.II, no.2, June 1923,
  p.19, p.23 (ill.); Quick, *Long*, p.34 (ill.), p.45; Bills (cat.
  no.186 and colour pl.), p.133 (ill.)
COLL.NO: BORGM RC01343

'Then to her listening ear responsive chords came
familiar, sweet and low.'

The painting depicts a young woman who has played her
stringed instrument and is listening for the musical re-
sponse, possibly of a lover. Like many paintings of this
period that depicted Eastern subjects, it emphasises the
sensual and exotic. This painting by Long is slightly un-
characteristic of his work in this period. He painted many
Eastern scenes, yet this differs in the highly polished tech-
nique that the artist adopts. In this he owes much to the
influence of Lord Leighton. The colours and textures and
depiction of fabric are carefully and sensuously painted and
show a rare aspect of Long's *oeuvre*.

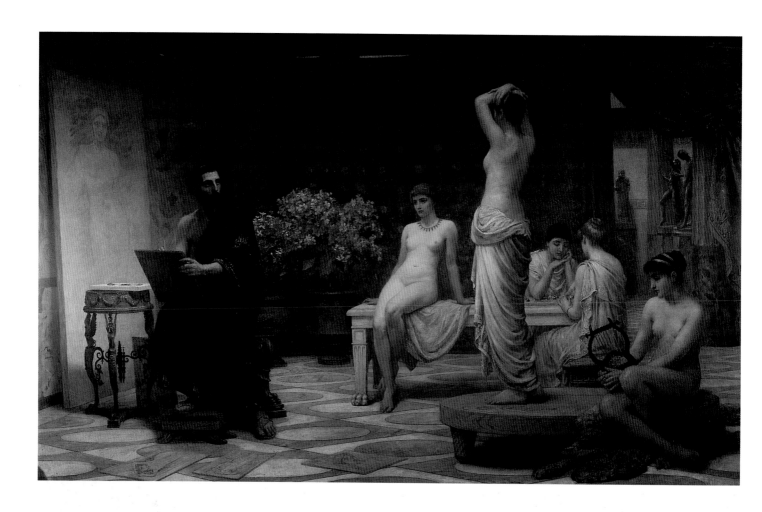

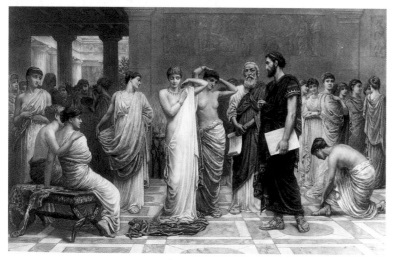

## 31: Edwin Long RA
(1829–91)
*The Chosen Five (Zeuxis at Crotona)*, 1885

Oil on canvas
Image size: 152.4 x 243.8cm, 60 x 96 in.
Frame size: 208.3 x 289.6cm, 82 x 114 in.
Signed: l.l. signed and dated on Zeuxis's footstool

PROV: Purchased by Fairless and Beeforth from the artist
in 1885; Merton Russell-Cotes
EXH: Lawrence Gallery, 168 New Bond Street, London
1885–9
LIT: *Anno Domini painted by Edwin Long R.A., also Zeuxis at
Crotona, etc.* Lawrence Gallery Catalogue, London 1885
(includes 1885 reviews of the work from: *Belfast News
Letter, Daily News, Edinburgh Daily Review, Society, the
Standard* and *the World*); *Magazine of Art*, 1885, p.xxii;
*Home and Abroad*, p.709, p.711; Quick, p.26 (no.86);
Quick, *Illustrated Souvenir*, p.42 (ill.) (no.86); *Bulletin*,
vol.II, no.2, June 1923, p.22 (ill.); Quick, *Long*, p.6, p.39
(ill.), p.45; Gaunt, p.171 (ill.); Joseph A. Kestner,
*Mythology and Misogyny*, University of Wisconsin Press
1989, pp.230–1, p.258 (ill.); Giles Walkley, *Artists' Houses
in London*, Aldershot: Scolar Press 1994, p.109; Alison
Smith, *The Victorian Nude*, Manchester University Press
1996, p.200, p.203 (ill.); Bills (cat. no.210 and colour
pl.), p.19, p.21, pp.48–9, p.137, p.148, p.149 (ill.), p.178
COLL.NO: BORGM RC01348

The subject for Long's painting *The Chosen Five* is the story

of the artist Zeuxis and his depiction of Helen of Troy. The narrative was taken by Long to create two companion paintings, *The Search for Beauty* (see opposite) and *The Chosen Five*.[1] His main sources for the paintings are the writings of Cicero and Pliny the Younger.[2] The story tells of the citizens of Crotona who build a temple to their protecting goddess Hera and commission the artist, Zeuxis of Hereclea to decorate it with an image of Helen. For Zeuxis to achieve this onerous task he selects the five most beautiful women of Crotona as models for his painting. 'For he knew that he could find no single form possessing all the characteristics of perfect beauty, which impartial Nature distributes among her children, accompanying each charm with a defect, that she may not be at a loss what to give the rest by lavishing all she has to afford one.'[3]

The depiction of such a voyeuristic subject presented difficulties for Long. For he was aware that it was a fine line that distinguished paintings that were considered 'immodest' or acceptable by critics. His response to this is to produce paintings, which are coolly academic. In *The Chosen Five*, there is very little sensuousness in the paintwork and the formal considerations of the work are brought to the fore. Long has not attempted to reveal Zeuxis's image of Helen in any other form than that of an unfinished sketch visible in the left-hand side of the painting.

The two companion paintings were commissioned by the fine-art dealers and publishers, Fairless and Beeforth, who exhibited them in their Bond Street gallery alongside, *Anno Domini: or the Flight into Egypt*.[4] These paintings were extremely popular with the gallery-visiting public who paid a shilling to see them and bought prints after them.

Merton as a great enthusiast of Long wrote: 'I am very proud to say that I secured five of his greatest works, viz., "Anno Domini", "The Chosen Five", and the series of "Jephthah's Vow", consisting of "Jephthah's Return", "Morning in the Mountains", and "The Martyr".… Long received £50,000 for all those in the Russell-Cotes Art Gallery…'[5]

1. *The Search for Beauty* is identical in date, size and medium
2. Cicero, *de Inventione*, II: i–iii and Pliny the Younger, *Epistles*, 35–9.
3. Cicero, *de Inventione*, II: iii
4. Edwin Long, *Anno Domini*, oil on canvas, 96 x 192 in., Russell-Cotes Art Gallery and Museum
5. *Home and Abroad*, p.709

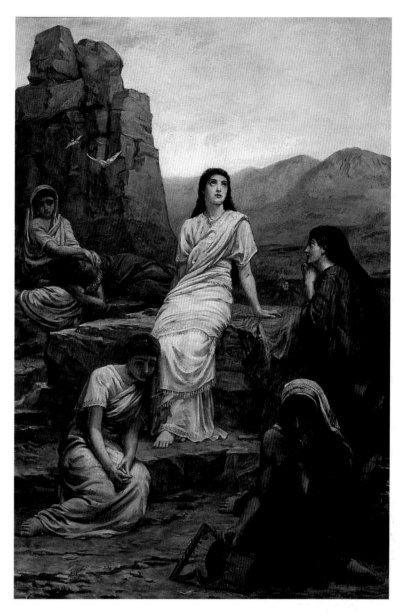

## 32: Edwin Long RA
(1829–91)
### *Study for Jephthah's Vows: In the Wilderness, c.*1885

Oil on canvas
Image size: 53.8 x 35.9cm, 21¼ x 14¼ in.
Frame size: 81 x 62.8cm, 31¾ x 24¾ in.
unsigned

PROV: Sold at Sotheby's on 29 January 1974 as *O Lord how Long!*; Sold at Sotheby's on 27 July 1976 for £100 as *Waiting*; Russell-Cotes Art Gallery and Museum
LIT: Bills (cat. no.214.1), p.151 (ill.)
COLL.NO: BORGM RC2735

This painting is a study for the finished painting, which makes up the central section of a triptych based upon the story of Jephthah's vow.[1] The story tells of Jephthah who makes a pact with God that if he will grant him victory in battle against the Ammonites, Jephthah will sacrifice the first living thing that greets him on his return home. This transpires to be Jephthah's only daughter whom he dutifully sacrifices after she has spent two months in the wilderness to bemoan her fate. The first painting depicts Jephthah's return; the second, his daughter's time in the mountains; and thirdly, the sacrifice. The works were commissioned by Fairless and Beeforth for their Bond Street Gallery and advertised widely as 'The Story of Jephthah'.

Merton describes the triptych through quoting the Bible directly. It is interesting to note that Merton suffered occasionally from prudishness and in quoting Judges he chooses to omit the recurring phrase: 'bewailing her virginity'. 'The passages in the Bible from which the subjects of the three "Jephthah's Vow" pictures are taken, are as follows: Judges xi … And he sent her away for two months: and she went with her companions … And it came to pass at the end of two months, that she returned unto her father, who did with her according to his vow which he had vowed.'[2]

1. *Jephthah's Vows: In the Wilderness*, 1885–6, oil on canvas, 89 x 60 in., Russell-Cotes Art Gallery and Museum
2. *Home and Abroad*, pp.710–11

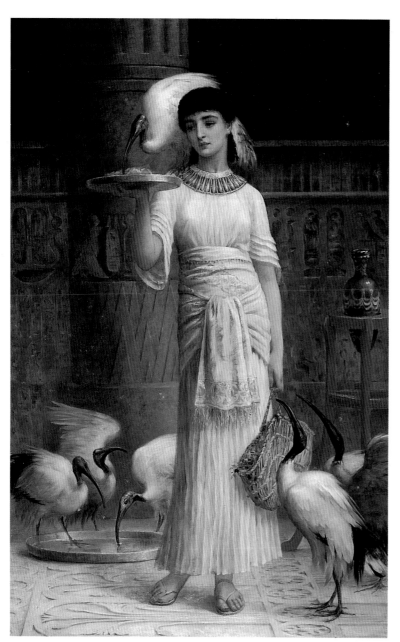

## 33: Edwin Long RA

(1829–91)

*Alethe, Attendant of the Sacred Ibis, 1888*

Oil on panel
Image size: 106.7 x 66cm, 42 x 26 in.
Frame size: 122 x 81.2cm, 48 x 32 in.
Signed: l.r. signed and dated on the vase stand

PROV: A. G. Kurtz; Sold at Christie's on 23 May 1891 for
£735; Sold at Christie's on 30 November 1928 for £42;
Bought by the Russell-Cotes Art Gallery and Museum in
1929

EXH: RA 1889 (66); *Royal Academy Bicentenary Exhibition
1768–1968*, RA, 14 December 1968 – 2 March 1969
(346); *Egyptomania, Egypt in Western Art, 1730–1930*,
Paris, Ottawa and Vienna, 1994 (336); *Iside, Il Mito, Il
Mistero, La Magia*, Palazzo Reale, Milan, 1997 (x.25); *Art
Treasures of England*, RA 1998 (184)

LIT: *Academy Notes* 1889, p.vi, p.7 (ill.); *Athenaeum*, 18 May
1889, p.637; W. Roberts, *Memorials of Christie's. A Record
of Sales from 1766 to 1896*, London: George Bell & Sons
1897, vol.1, p.162; Austin Chester, 'The Art of Edwin
Long, R.A.', *Windsor Magazine*, 1908, p.332 (ill.); Quick,
*Long*, p.9 (ill.), p.45; *Royal Academy Bicentenary Exhibition
1768–1968* [exh. cat.], London 1968, p.134; Peter A.
Clayton, *The Rediscovery of Ancient Egypt*, London: Thames
and Hudson 1982, p.180 (ill.); Jean-Marcel Humbert,
*L'Égyptomanie dans l'art occidental*, Paris: ACR édition 1989,
p.240; *Egyptomania, Egypt in Western Art, 1730–1930*, cat.
to an exh. at the Louvre, Paris, and Ottawa and Vienna,
1994, p.493 (ill.); Herman De Meulenaere, *Ancient Egypt
in Nineteenth Century Painting*, Belgium, Berko 1992, p.109
(ill.), p.138 (ill.); *Iside, Il Mito, Il Mistero, La Magia*, cat. to
an exh. at Palazzo Reale, Milan, Milan: Electa 1997, p.653
(ill.); *Art Treasures of England, The Regional Collections*, cat.
to an exh. at the Royal Academy, London: Merrell
Holberton 1998, p.250 (ill.); Bills (cat. no.254 and
colour pl.), p.21, p.22, p.38, p.163, p.168 (ill.), p.169

COLL.NO: BORGM RC01350

The painting *Alethe* is based upon a poem and novel by
Thomas Moore.[1] It tells of Alciphron, a young Greek phil-
osopher who travels to Egypt in AD 257 to discover the
secret of eternal life. He meets Alethe, a priestess of Isis,
a secret Christian, and helps her to escape from her life
at the great temple of Isis in Memphis. The couple are
caught, Alethe is martyred and Alciphron is sent to a life
in the mines where he meets his untimely end.

The painting owes much to an earlier painting by E. J.
Poynter that depicted a similar subject.[2] What is unique
about Long's work is the relatively ornamental depiction of
a figure who is in fact a Christian martyr. There seems little
in anything other than the title to indicate her impending
martyrdom. Long had been drawn to the subject of the
early Christian Church for some time and explored this
more fully in many of his earlier works.

The costume is almost a purely Victorian construction
and the setting is, on the whole, inaccurate. The gracefully
poised model appears to indicate that it was an aesthetic
exercise rather than a serious attempt to depict Moore's
narrative. It is an interesting example of one of Long's
smaller and rarer polished essays in depicting the ancient
world.

1. Thomas Moore's poem *Alciphron* (1827) formed the basis for his
   later novel *The Epicurean* (1839)
2. Sir Edward John Poynter, *Feeding the Sacred Ibis in the Halls of
   Karnak*, 1871, oil on canvas, 92.6 x 69.2cm

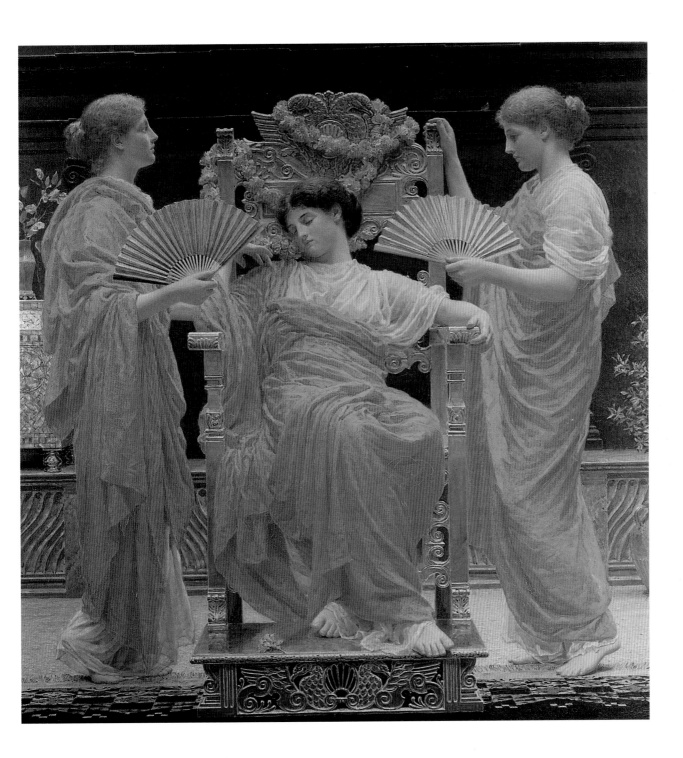

## 34: Albert Joseph Moore ARWS
(1841–93)
### *Midsummer*, 1887

Oil on canvas
Image size: 158.7 x 152.4cm, 62½ x 60 in.
Frame size: 195.6 x 188, 77 x 74 in.
Signed: Inscribed twice with anthemion (used by Moore in
  place of a signature)

PROV: William Connell collection from 1888–1908; Sold at
  Christie's in 1908 for £1,050; Sold at Sotheby's on 11 July
  1934 (lot 74) for £130 to Mr A. Casseres; N. Mitchell
of N. Mitchell Fine Art Gallery, 2 & 3 Duke Street, St
James's, London; Bought by the Russell-Cotes Art Gallery
and Museum from Mitchell in 1936 for £250
EXH: RA, 1887 (394); Glasgow *International Exhibition*,
  1888 (32); Montreal 1889; New Gallery, London, 1897–8
  (214); Irish International Exhibition, 1907; *Albert Moore
  and his Contemporaries*, Newcastle, 1972 (70); *Victorian
  Olympians*, Art Gallery of New South Wales, National
  Gallery of Victoria, Art Gallery of South Australia, 1975
  (26); *Victorian High Renaissance*, Minneapolis Institute of
  Arts, Manchester, Brooklyn, 1978–9 (83); *The Pre-
  Raphaelites and their Times*, Tokyo Shimbun, Hamatsu,
  Aichi, Daimaru, Yamanashi, 1985 (54); *The Victorians,
  British Painting 1837–1901*, National Gallery of Art,

Washington 1997 (58); *Art Treasures of England, The regional collections*, RA 1998 (185)

LIT: *AJ* 1887, p.248; *The Spectator*, 30 April 1887, p.591; *The Times*, 21 May 1887, p.8; A. L. Baldry, *Albert Moore: His Life and Works*, London 1894, p.xi, p.20, pp.60–1, pp.64–5, p.95, facing p.95 (ill.); *AJ* 1895, pp.48–9, facing p.50 (ill.); Richard Muther, *The History of Modern Painting 3*, 1907, facing p.356 (ill.); 'Albert Moore', *Masters in Art, 9*, 1908, pp.376–7, pl.7 (ill.); *Bulletin*, vol.XV, no.2, June 1936, pp.22–6, p.24 (ill.); Richard Green, *Albert Moore and his Contemporaries*, Newcastle 1972, p.2 (ill.), p.27; Robin Gibson, 'Albert Moore at Newcastle', *Burlington Magazine*, 1972, 114, p.888; *Victorian High Renaissance*, Minneapolis, Manchester, Brooklyn, 1978, p.153 (ill.); *So Fair A House* (ill. back cover); *The Victorians, British Painting 1837–1901*, National Gallery of Art, Washington 1997, pp.184–5, pl.58 (ill.); *Art Treasures of England, The regional collections*, London: Merrell Holberton 1998, pp.250–1, p.250 (ill.)

COLL.NO: BORGM RC01536

Albert Moore, a leading figure of the Aesthetic movement, painted *Midsummer* in 1887. Like much of his work the devotion to strong design and pattern is much in evidence in its symmetry and adornment. The influence of the Elgin marbles that Moore studied is also indicated in the graceful classical poses of the models. The positioning suggests a symbolic meaning although this remains vague and the interpretation remains open. The mood of the work is clearly expressed and the heat is suggested strongly through colour, light, tranquility and the languid poses of the central figures. In its strong and hot coloration it has been seen as a precedent for Frederick Leighton's *Flaming June* (1894–5).

The distinctive lighting effect of the work and unusually powerful coloration is uncharacteristic for Moore and his biographer A. L. Baldry wrote to Russell-Cotes noting: 'I certainly think that he must have made some quite definitive departure from his usual practice'.[1] Certainly it is one of Moore's most important works and was bought by an important patron of Moore, William Connal of Glasgow. The dark background and unusual intensity of the orange are not distinctively Moore, yet the fine detail and patterning, such as the mother-of-pearl cabinet are reflective of his aestheticism. The painting is virtually square which imposes compositional decisions and allows the artist to further explore symmetry and repeated decoration.

The work was purchased by the museum in 1936 for £250. The museum had attempted to buy the work in 1934 but failed due to its unrealistic offer of £50. The work is entirely fitting to the collection as Merton was a great admirer of Moore. 'My profound admiration for my late dear friend's pictures', he wrote, 'was only exceeded by that for himself.'[2] Indeed he devotes twelve pages of his autobiography to him[3] and recalls Moore, as he was apt to do with artists and people of distinction, a 'great friend'. His last memory of Moore is reflective of Merton's concerns, obsequiousness and sheer admiration of the artist:

I have a vivid and painful recollection of my last visit to his studio in Spencer Street, Westminster. I found him hard at work on this same picture. He was painting it for Mr. McCulloch, the wealthy Australian squatter. Albert Moore was a slave to his art and worked day and night *con amore*.

The fact that his days were numbered seemed to be ever present in his mind, but although this was the case he was apparently always cheerful, and was always ready to crack a joke or tell some funny little story whilst he was smoking his pipe. He was a great smoker, and rarely had his pipe out of his mouth. A casual observer would never have dreamt for one moment from his cheerful demeanour that he was such a patient and suffering martyr. On this particular occasion when I went in, he shook hands with me as usual in the heartiest manner, and afterwards placed his hands on my shoulders saying, 'I am delighted to see you, my old friend, as I feel that my days on this earth are drawing to a close'. With surprise I ejaculated, 'What makes you think that?' He said, 'Oh, I know. It cannot last much longer. In fact, it is now becoming a fight between the "fell enemy" and myself as to whether I shall be able to finish this picture for Mr. McCulloch or not.' On that occasion he presented to me one of his original little pictures of 'The Leader' in his fine picture 'Follow the Leader'.[4]

1. A. L. Baldry letter to Mr Silvester (Curator of the Russell-Cotes), 23 June 1936, Russell-Cotes archives
2. *Home and Abroad*, p.720
3. *Ibid*, pp.711–20
4. *Ibid*, p.717. Merton also owned other works by Moore including *Battledore*, see Appendix IV of 1905 Christie's sale (lot 96)

## 35: Charles Edward Perugini
(1839–1918)
### *A Capri Girl*

Oil on canvas
Image size: 35.6 x 28cm, 14 x 11 in.
Frame size: 53.3 x 45.8cm, 21 x 18 in.
Signed: l.r. with monogram

PROV: Merton Russell-Cotes; Russell-
Cotes Christie's Sale 11 March 1905
(lot 119), Sold to E. Howarth for £27
6s; Merton Russell-Cotes
LIT: Quick, p.25 (no.79); Quick,
*Illustrated Souvenir*, p.41 (ill.) (no.79);
*Bulletin*, September 1927, vol.VI, no.3,
front page (ill.), p.26
COLL.NO: BORGM RC1726

Charles Edward Perugini was born in
Naples in 1839. He met Frederic
Leighton in Rome and received great
encouragement from him becoming his
protégé. He moved to London in 1863
where he exhibited widely. Here he met
the painter Kate Dickens (Mrs Charles
Allston Collins 1860–73, the youngest
daughter of the celebrated novelist
Charles Dickens) whom he later mar-
ried. The subjects of his works, thought-
fully dressed and positioned female
models with decorative accessories, were
influenced by the Aesthetic movement
in their simplicity of form and colour.
His style and highly polished finish owes
more to his mentor Leighton, however.

The *Art Journal* often praised
Perugini's skill and ability. In 1882 it fea-
tured a full-page engraving of his paint-
ing *A Siesta* engraved by Frank Holl, and
praised that which often characterises
Perugini's work: 'painted with accurate
knowledge and skill, and are evidently
the result of a careful study of the
antique ... the control of light, the vari-
ety of texture ... are some of the points
which make up a charming picture.'[1]

1. *AJ* 1882, p.43

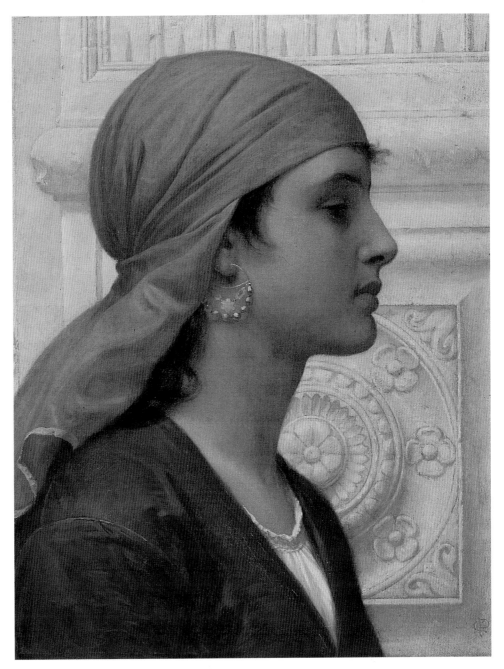

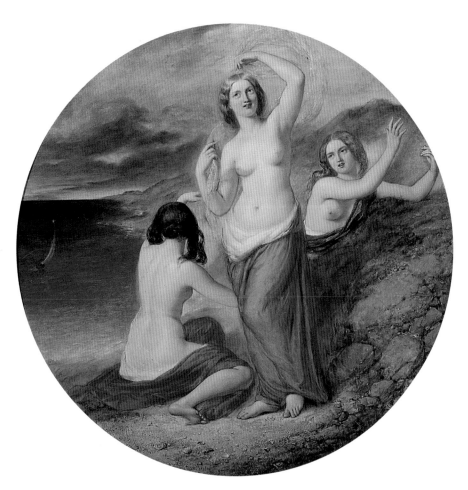

## 36: Frederick Richard Pickersgill RA
(1820–1900)
### The Syrens

Oil on panel
Image size: 50.4cm, 19¾ in. (diameter)
Canvas size: 50.8 x 50.8cm, 20 x 20 in.
Frame size: 70.5 x 70.5cm, 27¾ x 27¾ in.
Signed: l.r. 'F.R. Pickersgill ARA'
Label on back: 'Henry A Rawling, picture restorer'

PROV: Merton Russell-Cotes original collection
EXH: *The Nude in Victorian Art*, Harrogate Art
   Gallery, August 1966 (unnumbered)
LIT: Quick, p.25 (no.81)
COLL.NO: BORGM RC01735

Like Frost, Pickersgill was one of the immediate
followers of William Etty. They differed in many
ways from later Victorian painting and were quite
unfashionable at the time Merton was collecting.
This painting is typical in its subject and delicate
treatment by artists of this character. Paintings
such as this were known as 'fancy pieces', because
they contained no discernible narrative and
although they often used lines from Milton,
Shakespeare and Spenser, they were not so much
describing or elucidating a story as being fantasies
on set themes. Alison Smith in her book on Vic-
torian nudes describes them as 'presenting stock
mythological character sporting or idling by a
woodland glade or pool … quintessentially femi-
nine. Because the female body was considered
more naturally suited to scenes of fancy than the
male … in keeping with this "feminine" treat-
ment, the subjects themselves are slight and mod-
est. Delicately they arrange their coiffure or draw
a drape across their unprotected form.'[1] The deli-
cately poised and tinted nudes with carefully coif-
fured hair styles set within a decorative circular
shape are typical of works by Etty's followers.
Pickersgill painted this work at sometime between
1847 and 1857 the period that he was an ARA.
A similar work in scale, subject and treatment by
W. E. Frost in 1849 further illustrates this genre.[2]
Within this period Pickersgill had developed a
more ambitious work on the same subject, *Circe
with the Syrens Three* (RA 1849) taken from
Ariosto's *Orlando Furioso*.

   Merton had an admiration for Pickersgill as he
had for Frost although his greatest admiration was
for William Etty. Pickersgill lived at The Towers,
Yarmouth on the Isle of Wight (near
Bournemouth), from 1888 to his death in 1900
and there is the possibility that Merton may have
visited him there. Merton certainly appears to
have visited the sale that followed his death at
Christie's in 1901.[3] He owned a large-scale work
by Pickersgill, *A Festival in Honour of Pan* (1843,
oil on canvas, 30 x 50 in.) which he sold at
Christie's in 1905 (lot 120).

1. Alison Smith, *The Victorian Nude*, Manchester:
   Manchester University Press 1996, pp.90–1
2. *The Syrens* (1849), oil on canvas, 26 x 34½ in. Ill.,
   *Ibid*, p.91
3 The cat. for *The Property of F.R. Pickersgill, Esq. RA*, sale
   at Christie's on 26 February 1901 is still within the
   Russell-Cotes archive

## 37: Sir Edward John Poynter, Bt.
### PRA RWS
(1836–1919)
*Cleopatra and the Asp*

Oil on canvas
Image size: 44.3 x 34.2cm, 17½ x 13¼ in.
Frame size: 66 x 55.8cm, 26 x 22 in.
unsigned
Inscription on back: In blue pencil on the
back of the canvas 'E J Poynter *Cleopatra
and the Asp*'

PROV: Merton Russell-Cotes original collection
LIT: Quick, p.28 (no.90)
COLL.NO: BORGM RCO1751

Sir Edward John Poynter, painter of ancient
and classical subjects, was born in 1836. He
studied in France and learnt through the
French system of art training which differed
from the methods adopted by the Royal
Academy in Britain. His magnificent depiction of ancient Egypt exhibited at the Royal
Academy of 1867, *Israel in Egypt*, was a great
success and influenced many British
painters. In 1871 he was named professor
of the newly opened Slade School of Art.
He adopted the principles of French art
education and appointed the French artist
Alphonse Legros as his successor. He was
elected ARA in 1869, RA in 1876 and
named President on the death of Millais
in 1896.

This oil study of Cleopatra and the asp is
attributed to Poynter by Merton who has
written the artist and title on the back of
the work with his own hand. As Merton
almost certainly purchased the work before
Poynter's death in 1919 this has credence,
if not certainty.[1] The work is not untypical
of Poynter, who did produce oil sketches
for his finished works, yet it may be a hopeful attribution by Merton. Merton certainly
admired Poynter yet the only mention he
makes of him in *Home and Abroad* is his
address given on the death of Leighton in
1896.[2]

Unfortunately there are no known
finished works by Poynter of Cleopatra.
Certainly he considered painting the subject, but decided against it, a point discussed openly in a letter to his patron, Lord
Wharncliffe, in 1885, 'Tadema having done
Cleopatra so lately', he wrote, 'I could not
do it'.[3]

1. It was usual of Poynter to sign all his studies
   and this is unsigned raising some doubts about
   its authenticity. I am grateful to Alison Inglis
   for her very detailed comments on this work
2. *Home and Abroad*, pp.731–2
3. Poynter to Lord Wharncliffe, 30 April 1885,
   Wharncliffe Monuments, Department of Local
   History and Archives, Central Library,
   Sheffield, Wh.M.418

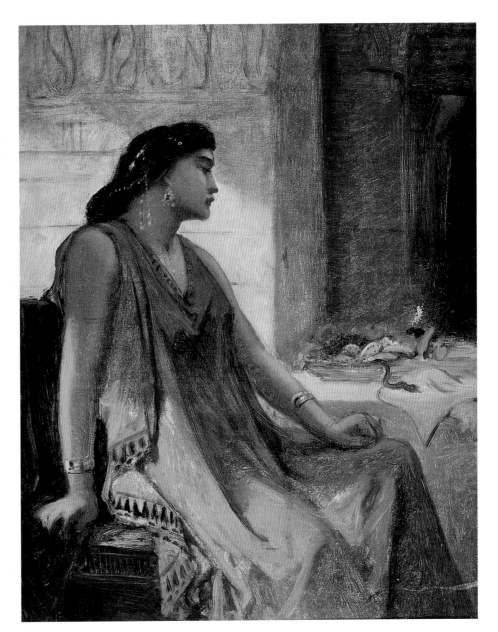

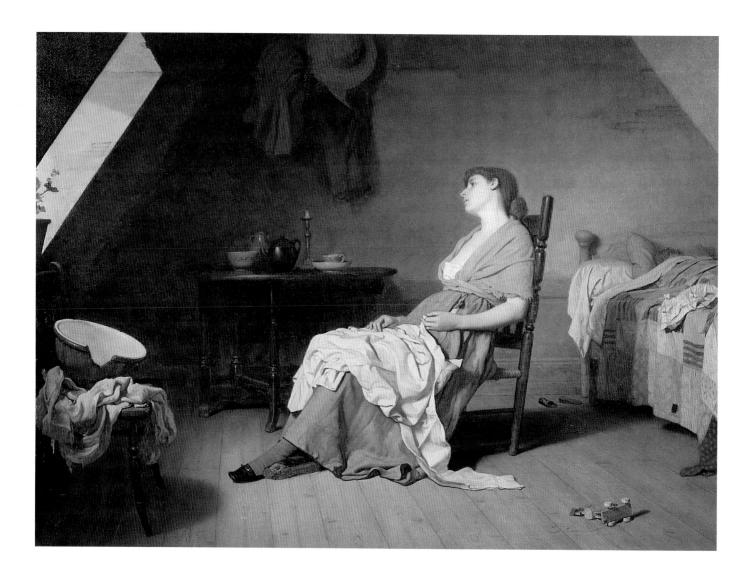

## 38: Edward Radford A R W S
(1831–1920)
*Weary* or *'The Song of the Shirt'*, c.1873

Oil on canvas
Image size: 59.7 x 82.5cm, 23½ x 32½ in.
Frame size: 91 x 113cm, 35¾ x 44½ in.
unsigned

PROV: Messrs Dowdeswell & Dowdeswells Gallery, Bond
   Street; Bought by Sir Merton Russell-Cotes, c.1873;
   Russell-Cotes Art Gallery and Museum
EXH: Manchester *Jubilee Exhibition* 1887 (no.335)
LIT: *AJ* 1877, p.68 (ill. opp. p.68, engraved by T. Brown);
   *Home and Abroad*, p.61, opp. p.722 (ill.); Quick, p.49
   (no.213); Quick, *Illustrated Souvenir*, p.63 (ill.), (no.213);
   *Bulletin*, March 1935, vol.XIV, no.1, p.8, p.9 (ill.)
COLL.NO: BORGM RC01782

Edward Radford was a genre painter and watercolourist
who specialised in highly detailed interiors usually contain-
ing a central female figure. The main figure of *Weary* is of
a woman who has been working through the night stitching
a shirt that lies in her lap. All the visual indications of the
wearisome task that she faces and her dedication to her

child were pointed out in the 1877 *Art Journal* who found
that although this was clear its interpretation still remained
open: 'Artists who design compositions of this kind, having
in themselves no definite meaning – one, that is, which
admits of varied reading or interpretation – certainly give
the spectator an opportunity of putting his own construc-
tion upon it'.[1] The painting was exhibited at the Dowdes-
well's Gallery on Bond Street where Merton purchased it.

A smaller version was made of the work for the Duke of
Albany. Merton recalled: 'A few days after I had purchased
it, the Duke and Duchess of Albany visited the galleries saw
this picture, and wished to purchase it. Mr. Dowdeswell
explained that it was already sold to me, but that he would
write to me, which he did, and I, not wishing to part with
the picture, suggested that if Mr. Radford would not object
to paint a replica, I would be perfectly willing for him to do
so. This he did, the replica being slightly smaller.'[2]

The *Art Journal* produced a full-page engraving after the
work in 1877, presumably from the copy as there are sev-
eral notable differences. The bowl is no longer cracked;
prints and more noticeable cracks have appeared on the
walls and 'a black bottle, suggestive of something stronger
and more pernicious'[3] had been added. The mood of each,
however, is the same. The colour, tones and myriad of in-
terior details in the painting succinctly echoes its title:
*Weary*. Merton in *Home and Abroad* also calls the work, *The*

*Song of the Shirt* despite the *Art Journal* commenting that 'there is nothing in her appearance to recall to mind the miserable heroine of Hood's "Song of the Shirt"…'[4] The work does seem to owe much to the influence of social-realist paintings that were directly inspired by Hood's poem and Merton's subtitle, which may or may not have come directly from the artist, appears apt:

> With fingers weary and worn,
> With eyelids heavy and red,
> A woman sat in unwomanly rags,
> Plying her needle and thread –
> Stitch! Stitch! Stitch!
> In poverty, hunger and dirt,
> And still with a voice of dolorous pitch
> She sang the 'Song of the Shirt'.[5]

The painting in its title, subject and composition more particularly owes influence to Thomas Faed's *Worn Out*. The composition is an almost identical reversing and the weary figure of a father who has kept awake all night for his sick child is similarly echoed in *Weary*. The work was painted a few years earlier when it was exhibited at the Royal Academy where Radford would have seen the work.[6]

1. *AJ* 1877, p.68
2. *Home and Abroad*, p.61. The copy appeared alongside loaned works of Merton's at the *Columbian Exhibition*, The Art Institute of Chicago 1893 (no.400), cat. p.137. Lent by HRH the Duchess of Albany
3. *AJ* 1877, p.68
4. *Ibid*
5. From Thomas Hood, *The Song of the Shirt*, *Punch*, Christmas 1843
6. Thomas Faed, *Worn Out*, 1868 (Forbes Magazine Collection)

## 39: Edward Radford A R W S
(1831–1920)
*A Grecian Girl*

Oil on canvas
Image size: 43.9 x 22cm, 17¼ x 8¾ in.
Frame size: 66 x 43cm, 26 x 17 in.
Signed: l.l. '*E. RADFORD*'
Inscription (on back): '*501*'

PROV: Merton Russell-Cotes original collection
LIT: Quick, p.60 (no.328); *Bulletin*, March 1935, vol.XIV, no.1, p.8 (ill.)
COLL.NO: BORGM RCO1781

This is a small neo-classical genre painting of a Grecian girl. Radford uses the same model as *Weary* to very different effect.

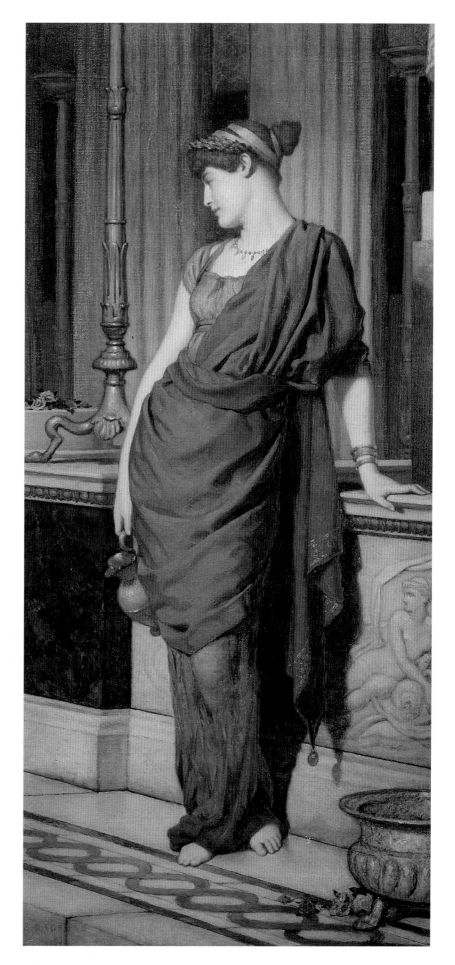

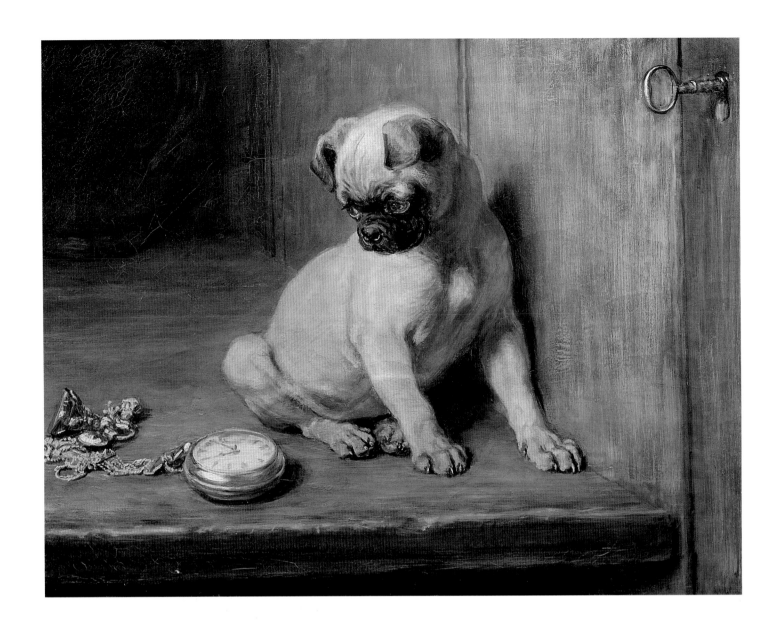

## 40: Briton Riviere RA RE
### (1840–1920)
### *Tick-tick*, 1881

Oil on canvas
Image size: 36.9 x 48.2cm, 14½ x 19 in.
Frame size: 66 x 76.2cm, 26 x 30 in.
Signed: l.l. *'B Riviere 1881'*

PROV: Merton Russell-Cotes before 1895; Russell-Cotes
   Christie's sale 11 March 1905 (lot 124) sold to
   Richardson for £111 10s; Merton Russell-Cotes
LIT: Sir Walter Armstrong, 'Briton Riviere', *AJ, Art Annual*
   1891, p.31; *AJ* 1895, p.295 (ill.); *Home and Abroad*, p.727;
   Quick, p.49 (no.207); Quick, *Illustrated Souvenir*, p.62
   (ill.), (no.207); *Bulletin*, June 1926, vol.v, no.2, front
   page (ill.), p.4
COLL.NO: BORGM RC01870

Briton Riviere was born in 1840. He studied at Cheltenham
College where his father, William Riviere, was a drawing
master. He was precociously talented and sent two works
for exhibition at the British Institution at the age of eleven,
*Kitten and Tomtit* and *Love at First Sight*. As early as these
works were, they gave a good indication to the direction
that his painting was to take, the latter depicting a kitten
being introduced to its first mouse. He débuted at the
Royal Academy in 1858. In the early 1860s he came under
the influence of the Pre-Raphaelites, particularly through
Millais, and produced several paintings produced accord-
ing to the principles of the brotherhood including *Elaine on
the Barge* and *Hamlet and Ophelia*. Each of these works, how-
ever, found no favour with the exhibition committee of the
Royal Academy and were turned away. He began exhibiting
again at the Royal Academy in 1864 when the influence of
the Pre-Raphaelites was less discernible in his painting and
was elected as an ARA in 1878 and a full Academician in
1881. As an animal painter, he was seen as the heir to
Landseer: 'Mr. Briton Riviere, R.A.', the *Art Journal* wrote in
reviewing Merton's collection 'is the one who comes closest
to Landseer, and it is only just to say that several of his im-
portant pictures are equal to many of the best Landseers'.[1]
In many of his ambitious works, the depictions of animals

are used in dealing with grander subjects such as *Persepolis*, *In Manus Tuas, Domine* and *Daniel*. Sir Walter Armstrong wrote in 1891 that the artist took greatest pride in works such as *Ganymede* where animals took the least part.[2] Despite this Riviere painted mainly animal scenes and was known by the majority of the public as an animal painter. Most typical of these works are where animals show discernible emotions and human characteristics such as *Treasure Trove*, *Sympathy* and *An Anxious Moment*. *Tick-tick*, incorrectly titled by Merton as *Tick-Tack*, depicts a miniature pug fascinated by the noise of a pocket watch.

Merton was a great admirer of Riviere writing that he 'is the most distinguished English artist in the portrayal of animals ... I have possessed several of his works, but perhaps the one that he appreciated most as his own work, although on a very small scale, is the one "Tick Tack", which hangs in the Russell-Cotes Art Gallery and Museum. It vividly portrays its own story, which is that of a pug puppy gazing with surprise and wonderment, and perhaps a little fear, at an old-fashioned "turnip" watch. He cannot understand where the sound comes from. It is altogether a most admirable little work in his best style.'[3]

1. *AJ* 1895, p.295
2. Sir Walter Armstrong, 'Briton Riviere', *AJ*, *Art Annual* 1891
3. *Home and Abroad*, p.727

# 41: Thomas Matthews Rooke R W S
(1842–1942)
## *King Ahab's Coveting*, 1879

   *i. Ahab covets Naboth's vineyard (top left)*
  *ii. Naboth refuses Ahab his vineyard (bottom left)*
 *iii. Jezebel promises Ahab to obtain it by false witness (top centre)*
 *iv. Elijah prophesises to Ahab and Jezebel their end (bottom centre)*
  *v. Jezebel thrown to the dogs (top right)*
 *vi. Ahab's body brought in from the battlefield (bottom right)*

Oil on canvas
Image size: Six panels presented three on two rows set in frame; outer images 35 x 31.8cm, 13¾ x 12½ in. (x4); central images 35 x 44cm, 13¾ x 17¼ in. (x2)
Frame size: 110 x 168cm, 43¼ x 66¼ in.
Signed: with initials in number 3 and dated '*1879*'
Inscriptions on back: printed label, '*RA, Bicentenary Exhibition 1968–1969, No.89*'; printed label, '*Royal Commission for the Chicago Exhibition 1893, BRITISH SECTION Fine Arts, No.122 ... T M Rooke ...-Cotes*'; written on back of canvas in paint, '*T M Rooke, 7 Anne's Gardens, Bedford Park, T? Green, King Ahab's Coveting*'; in pencil '*No.1*'.

PROV: Merton Russell-Cotes purchased from the Autumn Exhibition of the New Gallery, Regent Street, in 1892
EXH: RA 1879 (987–92); The New Gallery, Autumn Exhibition 1892 (183); *Columbian Exhibition*, The Art Institute of Chicago 1893 (415) [loaned by Merton Russell-Cotes]; RA *Royal Academy Bicentenary Exhibition 1768–1968*, 14 December 1968 – 2 March 1969 (346)
LIT: *The New Gallery, Regent Street Autumn Exhibition MDCCCXCII*, London: Richard Clay & Sons 1892, p.37; *Academy Notes* 1892, p.64 (ill.); *AJ* 1895 (unnumbered as it appeared at proof stage [was to be used as the last part with Laura Alma Tadema's *Always Welcome* only, all six illustrated and text taking up a complete page); *Columbian Exhibition*, The Art Institute of Chicago 1893, p.137; *Home and Abroad*, p.729, p.738; *Quick*, p.34 (no.112); *Bulletin*, December 1924, vol.III, no.4, pp.46–7, pp.48–9 (ill.); *Royal Academy Bicentenary Exhibition 1768–1968* [exh. cat.], London 1968, p.134
COLL.NO: BORGM RCO1891

As a young artist Thomas Matthews Rooke became closely associated with Burne-Jones and William Morris who exerted a significant influence upon his work. He also developed a close connection with John Ruskin for whom he worked drawing and painting, many of these illustrations are now in the Ruskin Museum, Sheffield. He trained at the Royal College of Art and Royal Academy Schools and exhibited at the Royal Academy from 1876. This particular work was exhibited at the Royal Academy of 1879 as six separate pictures depicting Ahab's coveting that read from top to bottom and left to right.[1] Blackburn's *Academy Notes* commented on 'One of the few serious works of religious art in the exhibition; it is decorative in treatment, similar to "Ruth" which was exhibited at, and purchased by, the Royal Academy in 1877. These delicate designs are placed in trying juxtaposition to some glaring colours.'[2] Yet it has closer precedents than *Ruth*. His 1876 RA painting, *Elijah, Ahab and Jezebel in the vineyard of Nahob, the Jezreelite* (no.1254) and his 1878 RA painting, *Death of Ahab* (no.533) deal with the same subject. Furthermore, the 1876 painting bears a great resemblance to no.IV of *King Ahab's Coveting*, the major differences being that the image is reversed and the dead Nahob has been removed.[3] Richard Quick, the

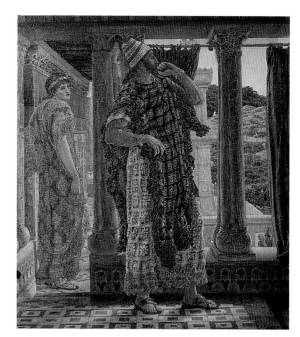

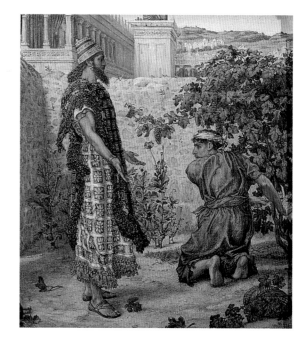

Russell-Cotes's first curator wrote: 'No.iv is a small variant of an earlier work (which suggested the whole) painted in 1875 for a student's competition at the Royal Academy and exhibited there the following year.'[4]

Merton purchased the work from the annual Autumn Exhibition at the New Gallery, Regent Street in 1892. When writing of Burne-Jones in his autobiography, Merton noted: 'His most famous pupil was T. M. Rooke, who, during the last few years of Burne-Jones' illness, no doubt contributed a considerable amount of work to his pictures, and in many ways quite equalled his great master. Rooke seemed to have a particular penchant for painting compositions depicting successive scenes of the same story, which were designed to be placed in one frame. Perhaps the finest of this class is "King Ahab's Coveting", presented to the Corporation of Bournemouth by me, and which now hangs in the Russell-Cotes Art Gallery. This picture, at the request of my late friend, Lord Leighton, was, together with other pictures (one being his own original work of "Perseus and Andromeda") sent to the Chicago International Exhibition. It has, at the request of the publishers of many religious works, been reproduced. Rooke produced his poetry not in verse, but portrayed it in his pictures. As I have said, he was Burne-Jones' most capable pupil.'[5]

1. I Kings 21,22; 29–38, II Kings 9; 30–37 and Chron xviii, 34
2. *Academy Notes*, p.64
3. The work is now in the South London Gallery. 'The large picture was bought by Messrs.Virtue who had it engraved in line, and from then it was passed to Lord Battersea, who subsequently presented it to the South London Gallery...', Quick, p.34. See *AJ* 1880 p.172 and ill. opp. and Giles Waterfield, *Art for the People, culture in the slums of late Victorian Britain*, Dulwich Picture Gallery 1994 (no.51)
4. *Ibid*, p.34
5. *Home and Abroad*, p.738. Merton is incorrect in saying that Leighton's study for *Perseus and Andromeda* went to Chicago and in fact loaned a work by E. B. Leighton to the exhibition

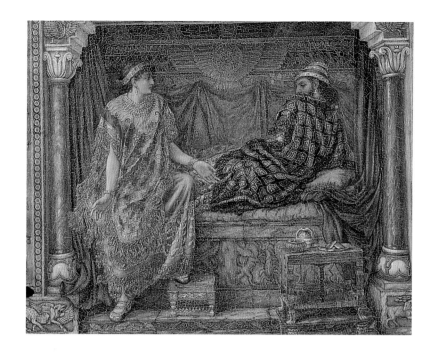

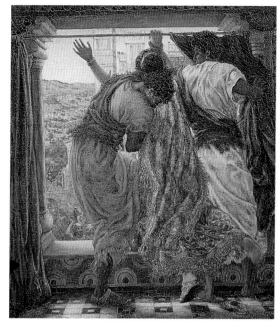

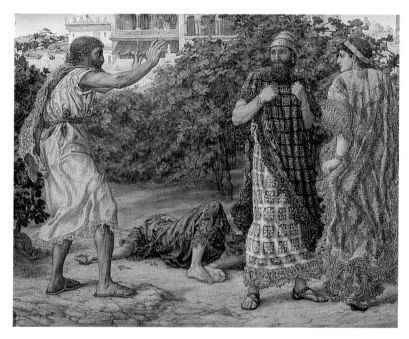

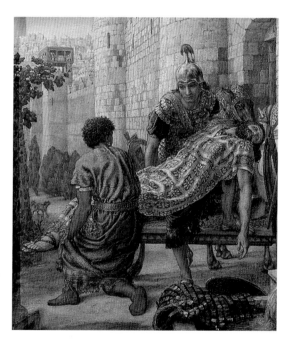

## 42: Dante Gabriel Charles Rossetti
(1828–82)
### Venus Verticordia, 1864–8

Oil on canvas
Image size: 83.8 x 71.2cm, 33 x 27½ in.
Frame size: 101.6 x 88.8cm, 40 x 35 in.
Signed: l.l with monogram

PROV: John Mitchell of Bradford; John Graham; Sold at
the J. Graham sale at Christie's, 30 April 1887 (lot 82)
for £472 10s; Arthur Anderson; Sold at Christie's 19 May
1894 (lot 34) for £525; H. S. Sanders-Clark; Sold at
Christie's, 30 July 1936 (lot 71) for £105; Bought in
1946 by the Russell-Cotes Art Gallery and Museum

EXH: Birmingham, *Special Loan Collection*, 1891 (179);
*Paintings and Drawings by the Pre-Raphaelites and their
Followers*, Russell-Cotes Art Gallery and Museum 1951 (9);
*D.G. Rossetti*, Commonwealth Institute 1978; *Dante Gabriel
Rossetti, Painter and Poet*, RA and Birmingham 1973 (317);
*The Pre-Raphaelites*, Tate Gallery 1984 (130); *Symbolism in
Europe*, Centro Atlantico de Arte Moderna, Las Palmas de
Gran Canaria 1990; *The Pre-Raphaelites and their Times*,
Japan touring exhibition 1985 (14); *Dei ed Eroi (Gods and
Heroes)*, Palazzo delle Esposizioni, Rome 1996 (37); *The
Age of Rossetti, Burne-Jones & Watts, Symbolism in Britain
1860–1910*, Tate Gallery touring exhibition 1997–8 (43)

LIT: *Athenaeum*, 21 October 1865, p.546; D. G. Rossetti,
unpublished letter to Boyce, 28 January 1868, University
College London Library; *Boyce Diaries*, p.48 (25 No-
vember 1864), p.54 (27 March 1868); William Poet
Sharp, *Dante Gabriel Rossetti. A Record and a Study*, London:
MacMillan & Co. 1882, pp.206–7; *AJ* 1884, p.167; Henry
Currie Marillier, *Dante Gabriel Rossetti: an illustrated mem-
orial of his art and life*, London: George Bell & Sons 1899
(no.149), p.54, n, pp.134–6; Joseph Leopold Ford
Hermann Madox Brown Hueffer, *Rossetti, a critical essay on
his art*, London 1902, pp.140–1; William Michael Rossetti
(ed.), *Rossetti Papers 1862–1870*, London 1903, p.227,
p.308, p.407; Ruskin, *Works*, vol.XXXVI p.489, p.491;
William Allingham, *A Diary* (ed. by H. Allingham and
D. Radford), London 1907, p.100; Ernest Radford, *Dante
Gabriel Rossetti*, London: George Newnes Ltd 1908 p.23;
J. C. Troxell, *Three Rossettis*, Harvard University Press,
1937, p.53. *Bulletin*, September 1946, frontpage (ill.),
first three pages [unnumbered]; Kerrison Preston (ed.),
*Letters from Graham Robertson*, London: Hamish Hamilton
1953, pp.397–8; Roger Lancelyn Green (ed.), *The Diaries
of Lewis Carroll* (2 vols), London: Cassell & Co. 1953,
vol.I, p.205; Oswald Dougherty and J. R. Wahl (eds),
*The Letters of Dante Gabriel Rossetti*, Oxford 1965–8, p.516,
pp.518–9, p.570, p.822, pp.836–7; David Sonstroem,
*Rossetti and the Fair Lady*, Middletown, Connecticut:
Wesleyan University Press 1970, p.113, p.219; Virginia
Surtees, *The paintings and drawings of Dante Gabriel Rossetti
(1828–1882): a catalogue raisonné*, Oxford: Clarendon
Press 1971 (no.173), pp.98–9, (ill. pl.248); *Dante Gabriel
Rossetti, Painter and Poet*, RA exh. cat. 1973, p.72; D. M. R.
Bentley, *Rossetti's Venus Verticordia, Bulletin*, vol.XXXVI,
no.7, July 1977, p.18 (ill.), pp.19–22; *The Pre-Raphaelites*,
Tate Gallery cat. 1984, pp.208–9, p.208 (ill.) [cat. entry
by Alastair Grieve]; *The Pre-Raphaelites and their Times*
[exh. cat.], Tokyo 1985, pp.52–4, pp.52–3 (ill.); Rosa
Vigili, *Rossetti's Pictures and Related Poems an Aesthetic
Approach*, Doctoral thesis for the University of Fribourg
1986, pp.45–6, pl.XIII; Alicia Craig Faxon, *Dante Gabriel
Rossetti*, Oxford: Phaidon 1989, p.136 (ill.), p.137, p.200;
Michael Gibson, *Le Symbolisme*, Köln: Taschen 1994, p.77

(ill.); *Dei ed Eroi (Gods and Heroes)* [exh. cat.] Palazzo delle
Esposizioni, Rome 1996, p.136, p.137 (ill.), p.138; Alison
Smith, *The Victorian Nude*, Manchester University Press
1996, p.30, pp.128–9 (pl.7); Andrew Wilton and Robert
Upstone (eds), *The Age of Rossetti, Burne-Jones & Watts,
Symbolism in Britain 1860–1910*, Tate Gallery [exh. cat.]
1997, pp.152–3, p.153 (ill.)
COLL.NO: BORGM RC01897

> She hath the apple in her hand for thee,
> Yet almost in her heart would hold it back;
> She muses, with her eyes upon the track
> Of that which in thy spirit they can see.
> Haply, 'Behold, he is at peace,' saith she;
> 'Alas! the apple for his lips, – the dart
> That follows its brief sweetness to his heart, –
> The wandering of his feet perpetually!'
>
> A little space her glance is still and coy;
> But if she give the fruit that works her spell,
> Those eyes shall flame as for her Phrygian boy.
> Then shall her bird's strained throat the woe fortell,
> And her far seas moan as a single shell,
> And through her dark grove strike the light of Troy.[1]

The title for the painting refers to one of Venus's many sur-
names and was taken from Lempriere's *Classical Dictionary*
which reads: 'VERTICORDIA, one of the surnames of
Venus, the same as the Apostrophia of the Greeks. This
name was given her because her assistance was implored
to turn the hearts of the Roman matrons, and teach them
to follow virtue and modesty. *Ovid. 4. Fast.* v.157., thus
describes the origin of the name.'[2] It is an unusual choice
for the painting whose various interpretations explore the
highly symbolic representation of sexual desire and attrac-
tion. Certainly the symbolic imagery alludes to the dangers
associated with sexual obsession and in this sense the title
may have a relevance.

Rossetti used two models for the painting, the first re-
called by his brother William: 'I can recollect that my
brother, being on the look out for some person to serve as
a model for the head and shoulders of his Venus, noticed
in the street a handsome and striking woman, not very
much less than six feet tall (almost all the ladies from
whom he painted with predilection were of more than
average stature). He spoke to this person, who turned out
to be a cook serving in some family in Portland Place, and
from her he at first painted his large "Venus Verticordia".
That was the only picture, I think, for which the handsome
*Dame de cuisine* sat to him …'[3] The portrait was repainted in
1867 however and substituted with the features of the more
familiar Alexa Wilding.

In painting the work Rossetti was keen to paint its details
with extreme care and he spent 'infinite time looking for
honeysuckles for my *Venus*, but the picture is going to be
a stunner now, and goes on fast'.[4] The symbolism of the
imagery was reinforced with the accuracy and sensuality of
the depictions. Fresh flowers were regularly sought in order
for him to achieve this. 'I am tied down to my canvas till all
the flower part of it is finished. I have done many more
roses, and have established an arrangement with a nursery-
gardener at Cheshunt, whereby they reach me every two
days at 2s. 6d. for a couple of dozen each time, which is
better than paying a shilling apiece at Cov[ent] Garden.
Also honeysuckles I have succeeded in getting at the Crystal
Palace, and have painted a lot already in my foreground,
and hope for more. All these achievements were made only
with infinite labour on my part, and the loss of nearly a
whole week in searching. But the picture gets on well
now….'[5] He wrote later to Ford Madox Brown that 'Roses

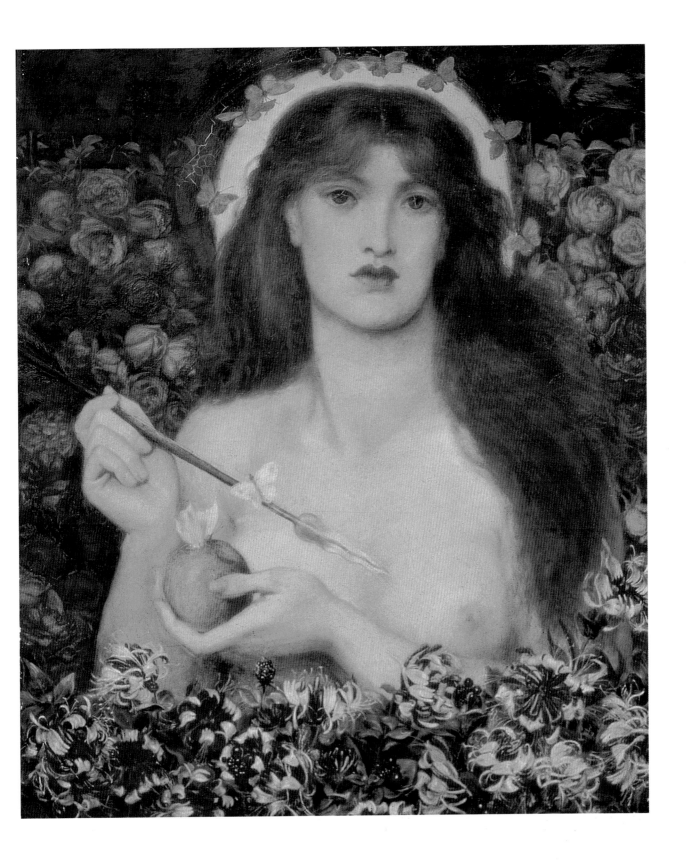

and honeysuckles have left me penniless ... What do you think of putting a nimbus behind my Venus's head? I believe the Greeks used to do it.'[6]

The work was commissioned by Mr John Mitchell of Bradford in April 1864. In August of that year 'A friend of Mr. Mitchell, who is to have the *Venus,* called from Yorkshire to see it the other day, and was much delighted. I hope it may do me good when it gets there.'[7] The following year Rossetti had still not completed the work and he wrote to Mitchell in September 1865: 'I much regret the continued delay with your picture of Venus which I had expected to send you before this when I saw you last. I still trust it will not now be very long in reaching you and am at least confident that it will be greatly the gainer by having awaited a moment of more undivided attention for its completion than I could have given hitherto. Your having several times expressed, yourself solicitous rather for its reaching you satisfactorily than speedily, has induced me to hope that it may please you sufficiently when seen at last to compensate for any delay by which it will have benefited. Meanwhile I am anxious that you should not think your picture, has in any degree, escaped my memory and so write this word. With kind remembrances to Mrs. Mitchell and your family...'[8] The work was finally completed in 1868 and the length of time that he struggled with it is an indication of its importance to him and the often conflicting imagery and symbols within the work. There are a number of sketches and versions of this work which further indicates Rossetti's fascination with this subject.[9]

The symbols within the work are in part contradictory and its meaning remains open to interpretation. Whether she is a *femme fatale,* a goddess 'implored to turn the hearts of the Roman matrons' or a symbolic reflection of Rossetti's confusion in his own private life has been discussed by many authors. The potency and associations of the symbols are reasonably clear individually. The roses and honeysuckles represent love, more particularly with the latter, sexual love and lust. These prompted Ruskin to write that 'I ... dislike the Flora',[10] and to criticise the honeysuckles: 'I purposely used the words "wonderfully" painted about those flowers. They were wonderful to me, in their realism; awful – I can use no other word – in their coarseness: showing enormous power, showing certain conditions of nonsentiment which underlie all you are doing- now...'[11]

The two symbols that Venus holds can be seen as contradictory, the golden apple that caused the fall of Troy, Paris is the 'Phrygian boy' of Rossetti's sonnet, with Cupid's dart. One foretells love, although Paris was killed by a poison dart at the siege of Troy, the other destruction caused by obsessive love. The iconographic imagery is further developed in the blue bird at the top right of the picture whose 'strained throat the woe foretell' and who is associated with the brevity of existence in contrast to the butterflies which have been seen as the souls of dead lovers.

Merton wrote a few words about Rossetti in his autobiography which seems to indicate that he was not a great admirer of the artist but felt that he should mention him. He also gives a rather misconceived allusion to the Futurists which illustrates his own conservatism. 'I do not think that my notes upon the pre-Raphaelite school would be complete without a few remarks upon the great painter and poet, Rossetti. Dante G. C. Rossetti was born in 1828, and was the son of an exiled Italian author who settled in London in 1824. He showed great talent as a painter from boyhood. I suppose it is an admitted fact that we owe to him the formation of the pre-Raphaelite Brotherhood, which was founded in 1848, but of whom nearly all have now passed away, and it seems very doubtful as to whether this school of art will ever be revived, at all events to the

extent that it has been developed in the past. The nearest approach to it, of course, is the wild-cat scheme that has been adopted by a few so-called "artists" in developing the Futurist school. From about 1850 Rossetti painted a great number of pictures remarkable for their extreme beauty of drawing, splendour of colouring, and poetic force. Among his best-known paintings are "Ecce Ancilla Domini", "Song of Solomon", "Beatrix", "Lilith", and "Dante's Dream". There are only two small examples of this artist's work in my collection.'[12]

1. Rossetti completed this sonnet for the painting in January 1868
2. John D. D. Lempriere, *Bibliotheca Classica: or a Classical Dictionary,* Reading 1788. Many later editions were available in the later half of the nineteenth century
3. W. M. Rossetti, *Notes on Rossetti and his Works* (part ii) *AJ* 1884, p.167
4. Rossetti to Ford Madox Brown, 9 August 1864, in Oswald Doughety and J. R. Wahl (eds), *The Letters of Dante Gabriel Rossetti,* Oxford 1965-8, p.516
5. Rossetti to his mother, 16 August 1864. *Ibid,* pp.518-19
6. Rossetti to Ford Madox Brown, 23 August 1864, *Ibid,* p.519
7. *Ibid*
8. Rossetti to John Mitchell, 14 September 1865, *Ibid,* p.570
9. See Virginia Surtees, *The paintings and drawings of Dante Gabriel Rossetti (1828–1882): a catalogue raisonné,* Oxford: Clarendon Press 1971, nos 173A–F, R.1–2
10. Ruskin, *Works,* vol.XXXVI, p.489
11. *Ibid,* p.491
12. *Home and Abroad,* pp.739–40. The two works, watercolours, are no longer in the collection

## 43: Joseph Arthur Palliser Severn RI ROI (1842–1931)
### *Interior of Ruskin's Study (Brantwood),* 1893

Watercolour
Image size: 25.4 x 35.8cm, 10 x 14 in.
Frame size: 51.5 x 62.8cm, 20¼ x 24¾ in.
Signed: l.r. 'A. Severn 1893'
Inscriptions on back: printed label, '*James Bourlet & Sons Ltd F34348*'; printed label, '*Graves Art Gallery, Sheffield*'; In handwritten ink on printed label, '*Account Ruskin Book No.67089 Name Mr. Ruskin's Study Artist A Severn Date 8.9.1893*'; written in blue crayon, '*Ruskin's Study by A. Severn*' (The husband of Ruskin's niece to whom he left his beautiful villa at Coniston) '*8/9/93 MRC*'

PROV: Possibly Thomas J. Barratt who loaned the work (or a replica of it) for the exhibition in Manchester 1904; Sir Merton Russell-Cotes, probably after 1904
EXH: *Ruskin Exhibition,* Spring 1904, Manchester City Art Gallery (424) [either this work or a replica of it]; Graves Art Gallery, Sheffield organised a small exhibition at the Goring Hotel, London, on 26 July 1952 for a 'Guild of St. George' meeting (transported by Bourlets)
LIT: *The Graphic,* 27 January 1900, p.114 (ill.), in M. H. Spielmann's essay on John Ruskin
COLL.NO: BORGM RC01958

Ruskin's influence within the nineteenth century was im-

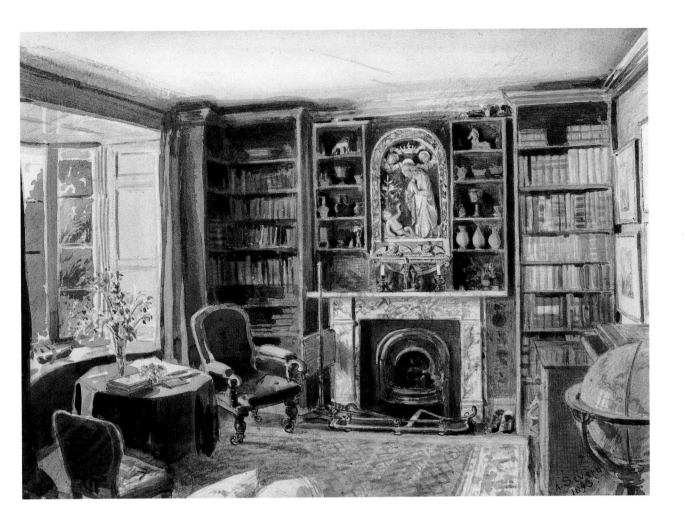

mense and far-reaching. Merton, like many collectors, held Ruskin in the highest regard. Their admiration of him was reflected in their collections and in seeking his valued advice and collecting anything from his own hand. Merton wrote: 'Of all the great Englishmen I have met John Ruskin as a man of letters and connoisseur of art stands alone'.[1] Indeed Merton's autobiography *Home and Abroad* contains a lengthy section on Ruskin, much longer than devoted to any other artist. Merton sought sanction from Ruskin and even sent him a still-life by George Walter Harris for his opinion. The Russell-Cotes collection contains a small sketch by Ruskin as well as many of his books. Merton and Annie even made the pilgrimage to Ruskin's lakeside home, Brantwood at Coniston, probably after Ruskin's death. He wrote of the visit: 'During our visit to Brantwood, Mrs. Severn [Ruskin's cousin] escorted us through the house, and we rejoiced beyond measure in viewing everything.'[2]

This watercolour depicts the northern half of John Ruskin's study at Brantwood, Coniston. The early Italian *Madonna and Child* above the fireplace is a ceramic plaque by Luca della Robbia (1400–82). The piece was bought for Ruskin in 1880 and installed in 1881. To the right on the wall are some of Ruskin's most prized Turner watercolours. The circular table to the left is where Ruskin wrote. Also visible within the painting are examples of ancient Greek and Cypriot pottery on the shelves above the fireplace.

On Merton's visit to Brantwood the room would have looked very much as it appears in the watercolour. He was shown around by Joan Agnew Severn (née Ruskin, John Ruskin's cousin and ward), the artist's wife. Ruskin pur-

chased Brantwood in 1871 and after his death in 1900 it was occupied by Joan and Arthur Severn who inherited it with its contents. Many of the works and objects within the house were sold in 1931 and the della Robbia, for example, can no longer be seen in the study. Joseph, or Arthur as he preferred to be called, was a landscape painter who specialised in scenes of the Lake District. He also painted several scenes of Brantwood including his bedroom, of which two copies exist.[3]

It is possible that Merton purchased the work on his visit to Brantwood, although the fact that it, or a replica of it, was exhibited at the 1904 Ruskin exhibition in Manchester may indicate that it was purchased from Thomas Barratt. In any case it was certainly seen as a memento of the visit to Brantwood and a reflection of his admiration of Ruskin.

1. *Home and Abroad*, p.745
2. *Ibid*, p.753
3. Two versions of this work exist: one in The Santa Barbara Museum of Art and one in the Ruskin Foundation, Ruskin Library, University of Lancaster. It is possible that two versions were painted of the study

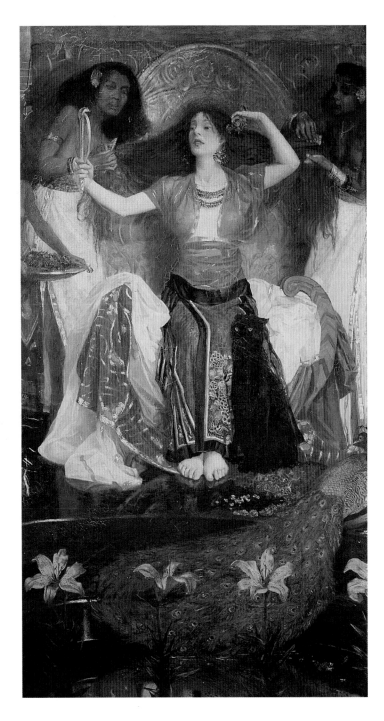

## 44: John Liston Byam Shaw ARWS RI
(1872–1919)
*Jezebel*, 1896

Oil on canvas
Image size: 147.6 x 80.5cm, 58¼ x 31¾ in.
Frame size: 208 x 122cm, 81¾ x 48 in.
Signed: l.r. '*BYAM.SHAW.96.*'
Printed label on back: '*61 Queen's Road, Geth … Picture Framers and Restorers*'

Printed label on back: '*Dowdeswell & Dowdeswells Ltd, Publishers Valuers and Dealers in Fine Art, 160 New Bond Street, London W.*'

PROV: Merton Russell-Cotes original collection
EXH: RA 1896 (950)
LIT: Quick, p.32 (no.106); Quick, *Illustrated Souvenir*, p.49 (ill.) (no.106); *Bulletin*, June 1925, vol.IV, no.2, p.14, p.15 (ill.), p.16; Rex Vicat Cole, *The Art and Life of Byam Shaw*, London: Seeley, Service & Co. Ltd 1932, pp.53–4, p.60, p.209; Gaunt, p.173 (ill.)
COLL.NO: BORGM RC01968

John Liston Byam Shaw was born in Madras in 1872. The family later moved to England where he trained at the Royal Academy Schools. He was part of a later generation of artists that were influenced by the Pre-Raphaelites, an influence very apparent in this painting. He was also a prolific illustrator with a strong feeling for design which show evidence of the art nouveau style. The lyricism of his design does not undermine the carefully studied and painted figures, however, and his training at the Royal Academy is evident in his work. The subjects for Shaw's work were Pre-Raphaelite and he based many of his paintings on Rossetti's poems. The Old Testament story of Jezebel is treated with a sensuality of colour and form typical of the later Pre-Raphaelite influence. The strong compositional design of the work was extended by Shaw to cover the frame whose relief designs depict Jezebel's death by being thrown to the dogs.

The sensuality of the picture initially caused problems for the artist who was unable to sell it. The model for Jezebel was Miss Rachel Lee, a close companion to Shaw throughout his life, who appeared nude in the painting when it was first exhibited at the Royal Academy in 1896. Rex Vicat Cole in his book *The Art and Life of Byam Shaw*, wrote: ' "Jezebel" … was exhibited at the Academy, but for years remained unsold. Certain people objected to Jezebel's nudity. An offer came subject to this being altered – money was scarce, and the artist unfortunately gave in. The picture as repainted hangs in Bournemouth Art Gallery.'[1]

Shaw wrote about the alterations that he made. 'I have put the gold on Jez: and am going to paint designs on top. Of course, it means painting it all up a higher key, but that is all the better. Moira [Professor G. E. Moira RWS] suggested to me to put Jezebel into a much more mysterious light and shade, so the next day I had to slash at it all over again and took out nearly all I had done since you left, but I think it looks better.'[2] And later his satisfaction at the work he carried out: 'Of course, it is unnecessary to inform you that I am having Jez's canvas altered. I think it is an improvement.'[3]

Whether or not it was Merton who requested Jezebel to be clothed or not is unclear. Certainly he had a tendency toward prudery if the nudes were not strictly academic or considered too risqué. The work, from the label on the back, appears to have been sold through Dowdeswell & Dowdeswells of New Bond Street where Merton bought several works. The gallery exhibited many of Shaw's works including at least five solo exhibitions between 1899 and 1916.

1. Rex Vicat Cole, *The Art and Life of Byam Shaw*, London: Seeley, Service & Co. Ltd 1932, p.53
2. Byam Shaw, quoted in Cole, pp.53–4
3. *Ibid*, p.56

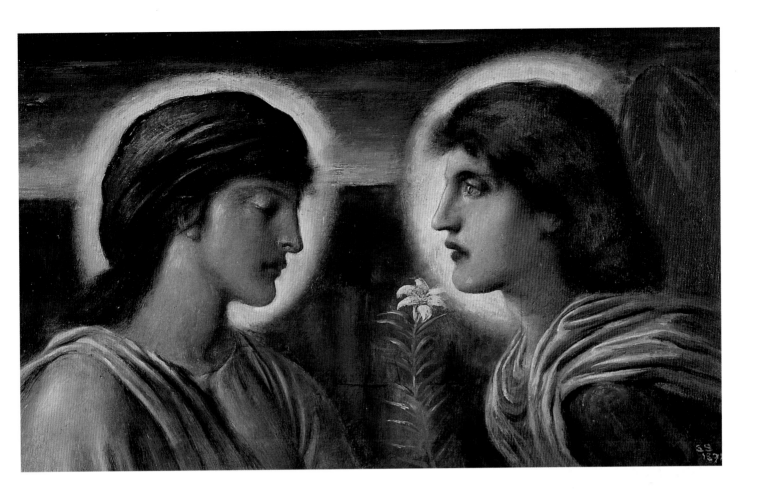

## 45: Simeon Solomon
(1840–1905)
*The Annunciation,* 1892

Oil on board
Image size: 37.5 x 62.2cm, 14¾ x 24½ in.
Frame size: 56.8 x 81.9cm, 22½ x 32¼ in.
Signed: l.r. '*SS 1892*'

PROV: Gift to the Russell-Cotes Art Gallery and Museum by
   Miss Dorothy Allam in 1971
COLL.NO: BORGM RC2734

Simeon Solomon was born in London in 1840, the son of
Michael Solomon, a Livorno hat importer and prominent
member of the Jewish community. Solomon was schooled
early in Hebraic law and ritual. His art education began
when he joined his older brother Abraham in his Gower
Street studio. His talents were quickly recognised and he
entered the Royal Academy Schools at the age of fifteen.
He began exhibiting at the Royal Academy in 1858 with a
painting depicting Abraham and Isaac. His paintings reflect
his devotion to his faith painted in a clearly Pre-Raphaelite
style, being seen by the brotherhood as a painter of great
promise. He carried out design work for William Burges
and William Morris and illustrated many books including
Swinburne's pornographic works, *Lesbia Brandon* and *The*

*Flogging Block.* In 1872 he exhibited his last picture at the
Royal Academy due to the disgrace of being convicted of
homosexual offences in 1873. His life from this point was
that of an outcast, due to his own will and the stigma of his
sentence. He lived most of his remaining years at St Giles
Workhouse, Holborn, where he died in 1905.

Solomon did not exclusively paint Jewish subjects and his
fascination for all religious rituals tied with the exotic led
him to paint many varied themes. This painting of the
Annunciation dates from 1892. He had continued to ex-
hibit at the Grosvenor Gallery including a painting of the
same subject two years earlier.[1] As a recluse he cast a
strange figure lost in a world of his own imaginings and
inspirations as Bernard Falk recalled: 'Sometimes he would
startle his fellow paupers by repeating aloud whole passages
from the *Song of Solomon,* his favourite inspiration, or by in-
toning *Kol Nidrei,* the prayer uttered by devout Jews on the
eve of the great White Fast, or, as if unconscious of the in-
congruity of the mixture, humming one of the Gregorian
chants heard in the Carmelite Church, Kensington.'[2]

Although Merton does not specifically mention Simeon
Solomon, he had two small works in his collection: an oil
study of a knight and a watercolour study of a head.

1. Grosvenor Gallery 1890, *Annunciation* (246)
2. Bernard Falk, *Five Years Dead,* London: Hutchinson & Co. 1937,
   p.330

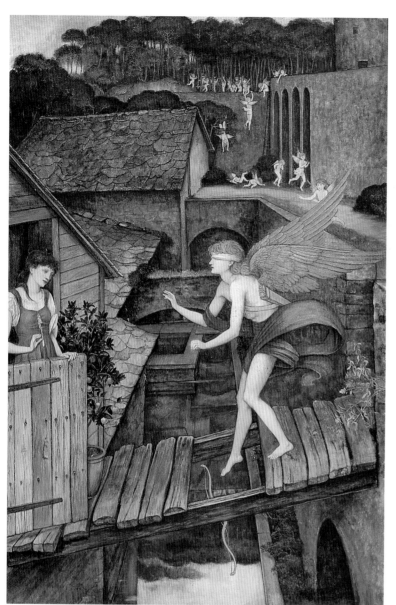

## 46: John Roddam Spencer Stanhope
(1829–1908)
### Love Betrayed

Tempera on paper on board (?)
Image size: 80 x 53cm, 31½ x 20¾ in.
Frame size: 98 x 71cm, 38¾ x 28 in.
unsigned

PROV: Purchased by the Russell-Cotes Art Gallery and
   Museum in January 1950
LIT: *Bulletin*, September 1950, fifth page (unnumbered)
COLL.NO: BORGM RCO2039

Born January 1829, the son of John and Lady Elizabeth
Spencer Stanhope, John Roddam Spencer Stanhope was
educated at Rugby and Christ Church, Oxford. He studied
with the artist G. F. Watts during his summer vacation of
1850. 'As Watts was then living at Little Holland House',
he wrote, 'I spent a good deal of time there, and there it
was that I met Rossetti, Burne-Jones, and other pre-
Raphaelites.'[1] This led to the very direct influence of the
Pre-Raphaelites, in particular, Burne-Jones. 'I was invited
by Rossetti to join them in decorating the big room of the
Union Club at Oxford. The lunette I painted was next
to one Burne-Jones was working at, and we became firm
friends.'[2] The development of his painting owed a great
deal to this influence and association. In comparison to
the work of Burne-Jones, Stanhope's are bolder in outline,
stronger in colour and often lack the subtlety of tone and
drawing evident in his mentor's work. The other immense
influence on his work was Italian art, a devotion that
led him to move permanently to Florence in 1880. He
attempted to paint modern pictures in the mode of the
Italian Renaissance. This meant that he not only adopted
an allegorical language of complex symbols but he also pre-
ferred to paint using tempera in emulation of the painting
techniques of historic Italy.

*Love Betrayed* is an allegorical story represented through
blind Cupid or Love, being led to his fall through the hole
in the bridge where his bow has already fallen. The impli-
cation is that the young woman to the left of the picture is
betraying him through false hope.

1. Spencer Stanhope, quoted in William De Morgan's introduction
   to the *Catalogue of Pictures and Drawings by the late R. Spencer
   Stanhope*, Carfax Gallery, London, March 1909, p.7
2. *Ibid*, pp.7–8

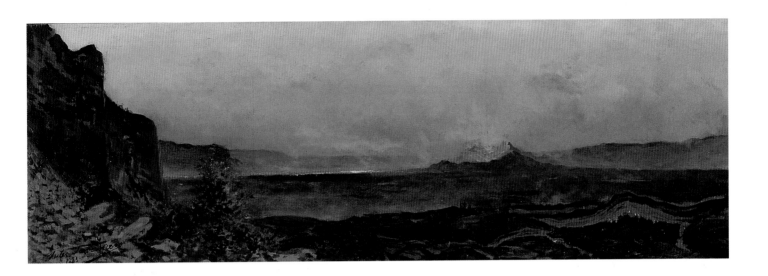

## 47: Jules Taverniers
### *The Crater of Kilauea, Island of Hawaii*, 1885

Oil on canvas
Image size: 24.7 x 75cm, 9¾ x 29½ in.
Frame size: 42 x 92cm, 16½ x 36¼ in.
Signed: l.l. *'Jules Taverniers 1885'*
Inscription on slip frame: *'Painted on the spot for Mr. And
    Mrs. Russell-Cotes during their visit 16th – 21st July 1885,
    J Taverniers Chevalier Legion of Honour'*

PROV: Merton Russell-Cotes from the artist in 1885
LIT: *Home and Abroad*, p.726; Quick, p.15 (no.30)
COLL.NO: BORGM RCO2088

A painting that records Annie and Merton's visit to Hawaii
in 1885. Merton was to recall later that 'whilst sojourning
in Honolulu, my wife and I met two French artists, Jules
Taverniers and Chas. Ferneaux. Jules Taverniers was a
Knight of the Legion of Honour and a remarkably clever
artist. He was travelling like ourselves for health and
pleasure. On our trip to Hawaii to explore the great vol-
cano of Kilauea he, at our invitation, accompanied us as
our guest, and I commissioned him to paint the picture
which is now in the Russell-Cotes Art Gallery, of the interior
of Kilauea, the largest active volcano in the world.'[1]
Merton's autobiography contains many exaggerations and
the fact that Jules Taverniers does not appear in Benezit's
comprehensive dictionary of artists despite claiming that he
was a *chevalier de la Légion d'honneur*, seems rather dubious.[2]

1. *Home and Abroad*, p.726
2. A French 19th-century landscape artist Jules Tavernier is listed
    in E. Benezit, *Dictionnaire des peintres, sculpteurs, dessinateurs et
    graveurs*, Librarie Gründ 1948, of whom little is known, not a
    *chevalier de la Légion d'honneur*, which indicates either Merton's
    or the artist's exaggeration

1.
Sidney Paget, *THE DISPERSAL OF SIR HENRY IRVING'S TREASURES (lot 175) A scene at Christie's*, water-colour showing the sale of James Archer's portrait of Irving. Illustration for *The Sphere*, 23 December 1905, p.243.

2.
Palette of Frederick Goodall RA
Bears the plaque 'The Palette of Frederick Goodall, R.A. – Bought by M RUSSELL-COTES, F.R.G.S.'

3.
Palette of Lord Leighton bearing the plaque: 'LEIGHTON'S PALETTE BOUGHT AT CHRISTIE'S BY MERTON RUSSELL-COTES, F.R.G.S.'

4.
Letters from 1864 by Edwin Landseer and others relating to Landseer's replica of *The Highland Flood* (1864).

5.
Letter by Lucy Kemp-Welch discussing *Gypsy Horse Drovers*, c.1922.

6.
Catalogue of the Edwin Long Gallery, text by Rev. Canon Farr, 1894.

7.
Catalogue of the *Royal Jubilee Exhibition*, Manchester 1887.

8.
Catalogue of the *International Exhibition*, Glasgow 1901, a presentation copy from Glasgow Corporation to Merton Russell-Cotes.

9.
Richard Quick, *Catalogue of Pictures and Sculpture in the Russell-Cotes Art Gallery*, 1923.

10.
A replica of the Souvenir Album presented to the Lord Mayor of London and the Lady Mayoress on 5 June 1909. Annotated by Merton Russell-Cotes.

11.
Three Christie's catalogues annotated by Merton Russell-Cotes.

12.
Merton Russell-Cotes, *Home and Abroad* [autobiography in 2 vols], Bournemouth: privately published 1921.

13.
W. Roberts, *Memorials of Christie's* [2 vols] London: George Bell & Sons 1897. First of two volumes inscribed to Merton by Thomas H. Woods, of Christie, Manson and Woods, 18 February 1898.

14.
Lucy Kemp-Welch study for *Gypsy Horse Drovers*, oil on board. Contains an image on both sides, one of an overall composition and the other of a horse's head.

15.
*Art Journal*, 1895 which contains a series of articles on Merton's fine-art collection.

Each painting is prefixed by Agnew's own reference number.

Buying on 11 September 1886

3395 Morgan, *A Midday Meal* for £225
Bought by Agnew's from
A. Hartley on 13 April 1886

Buying on 13 September 13 1886

2464 H. Andretti, *Flowers* for £36 15s
Bought by Agnew's from Bradley
on 20 June 1881 for £25

3992 A. Hartley, *An Intruder* for £21
Bought by Agnew's on 13 April
1886

Buying on 12 August 1889

2206 Topham, *The Hostage Bergams*
for £78 15s
Bought by Agnew's from the
artist on 7 November 1881 for
£70

2673 Andretti, *Flowers* for £52 10s
Bought by Agnew's from
Dewhurst on 7 November 1881
for £36

4315 Brett, *Penally* for £36 12s
Bought by Agnew's for £22 6s
19 February 1887

5249 Cooke, *Façade of San Georgio,
Venice* for £73 10s
Bought by Agnew's for £28 7s on
7 May 1889

5273 J. W. Nichol, *When a Man's
Single* for £105
Bought by Agnew's from H. Hill
for £52 on 25 May 1889

5290 Graham, *Ramblers*
Bought by Agnew's on 28 May
1889 from Reisach

5291 Watercolour *Sandiggers,
Cornwall*
Bought by Agnew's on 28 May
1889 from Reisach for £400

Buying on 22 September 1891

1631 Frost, *The Sea Cave* for £100
Bought by Agnew's on 30 July
1880 from G. E. Potter

Buying on 7 November 1891

4914 Goodall, *The Palm Offering*
(49 x 54½ in.) for £787 10s
Bought by Agnew's from
Gambard 14 June 1888 for £500

Selling on 7 November 1891

6217 J. R. Reid, *Where are you going
to?* for £50
Agnew's sold to Hepper & Sons
26 March 1895

6218 Hill, *Peasants*
Agnew's sold to Capes and
Dunn, 15 December 1891 for
10 guineas

6219 Baker, *Landscape*
Agnew's sold to Capes and
Dunn, 15 December 1891 for
£2 7s 6d

6220 Pettit, *Landscape* for £20
Agnew's sold to A. C. Blair on
14 March 1892 for £47 5s

(lot numbers are given for art sales)

7 March 1905
*Modern Artists' Proof Engraving and
Etchings*
(part sale, lots 116–43)

9 March 1905
*Silver Plate and Objects of Vertu*
(full sale)

10 March 1905
*Old Nankin Porcelain, Chinese
Enamelled Old English and
Continental Decorative Objects and
Furniture* (full sale)

11 March 1905
*Fine Modern Pictures and Water
Colour Drawings*
(full sale, lots 1–153)

2 December 1905
*Drawings*
(part sale, lots 115–52)

17 February 1910
*Objects of Vertu*

18 February 1910
*Porcelain and Furniture*

2 April 1910
*Paintings and Drawings*
(part sale, paintings lots 114, drawings
lots 116–20)

4 April 1910
*Paintings and Drawings*
(part sale, drawings lots 108–20,
paintings lots 121–39)

27 April 1914
*Paintings and Drawings*
(part sale, drawings lots 148–53,
paintings lots 154–74)

16 May 1919
*Modern Pictures and Water Colour
Drawings*
(part sale, drawings lots 1–4, paintings
lots 5–36)

On the Saturday of 11 March 1905, Merton Russell-Cotes sold a great proportion of his loan collection. He wrote: 'I decided to let Christie's dispose of the collection for me, and after selecting about a third of the pictures which I was desirous of retaining, I sent the remainder to Christie's where they were placed under the hammer in March 1905, by Lance Hannen (the principal of the firm of Christie, Manson and Woods), who told me that it was the most complete representative collection of British Art that had passed through their hands' (*Home and Abroad*, p.688).

CATALOGUE OF
FINE
## MODERN PICTURES
AND
## WATER COLOUR DRAWINGS
THE PROPERTY OF
## MERTON RUSSELL COTES, ESQ.
*of East Cliff Hall, Bournemouth*
WHICH
will be sold by auction by
## MESSRS. CHRISTIE, MANSON & WOODS
AT THEIR GREAT ROOMS
8 KING STREET,
ST JAMES'S SQUARE
ON SATURDAY, MARCH 11, 1905
AT ONE O'CLOCK PRECISELY:

May be viewed Three Days preceding,
and Catalogues had
Messrs. CHRISTIE, MANSON and
WOODS' Offices
*8 King Street, St James's Square, S.W.*

---

## CATALOGUE

On SATURDAY, MARCH 11, 1905,

AT ONE O'CLOCK PRECISELY,

## WATER COLOUR DRAWINGS

H. ALLINGHAM, 1878
1 HAYMAKING
3¾in. by 6¾in.

SAM BOUGH, R.S.A., 1864
2 A CASTLE ON A CLIFF
7in. by 9in.

BIRKET FOSTER
3 KENSINGTON GARDENS
4in. by 5½in.

T.B. HARDY, 1891
4 OFF DOVER
19½in. by 29½in.

T.B.HARDY, 1876
5 DUTCH PINCKS: Low tide
13in. by 19½ in.

T.B. HARDY
6 THE SANTA MARIA DELLA
SALUTE, VENICE; and HASTINGS
– *a pair*
5in. by 7in.

T.B. HARDY
7 RIVA SCHIAVONE; and A RAINY
DAY, VENICE – *a pair*
5in. by 7in.

J. HOLLAND, 1857
8 A CANAL SCENE, VENICE
14½in. by 20½in.
*From the Artist's Sale*

E.K. JOHNSON, 1883
9 PLUCKING THE ROSE
15in. by 8¼in.
J. MacWHIRTER, R.A.
10 RIVA SCHIAVONE, VENICE
10½in. by 8¼in.

L. DA RIOS, 1886
11 TEASING GRANDMOTHER
24½in. by 19in.

D. ROBERTS, R.A., 1838
12 BAZAAR OF THE STREET
LEADING TO THE MOSQUE
OF THE MOORISTAN, CAIRO
19in. by 13in.
*From the Collection of Sir J. Pender, 1897*
*Lithographed in Robert's 'Holy Land*
*and Egypt,' vol.VI.*

D. ROBERTS, R.A., 1832
13 THE ENTRY INTO JERUSALEM
9in. by 12¼in.

HENRIETTE RONNER
14 CAT AND KITTENS
14in. by 20in

P. SADÉE
15 LOOKING FOR THE
FISHING-BOATS
19½in. by 16in.

## PICTURES

S. ANDERSON
16 MUSIC HATH CHARMS
13½in. by 11in.

F. ANDREOTTI
17 THE MISER
10½in. by 8½in.

G.H. ANDREWS.
18 A FÊTE CHAMPÊTRE
19½in. by 25½in.

R. ANSDELL, R.A., 1870
19 DEER-STALKING
12in. by 19in.

J. AUMONIER
20 BELLAMO, ITALY
27in. by 44in.

B. BARKER (OF BATH), 1828
21 A WOODY RIVER SCENE,
with angler, peasant and cattle
25in. by 35in.

W. BEATTIE-BROWN, R.S.A., 1887
22 AUCHNASHALLACH
DEER FOREST
20in. by 26in.

R. BEAVIS
23 STACKING OATS, SUSSEX
24in. by 36in.

R. BEAVIS, 1875.
24 MOUNT SINAI
20½in. by 30in.

F. BRAMLEY, A.R.A., 1887
25 'EYES AND NOT EYES'
45in. by 36in.
*Exhibited at the Royal Academy, 1887*
*Exhibited at the Guildhall, 1900*

F.M. BREDT
26 LADIES OF THE HAREM
ON A MOORISH HOUSETOP
36in. by 54½in.

J. BRETT, A.R.A., 1881
27 EBB TIDE
7in. by 14in.

J.B. BURGESS, R.A., 1876
28 GOOD NEWS AND BAD NEWS
40in. by 32in.
*Exhibited at Glasgow, 1901*

J.B. BURGESS, R.A.
29 A SPANISH COQUETTE
11½in. by 8½in.

J. CASSIE, R.S.A., 1871–4
30 THE MOUTH OF THE RIVER TAY
26½in. by 49in.

VICAT COLE, R.A.
31 ARUNDEL PARK
13½in. by 23in.

W. COLLINS, R.A.
32 UNLOADING A HAY-BOAT
10in. by 13½in.

G.W. COOKE, R.A., 1866
33 THE UNDERCLIFF AT VENTNOR
21in. by 37in.

E.W. COOKE, R.A., 1856
34 VENICE
11½in. by 17in.

M. MURRAY COOKESLEY, 1897
35 THE GAMBLER'S WIFE
60in. by 42in.

T.S. COOPER, R.A., 1867
36 CANTERBURY MEADOWS:
A cool retreat
47in. by 72in.

T.S. COOPER, R.A., 1852
37 SHEEP ON THE HILLS
25½in. by 36in.

T.S. COOPER, R.A., 1886
38 A DONKEY AND GOATS
On panel – 17½in. by 13½in.

T.S. COOPER, R.A., 1882
39 IN THE SPRINGTIME
OF THE YEAR
On panel – 15½in. by 21½in.
Exhibited at the Royal Academy, 1882

T. CRESWICK, R.A.
40 A ROCKY STREAM
22in. by 27½in.

T. CRESWICK, R.A.
41 A LANDSCAPE, with woodcutter
On panel – 11½in. by 18in.

E. CROFTS, R.A., 1880
42 THE OUTLAW
11in. by 17½in.

T.F. DICKSEE, 1886
43 CLARICE
17in. by 13in.

J. DISCART
44 A DEALER IN EARTHENWARE
On panel – 16½in. by 11in.

EDWIN ELLIS
45 RETURN OF THE FISHERMAN
17½in. by 33in.

EDWIN ELLIS
46 THE TWILIGHT HOUR
15½in. by 23in.

EDWIN ELLIS
47 THE BATHERS
11½in. by 47in.

EDWIN ELLIS
48 A COAST SCENE,
with fishing boats drawn up
11½in. by 47in.

D. FARQUHARSON, A.R.A., 1890
49 'DOUN BY THE TUMMEL'
7½in. by 13½in.

A. FERRARIS, 1890
50 DRIVING A BARGAIN: CAIRO
On panel – 24in. by 19in.

C. FIELDING
51 VIEW NEAR CUCKFIELD,
in the Weald of Sussex
10in. by 18in.

LUKE FILDES, R.A.
52 A BRUNETTE
13½in. by 10in.

LUKE FILDES, R.A.
53 WASHING-DAY
On panel – 4¾in. by 8½in.

D. FRÈRE, 1872
54 THE CHEF
On panel – 13in. by 10¼in.

E. FRÈRE, 1880
55 A STREET IN A FRENCH TOWN
13in. by 10in.

SIR J. GILBERT, R.A., 1865
56 THE TIMBER-WAGGON
27½in. by 36in.

J.W. GODWARD, 1893
57 DAY-DREAMS
32in. by 17½in.

J.W. GODWARD, 1897
58 DOLCE FAR NIENTE
30in. by 50in.

J.W. GODWARD, 1896
59 HEAD OF A GIRL
13½in. by 11½in.

F. GOODALL, R.A., 1867
60 THE PALM OFFERING
21in. by 15in.
Exhibited at Glasgow, 1901

F. GOODALL, R.A., 1859–70
61 GATE OF THE COPT QUARTER,
TANGIER
10in. by 15in.

C. VAN HAANEN, 1883
62 HEAD OF A VENETIAN GIRL
On panel – 20½in. by 14½in.
From the Collection of Lord Leighton,
1896

ARTHUR HACKER, A.R.A., 1885
63 LEFT IN CHARGE
17½in. by 23½in.

KEELEY HALSWELLE, A.R.S.A.
64 A MILL ON THE OUSE
15in. by 22½in.

KEELEY HALSWELLE, A.R.S.A.
65 GNARLED OAKS,
DANBURY PARK
15in. by 22½in.
From the Artist's Sale, 1891

F.D. HARDY, 1889
66 A COTTAGE, with children
On panel – 6½in. by 5in.

HEYWOOD HARDY, 1876
67 THE BUTTERFLY
34in. by 27in.

A. HARLAMOFF
68 HEAD OF A GIRL
13in. by 9in.

B. NAPIER HEMY, A.R.A., 1885
69 FALMOUTH REGATTA
On panel – 13in. by 19in.

C. NAPIER HEMY, A.R.A., 1885
70 H.M.S. 'GANGES'
19in. by 13½in.

R. HILLINGFORD
71 BARON MUNCHAUSEN
RELATING HIS ADVENTURES
20in. by 30in.

COLIN HUNTER, A.R.A. 1879
72 LANDING FISH
19in. by 34in.

L.B. HURT, 1904
73 CATTLE IN THE HIGHLANDS
25½in. by 40in.

L.B. HURT, 1891
74 HIGHLAND CATTLE
ON THE SEA-SHORE
23½in. by 40in.

L.B. HURT, 1903
75 HIGHLAND CATTLE ON THE
SHORE OF A LOCH
25½in. by 39½in.

L.B. HURT, 1886
76 SNOWDON FROM NEAR
LLYN LYDDAW
18½in. by 12½in.

L. JIMINEZ, 1876
77 GOSSIPS
On panel – 6½in. by 4in.

YEEND KING
78 OLD MILL AT OFFLEY
23½in. by 35½in.

YEEND KING
79 A LANDSCAPE, with farmstead
30in. by 23in.

YEEND KING
80 PEASANTS RETURNING FROM
CHURCH, NORMANDY
19½in. by 15½in.

YEEND KING and MATTHEW HALE,
1882
81 IN AN OLD GARDEN:
Sunshine and Shadow
27½in. by 36in.

B.W. LEADER, R.A., 1866–94
82 THE LLEDR VALLEY
28in. by 40½in.

B.W. LEADER, R.A., 1875
83 ON THE BANKS OF DERWENT
WATER
12in. by 9½in.

F.R. LEE, R.A., 1860
84 THE ROCK OF GIBRALTAR
27½in. by 50in.
*From the Collection of D. Dunbar, Esq.,
1894*

F.R. LEE, R.A., 1860
85 GIBRALTAR FROM THE RUINS
OF FORT ST. BARBARA
12in. by 24in.

E. BLAIR LEIGHTON, 1890
86 'HOW LISA LOVED THE KING'
'Lisa, the only child of a rich merchant
of Palermo, having fallen ill through
love of King Pietro of Sicily, asks
his favourite musician, Minuccio,
to come and sing to her'
40in. by 66in.
*Exhibited at the Royal Academy, 1890
Exhibited at Chicago, 1893*

E. BLAIR LEIGHTON, 1892
87 WHERE THERE'S A WILL,
THERE'S A WAY
36in. by 23½in.
*Exhibited at Glasgow, 1901*

C.J. LEWIS
88 THE SHEEPFOLD
19½in. by 39in.

C.J. LEWIS, 1865
89
'I steal by lawns and grassy plots,
I slide by hazel covers,
I move the sweet forget-me-nots
That grow for happy lovers.'
15in. by 31in.

J. LINNELL, SEN., 1865
90 EVENING
27½in. by 39in.

E. LONG, R.A.
91 JAIRUS'S DAUGHTER
33½in. by 44in.
*Exhibited at the Royal Academy, 1889*

HAMILTON MACALLUM, 1872–3
92 CALM OFF ARRAN
14½in. by 27½in.

R.W. MACBETH, A.R.A., 1891
93 LATE FOR THE FERRY, LYNN
13½in. by 22½in.
*Exhibited at the New Gallery, 1892*

J. MacWHIRTER, R.A.
94 OUT IN THE COLD
30in. by 44in.
*Exhibited at the Royal Academy, 1874*

CLARA MONTALBA, 1886
95 THE SANTA MARIA DELLA
SALUTE, VENICE
16in. by 10in.

ALBERT MOORE
96 BATTLEDORE
42in. by 18in.

H. MOORE, R.A., 1890
97 BREEZE OFF THE
ISLE OF WIGHT
36in. by 61in.

H. MOORE, R.A.
98 SHINE AND SHOWER
16in. by 25½in.

H. MOORE, R.A., 1871–6
99 NEAR HARLECH, NORTH WALES
14½in. by 25½in.

FRED. MORGAN, 1879
100 THE MID-DAY REST
41in. by 63½in.

P.R. MORRIS, A.R.A.
101 FRIENDS OR FOES
30in. by 19½in.

DAVID MURRAY, R.A., 1891
102 THE SHINGLES, RYE, SUSSEX
23in. by 36in.

DAVID MURRAY, R.A., 1894
103 AUTUMN BLUE AND GOLD
17½in. by 23½in.

DAVID MURRAY, R.A., 1894
104 THE SILVER OF LATE SUMMER,
CORFE CASTLE
11½in. by 17½in.

DAVID MURRAY, R.A., 1897
105 HEATHLAND
11½in. by 17½in.

ERSKINE NICOL, A.R.A., 1852
106 THE BACHELOR
*On panel – 13in. by 10in.*

ERSKINE NICOL, A.R.A., 1852
107 'OCH! BOTHERATION!'
12in. by 10in.

J. WATSON NICOL, 1880
108 AN UNPLEASANT REMINDER
16in. by 20½in.

E.J. NIEMANN, 1852
109 KENILWORTH CASTLE
18½in. by 29in.

E.J. NIEMANN, 1870
110 FESTINIOG, NORTH WALES
21in. by 27in.

E.J. NEIMANN, 1874
111 LEXTON BRIDGE, COLCHESTER
14in. by 29½in.

STEFANO NOVO, 1893
112 A VENETIAN
PEASANT-WOMAN
*On panel – 21in. by 9in.*

JULIUS OLSSON
113 A FROSTY EVENING
30in. by 40in.
*Exhibited at the New Gallery, 1899
Exhibited at Glasgow, 1901*

G.B. O'NEILL
114 THE SQUIRE'S DAUGHTER
13½in. by 16½in.

A. PARSONS, A.R.A., 1881
115 A LOCK-KEEPER'S GARDEN
36in. by 17in.

E. PAVY, 1886
116 THE SNAKE-CHARMER
*On panel – 13in. by 22½in.*

E. PAVY, 1886
117 A STREET SCENE, ALGIERS
19½in. by 14½in.

P. PAVY, 1887
118 AT CAIRO
*On panel – 11in. by 8½in.*

C.E. PERUGINI
119 HEAD OF A CAPRI GIRL
13½in. by 10½in.

F.R. PICKERSGILL, R.A., 1843
120 A FESTIVAL IN HONOUR
OF PAN
30in. by 50in.

V. POVEDA, 1892
121 PROCESSION DE LA FÊTE-
DIEU: CHURCH OF FRARI, VENICE
20in. by 26½in.

J.B. PYNE
122 BRISTOL DOCKS
30in. by 24in.

G. QUADRONE, 1873
123 A SOLILOQUY
*On panel – 7in. by 6in.*

BRITON RIVIERE, R.A., 1887
124 TICK TACK
14½in. by 19in.

P.H. SADÉE
125 THE FISHING-BOATS'
DEPARTURE
*On panel – 7¾in. by 11½in.*
W. DENDY SADLER, 1886
126 A GAME OF CHESS
29in. by 40in.

W. DENDY SADLER
127 'LADIES AND GENTLEMEN!'
30*in*. by 17*in*.

C. SEILER, 1890
128 DRESSING
*On panel – 6³/₄in. by 4³/₄in.*

G. SIMONI, 1886
129 THE CARPET-MERCHANT OF
FLEMEEN, MOROCCO
21¹/₂in. by 14*in*.

R. SORBI, 1883
130 A TRIBUTE TO BACCHUS
14*in*. by 11*in*.

C. STANFIELD, R.A., 1836
131 A SEA PIECE, with fishing-boats
23*in*. by 35¹/₂in.

MARCUS STONE, R.A., 1878
132 THE POST-BAG
29*in*. by 49*in*.
*Exhibited at the Royal Academy, 1878*

MARCUS STONE, R.A.
133 A PEASANT GIRL
*On panel – 15¹/₂in. by 11¹/₂in.*

SIR L. ALMA TADEMA, R.A.
134 VENUS AND MARS
23*in*. by 11*in*.

SIR L. ALMA TADEMA, R.A.
135 READY FOR THE OPERA
*On panel – 15in. by 19in.*
*From the collection of*
*Mrs Bloomfield Moore, 1900*

LADY ALMA TADEMA
136 ALWAYS WELCOME
15*in*. by 21¹/₂in.
*Exhibited at the Grosvenor Gallery, 1887*

H. TENKATE, 1856
137 EXAMINING THE SPY
*On panel – 10in. by 13in.*

H.H. LA THANGUE, A.R.A.
138 THE CORNFIELD
12*in*. by 15¹/₂in.

A. VICKERS, 1831
139 NEAR HARLECH,
NORTH WALES
*On panel – 11¹/₂in. by 15¹/₂in.*

SIR E.A. WATERLOW, R.A. 1884
140 SAND-DIGGING,
NORTH CORNWALL
35*in*. by 60*in*.
*Exhibited at the Royal Academy, 1884*

J. WEBB
141 DUTCH FISHING-BOATS,
SCHEVENINGEN
19¹/₂in. by 32*in*.

J. WEBB, 1880
142 CALM NIGHT ON THE
SCHELDT, HOLLAND
*On panel – 14in. by 19¹/₂in.*

OTTO WEBER
143 CATTLE ON THE BANKS
OF A RIVER
17*in*. by 30*in*.

T. WEBSTER, R.A.
144 THE PEDLAR
*On panel – 8¹/₂in. by 11¹/₂in.*

W.L. WYLLIE, A.R.A.
145 AVE MARIA! Invocation to the
Virgin for Success to the Draught
at the Herring Fishery
33*in*. by 57*in*.
*Exhibited at the Royal Academy, 1872*

C.W. WYLLIE, 1876
146 THE MILL WEIR
24*in*. by 34*in*.

C.W. WYLLIE, 1889
147 EBB TIDE, EMSWORTH,
SUSSEX
19¹/₂in. by 35¹/₂in.

W L. WYLLIE A.R.A., 1863
148 IN THE FOREST
22¹/₂in. by 35¹/₂in.

W.L. WYLLIE A.R.A., 1872
149 A SEA PIECE, with fishing-boats
18*in*. by 32*in*.

W.L. WYLLIE A.R.A., 1882
150 MALDON, ESSEX, Evening
17¹/₂in. by 32*in*.

W.L. WYLLIE A.R.A.
151 TOIL, GRIME AND WEALTH
ON A FLOWING TIDE
14*in*. by 22*in*.

W.L. WYLLIE A.R.A., 1881
152 LOW TIDE
9¹/₂in. by 17¹/₂in.

W.L. WYLLIE A.R.A.
153 LEAVING DOCK
8*in*. by 15¹/₂in.

Published on the occasion of the exhibition
*A Victorian Salon: Paintings from the Russell-Cotes Art Gallery
and Museum, Bournemouth, England*
Dahesh Museum, New York   19 January – 17 April 1999
Frick Art & History Centre, Pittsburgh   6 May – 4 July 1999
City Art Museum, Helsinki   August – September 1999

First published in 1999 by
Russell-Cotes Art Gallery and Museum, Bournemouth
Bournemouth Borough Council
in association with
Lund Humphries Publishers
Park House, 1 Russell Gardens, London NW11 9NN

British Library Cataloguing in Publication Data
A catalogue record for this book is available from the British Library

ISBN 0 85331 748 8

Designed by Peter Guy
Typeset by Tom Knott
Printed in Belgium by Snoeck-Ducaju & Zoon, Ghent

Distributed in the USA by Antique Collectors' Club
Market Street Industrial Park
Wappingers Falls
NY 12590, USA

Front cover:
Anna Alma Tadema
*Drawing Room, 1a Holland Park,* 1887 (Cat.1)

Back cover:
Dante Gabriel Charles Rossetti
*Venus Verticordia,* 1864–8 (Cat.42)